Nahum HaLevi

נ"ח מ"ק ב"י

March 2021

Praise for Color of Prophecy

Is it any wonder that when a respected brain surgeon – a master mechanic of our human body's Holy of Holies – applies his full-spectrum genius to Torah and art, the result is a luminous explosion of color and delight? From our beginnings in Adam, a *red* earth creature infused with Divine breath, there is no vision without the radiance of color. *The Color of Prophecy* deepens our human understanding as to why. Bravo to HaLevi!

Rebecca Alban Hoffberger
Founder and director of the American Visionary Art Museum, America's official national museum for outsider art
Baltimore, Maryland

The Color of Prophecy, which is steeped in heritage and history, as well as in mystery and metaphysics, is a marvelously combined literary and visual vehicle that attempts to make palpable the transcendent meanings and sources of prophecy and Judaism. It probes truths that lie beyond the capacities of conventional language, "rational" thought, or verifiable scientific scrutiny. This book is a work of synesthetic and spiritual intensity, which constitutes a transmission of the rich artistic, religious, and prophetic core of Judaism.

Simon Zalkind
Director of the Singer Gallery, Mizel Arts and Culture Center
Denver, Colorado

The descriptions in this scholarly book are as much a work of art as the pictures they describe.
The focus of Nahum HaLevi's paintings, in his own words, are "*an attempt to understand the underlying nature, structure, and essence of the universe – in other words, to apprehend God.*" No artist could have a more noble or worthier pursuit.
There are Bible illustrators and Bible artists; Nahum HaLevi is a Bible artist in the truest sense. His art is inspiring – his descriptions awaken a sense of wonder. It is my privilege and honor to highly recommend this book.

Graham D. Kennedy
Bible illustrator and editor of the *Bible Illustration Blog*
Manchester, Lancashire, United Kingdom

Do you process ideas through pictures or language? Either way, Nahum HaLevi's book will fascinate you. It contains a wealth of beautiful paintings and fascinating information – visual and interpretive midrash from a world-class scholar of the Hebrew Bible.

Elizabeth Fletcher, author of *Women in the Bible*
Sydney, Australia

Nahum HaLevi's paintings are colorful and extensively expressionist, vivid representations of biblical events.

David Brennan
Editor, *Bible-library.com*
Lebanon, Connecticut

The COLOR of PROPHECY

Nahum HaLevi

The COLOR of PROPHECY
Visualizing the Bible in a New Light

gefen
publishing house בית הוצאה לאור
JERUSALEM • NEW YORK Est. 1981

Cover Design: Leah Ben Avraham / Noonim Graphics
Typesetting: Irit Nachum
Cover painting: Mosheh Moskowitz

ISBN: 978-965-229-579-8

1 3 5 7 9 8 6 4 2

Gefen Publishing House Ltd.
6 Hatzvi Street
Jerusalem 94386, Israel
972-2-538-0247
orders@gefenpublishing.com

Gefen Books
11 Edison Place
Springfield, NJ 07081
516-593-1234
orders@gefenpublishing.com

www.gefenpublishing.com

Printed in Israel

Send for our free catalogue

Library of Congress Cataloging-in-Publication Data

HaLevi, Nahum, 1957-
The color of prophecy : visualizing the Bible in a new light / Nahum HaLevi.
p. cm.
ISBN 978-965-229-579-8
1. Bible. O.T. Prophets–Criticism, interpretation, etc. 2. Bible. O.T. Prophets–
Illustrations. 3. Painting, Modern. 4. Prophets in art. I. Title.
BS1505.52.H35 2012
224'.06–dc23
2012011916

To my wife, Helen Peshya Leah,

and to my children,

Mosheh Tzvi, Ahmnon Dov, Yahron Zev,
and Zehava Tzipora Raquel

Contents

Illustrations
Paintings and Descriptions

1. Isaiah's Symphony in Salv-A-tion Major
 Oil on canvas, 48 x 64 inches, 2009

2. The Book of Jeremiah: Jackals and Shackles
 Oil on canvas, 64 x 48 inches, 2008

3. Ezekiel's Brain: Flotations and Rotations in the River of Time
 Oil on canvas, 60 x 48 inches, 2010

4. The Bride of Hoseashtein: Betrothal and Exile
 Oil on canvas, 36 x 24 inches, 2007

5. Joel: Devastation verses Exaltation
 Oil on canvas, 36 x 24 inches, 2007

6. The Book of Amos: Streaming Social Sentience
 Oil on canvas, 64 x 48 inches, 2009

7. Obadiah: The Pride and Fall of Esau
 Oil on canvas, 24 x 36 inches, 2007

Foreword

Since we live in a modern world, which offers a great deal of individualized choice as to color – in the cars we buy, the walls of our homes, our clothes, and even our hair and contact lenses which afford us opportunity to rewrite what natural colors we inherited – we tend to think of color as a matter of preference, style, whim, or even in terms of herd-like adherence to momentary commercial trendiness driven by some merchandizing pundit (as in, "this year's hot new color is green"). There is such abundance of color choice in so many aspects of our daily lives that color may seem to have devolved into a matter of the everyday mundane. Then, along comes a scholar and an artist who relishes and intuits the true and essential power of color and sets out to juxtapose the meaning of color with prophecy, no less – prophecy being something few of us consider in any meaningful way in our everyday lives.

I remember the first time I read the excruciatingly detailed Torah instructions given by the Divine as to the construction and interiors of the Tabernacle in the wilderness. Here, I admit to responding rather flippantly. My first reaction was, "What is God, an interior decorator?" For people on the run, stuck in the middle of nowhere, how easy was it to find the dyes for blue, red, and especially purple – a rare and hard-to-make color derived from a sea creature? "Hello, Hashem, these folks are stumbling around a dry desert!" And just as I was enthralled with the idea that our Creator could possibly care about the color balance within a braid of blue and red and purple in wall hangings, best of all I loved to whom He assigned the

task of carrying out this divine vision. He wanted none of those highly skilled adults, laden with their technical art-craft gifts honed from decades of service to Egyptian royals. No, the Creator wanted two thirteen-year-old boys and best friends to be in charge of building His Shrine! Why? Because they had the uncorrupted capacity to listen within to His instructions and not draw on any past experience with any other fancy schmancy building done for any earthly authorities. You see, from this we learn that even God prefers self-taught, intuitive artists!

As a founder and director of a very unique national museum, the American Visionary Art Museum in Baltimore, Maryland, I have devoted our entire center to serve as a showcase for intuitive fresh thought and art derived from folks gifted with a capacity to listen to that "still small voice" within. They create wonders not as the result of listening to the learned in the arts, or from art that has come before them, but rather from listening and feeling a vision foremost from within. Among the many visionary artists who have brought their intuitive visions to the public via our wildly popular, very spirited museum, there has been one I especially adore and respect – a more aged version of a willing thirteen-year-old Bezalel – a highly respected brain surgeon and Torah lover named Nahum HaLevi who intuited his own way into his art. I joke that our secular museum is devoted to revealing Torah concepts "by stealth" in almost every one of our annual themed mega-exhibitions. Even a cursory review of our past themes will reveal the truth in that statement. Among all the critical acclaim our museum has achieved, none is more cherished than the frequent assertion from our visitors that "The American Visionary Art Museum is the single most healing place" they have ever been.

Nahum HaLevi's works have been shown with us, on more than one occasion, in this regard. His life in paint combines seamlessly with his intimacy with the visceral sanctity of human red blood and silky grey matter in his work as a brain surgeon. Both gifts hearken back to a heightened gift of vision and of care, understanding, and healing.

Herein, we delight in HaLevi's attention to all the details attached to the business of the Prophets, which he fleshes out for us on the backdrop of their symbolic connection to color. Even the beauty of HaLevi's multidecade happy marriage was first graced by his wise wife's honeymoon gift of a tin

box of paints.

Whenever I think I should abandon all this art stuff, which requires such constant hard work, and just go help people with the simple basics of survival at some grassroots level, far removed from gala openings and the need for incessant fundraising, I am comforted by my discovery of the egoless bowerbirds who spend such enormous and singular efforts decorating their up-to-eight-feet-tall nests with elaborate color and material patterns. Among their favorite embellishments are the royal blue caps discarded from gallon milk jugs, and crimson red leaves. These colored bits they carefully seek out and collect and then skillfully arrange in distinct patterns along with other bright shining things, all under a chuppah-like, intricate arched maze of tall twigs. They, with their male bird brains, do this to the profound delight of their females, in ways that would trump even the genius of famed nature artist, Andy Goldsworthy! That said, somewhere between Hashem's detailed instructions for interior design and Temple layout and the hardwired aesthetics of His bowerbirds, I realized that dedicating one's life to communal reflection on aesthetics and the great themes that have always inspired or bedeviled humankind constitutes an important language and a meaning as valid as any ever spoken in words – particularly when one attempts to do so in the spirit of loving care kindred to our Creator's and his little bird buddies out there, working devotedly in their wilderness.

Here is a fine book, dear reader, that enlivens our take on both prophecy and color, intention, symbol, and love. Nahum HaLevi's entire life reminds us that the wide choice of what one human can preoccupy him- or herself with in just one lifetime is indeed a nutrient-rich, colorful spring, open to its own lively embellishment at every turn and to be shared to the greater benefit of us all. For the courage to spread his wings in such delightful ways, and for the way he cares for others so sincerely and kindly, Nahum HaLevi has won my profoundest admiration. He isn't just a good doctor, or just an accomplished self-taught artist, or a scholar of medicine and a student of Torah, HaLevi is someone fueled by a deep appreciation for the preciousness of being and *creative invention*, who is in on the adventure of discovery right alongside of each of us – big time.

Toward the end of his life, the great artist Vincent Van Gogh wrote to

his brother, Theo, his own conclusion as to what matters most. He wrote, "The more I think, the more I feel, that there is nothing more truly artistic than to love people."

Would not the Creator, the Greatest Artist, Solomon's "Conductor," the Author of Love, and the One to Whom we Belong, be in full agreement with this assessment of what best constitutes true artistry? Dr. Nathan Moskowitz, aka Nahum HaLevi, is a true artist, full of love.

Rebecca Alban Hoffberger
Founder and director of the American Visionary Art Museum
Baltimore, Maryland

Acknowledgments

This book wouldn't have been possible without the contribution of many individuals who taught and inspired me throughout my life. I had the great fortune of growing up in an environment where I was exposed to Jewish, biblical, Talmudic, and Hebrew studies under the tutelage of many talented teachers, who provided me with a lifelong fascination and love of Tanach, Jewish literature, and history. I am grateful to my parents for having transmitted to me their native Yiddish language and culture, which pepper the sensibilities of this book.

I am deeply indebted to my wife, Helen, who provided me my first paint set as a birthday gift soon after we married when I confided in her my strong desire to paint. This desire, nurtured by her, blossomed into a lifelong, serious, joyful, and creative enterprise directly leading to the publication of this book. She has been a constant source of inspiration as well as an unending font of historical wisdom supplementing my knowledge of world civilizations. This book would not have taken form without her encouragement and helpful advice.

I am very grateful to my son Mosheh, who photographed all the paintings that appear in this book. He is very gifted with computer and technological skill, and his assistance was absolutely critical for the editorial preparation of the photographic images and the initial manuscript and layout of this book. He is also solely responsible for creating my website, which is referenced throughout this book. I thank my son Ahmnon for being my greatest fan. He constantly encourages me to paint and think big.

I am always striving to be as good a painter as he thinks I am. I thank my son Yahron for his unending spiritual inspiration and for transmitting to me his great knowledge of religious thoughts and texts. He constantly imbues me with the sense of the sacred. I thank my daughter Zehava for being my fiercest critic. She lovingly encourages me to make my paintings as three dimensional as possible. I will always strive to achieve her exemplary artistic skills of figure proportion and spatial sentience, which I'll probably never be able to match, and for this I am very proud of her.

I am deeply indebted to all the professionals at Gefen Publishing House. Firstly I would like to thank Ilan Greenfield for making the decision to publish and disseminate this book. I thank Lynn Douek for coordinating all the Gefen contacts and communications and for making the publication of this book a thoroughly thoughtful and enjoyable experience. Many thanks to the entire Gefen editorial staff for their professionalism in bringing about the publication of this book.

Introduction

This book is a unified artistic-literary, interpretive commentary on the Latter Prophets (*Nevi'im Acharonim*) section of the Hebrew Bible. It attempts to express the ecstatic poetic narrative and mind-altering visions of the Hebrew Prophets in a distinctly Jewish midrashic – yet unique – manner, deriving multiple visionary images from multiple translations of the original Hebrew text, and then retranslating the derived fused images back into a fresh literary biblical analysis.

It is conceptually derived from a playful synthesis of alphabetic and kaleidoscopic collages, all of which emanate and radiate from the melodious and rhythmic voices of the prophets. It blends linguistic cognition with visual perception, words with images, thoughts with dreams, and quantum physics with metaphysics. Biblical characters and historical events are portrayed through the medium of painted pictures and letters, existing as discrete points in the eternal, vast, space-time continuum, not only in the historical past but also in the eternal present.

This book contains fifteen chapters, one chapter for each of the fifteen books of the Prophets. Each chapter is accompanied by a photographic image of an original oil painting and the biblical analysis derived from it. The juxtaposition of Prophetic paintings with their accompanying commentaries weaves a uniquely integrated visionary-literary midrashic tapestry. For every book chapter, multiple biblical images derived from multiple Hebrew definitions, along with single and multiple biblical characters – from different chronological and geographical space-time

coordinates – are intermingled into one unified, loud, and colorful visual-literary canvas, blending past, present, and future. Fragments of their original biblical stories are preserved while new stories are simultaneously created, which provide novel understandings of the Bible and insights into the genesis of Judaic and biblical thought.

"Synesthesis" is a neurological condition experienced by a minority of individuals whose brains crisscross and confuse different senses. For example, some people can taste or hear colors; other individuals can actually see sounds. This rare phenomenon is described in the Torah. When God descended on Mount Sinai and gave Israel the Ten Commandments it is narrated that they all saw the sounds of the shofars (trumpets) and the sounds of thunder.

This book attempts to convey the multisensory synesthetic prophecies experienced and mellifluously expressed by the great visionaries of the Hebrew Bible. It proffers a visual-literary key to apprehend the transcendent multimodal landscapes of their exceptionally hyperactive minds. By alternatingly viewing the paintings presented in this book and reading the intricate biblical analyses derived from them, you might begin to imagine seeing what the prophets see, hearing what they hear, and perceiving what they perceive. Hopefully you will fuse sight and sound; combine images and alphabet; blend past, present, and future; and visually appreciate illuminated symphonies – and momentarily be transported to a separate reality.

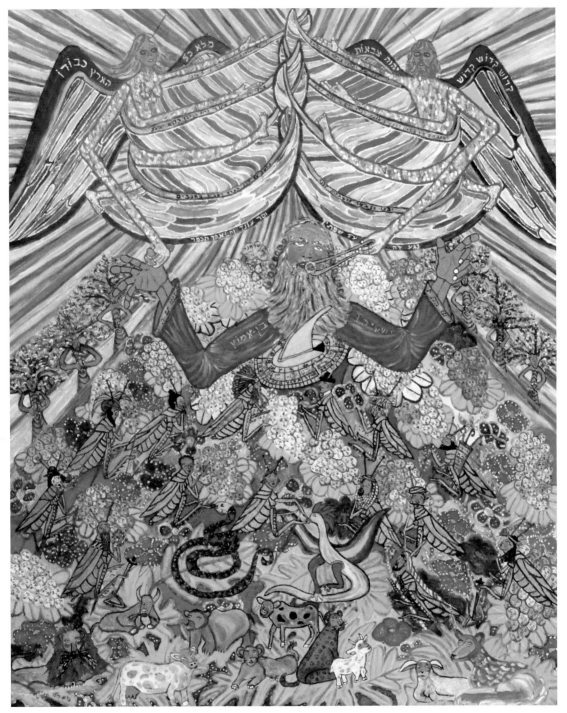

Isaiah: 2009/48X64 inches/oil on canvas

Isaiah's Symphony in Salv-A-tion Major

1

This painting attempts to visually distill the essence of Isaiah's majestic symphonic visions and his unbridled poetic ecstasy. It portrays Isaiah's optimistic dream of the joyous unification of the entire natural world under the canopy of God, including the mystically animated heavens and earth, all plant and animal life, and all the nations of the world.

Isaiah, son of Amoz, lived in Judah in the eighth century BCE during the reigns of the Judean kings Uzziah, Jotham, Ahaz, and Hezekiah. Isaiah, or Yeshayahu in Hebrew, means "God will save" or "the salvation of God." Amoz, or Amotz in Hebrew, means "courage," a reflection of Isaiah's personality.

The essence and overriding message of the book of Isaiah is salvation, and indeed the Hebrew word "salvation" is mentioned throughout the book innumerable times in multiple grammatical permutations, either as a name, a noun, or a verb (in singular and plural, and in past, present, and future tenses).

The sixty-six chapters of Isaiah form an intricately layered, unified tapestry of poetics weaving together a multiplicity of seemingly contradictory messages balancing themes of

1) admonition (*tochachah*) and those of comfort (*nechamah*),
2) universal destruction versus universal salvation,
3) Israel's destruction versus its ultimate salvation and reunification with Judah,
4) Judah's destruction versus its salvation,
5) Judah's and Israel's exile versus their ingathering, and
6) God's conditional abandonment versus His unconditional love.

This dichotomy of destinies meted out based on good or bad behavior has its origins in Deuteronomy (11:26–29), where blessings and curses are associated with Mount Grizim or Mount Ebal, respectively.

Ultimately, this symphony of undulating alternative destinies reaches a crescendo with the magnified celebratory notes and chords of universal salvation. The constant source from which all salvation emanates throughout the entire book is God, Who sits atop His holy mountain (har kadosh) located in His Temple, which is located in Judah, specifically in Zion – more specifically in Jerusalem, the city of David, the eternal capital of either Isaiah's contemporary Judah or a future reunified monarchy of Judah-Israel. This redeemed, reunified monarchy in Isaiah's visions will revert to its ancient idyllic Judean, not Israelite, rule – that is, to the house of David and his descendants, with its capital and Temple in Jerusalem, not Samaria. As introduced in the first sentence of the book, Isaiah's visions are those concerning Judah and Jerusalem.

Isaiah has a theophany at the beginning of King Ahaz's reign. He envisions God sitting upon His throne, high and exalted, and His train is filling the Temple. God is flanked by two seraphs (seraphim is the plural in Hebrew). Seraph in Hebrew means "burning fire." Each seraph has six wings; two wings cover God's face, two wings cover His feet, and two wings are used by the seraphim to fly (6:1–2).

Isaiah's theophany is illustrated at the top of this painting, above his head. Isaiah is the large central figure clad in a red robe. His name, Isaiah son of Amoz, is written in Hebrew across his chest.

Two flying, blazing seraphim, angels on fire, are covering God with their wings, as described in the text. God's powerful, incandescent, refracted light rays emanate from behind the seraphim's wings, radiating throughout the universe, bathing the entire landscape. This conception of God is inspired by the text "The sun will no longer be your light by day, neither will the moon provide you light, but God will be your everlasting light, your God will be your glory. The sun will no longer set, neither will the moon withdraw itself, for God will be your eternal light, and the days of your mourning will be completed" (60:19–20).

The seraphim call out to each other: "Holy, holy, holy is the Lord of Hosts. The whole earth is full of His glory" (6:3). In this painting these

words are written in light blue Hebrew on the upper dark blue wing rims of the seraphim. Isaiah, realizing he has actually seen the face of God, believes he is undone because being a man of unclean lips who dwells in the midst of a people of unclean lips, he is not worthy.

At this point one of the seraphim flies toward him with a hot glowing stone clasped by the Temple's golden tongs and presses the stone against Isaiah's mouth, purifying him and saying to him, "Behold, this has touched your lips, and it removes your error, and expiates your sins" (6:7).

In this painting this seraph is illustrated on the upper right, impressing Isaiah's lips with the burning stone. The seraph's words are written in light blue Hebrew on the dark blue rims of the seraph's lower wings. The other seraph on Isaiah's left is holding Isaiah's right hand to comfort him from the sting of the hot coal. This is inspired by the passages "I, God, have called you in righteousness, and I will hold your hand" (42:6) and "For I am God your Lord holding your right hand, Who says to you: Have no fear, I will help you" (41:13).

Isaiah then hears God's voice saying, "Whom will I send and who will go for us?" Isaiah answers, "Send me" (6:8). In this painting these words are written in dark red Hebrew on the green flower to the left of Isaiah's head.

Isaiah later asks, "God, how long?" These words are written in light red Hebrew on the same green flower to the left of Isaiah's head.

Isaiah's theophany is taking place in the Temple's inner sanctum in Jerusalem, where the altar's tongs are within the seraphim's reach. God's train, which fills the sanctuary (*hechal*), is interpreted in this painting as a metaphor for God's light rays filling the universe.

Because Isaiah's universal theology and his local, Near Eastern, contemporary politics are so closely intertwined – indeed they are indistinguishable from each other – it is important to understand Judah and Israel's geopolitical status during his lifetime (and some time beyond). Thus we can contextualize Isaiah's political-theological advice and guidance to the Judean kings, Ahaz and Hezekiah, and to the Judean people in general, which was imparted to them in the form of prophetic visions and divine guidance.

Isaiah's prophecies concerning specific events and their outcomes in

his lifetime revolve around two critical historical periods: Ahaz's reign and later Hezekiah's reign, when Judah's very existence and continuity are threatened by external enemies. Additional prophecies not occurring during Isaiah's lifetime are also interwoven into the text without strict chronological sequence. These critical events include Judah's conquest, exile by Babylon, and Judah's subsequent ingathering and return facilitated by King Cyrus of Persia. The prophecies related to these momentous events were most likely added posthumously many years later, applying Isaiah's brilliant poetics of salvation to color these epic occurrences.

The first existential crisis within Isaiah's lifetime facing Judah occurs during King Ahaz's reign. After the Assyrian monarch Tiglath-Pileser threatens to invade Israel and Syria, Ahaz refuses to align himself with Israel and Syria against Assyria, and as a result, the confederacy of Israel and Syria attacks Judah.

Sadly, the Kingdoms of Judah and Israel – who have been divided ever since the idyllic unified days of Kings David and Solomon – now forge completely separate alliances with different nations and are at war with each other, just like any other run-of-the-mill, separate, competing, neighboring monarchies. They see each other as distinct nations, at best sharing earlier common genetic ancestry just like, and no different from, the nations of Edom, Moab, and Ammon.

Judah and Israel have separate capitals, Jerusalem and Samaria respectively. As disparate as both monarchies are, they nevertheless still share a mutual abandonment of God and an unquenchable thirst for paganism (the root cause of all their woes). Judah's moral, theological status is slightly higher than Israel's because within its boundaries resides God's earthly dwelling, His Temple, in Jerusalem, the city of David.

It is at this juncture that "Aram [Syria/Damascus] and Israel went up to Jerusalem but could not prevail against it" (7:1). According to Isaiah this is because of God's intervention and also because Judah asked Assyria to intervene, though they paid the price of vassaldom. Judah is now effectively aligned with Assyria against Israel and Syria, and thus shares responsibility for Assyria's gradual conquest of Israel (and Syria). A substantial portion of Israel is now carried into captivity to Assyria. In 722 BCE, the Assyrian monarch Shalmanesser V captures Samaria, Israel's capital, and takes

captive the remainder of Israel's inhabitants, sending them to Assyria (II Kings 17:3–6). Independent Israel ceases to exist.

Judah's second existential crisis takes place under Hezekiah, who, after Ahaz's death, was encouraged to rebel against Assyria and entered into an alliance with Egypt, seeking help to thwart off Assyria and shake off its vassaldom. Not very long after Israel is exiled, in 701 BCE, Sennacherib the Assyrian king invades Judah and takes its fortified cities (36:1), with one regiment threatening Jerusalem. The barbarians are at the gates. Judah knows very well that it can now easily suffer the same fate as Israel did under the Assyrians, their prior allies with whom they precipitated Israel's demise – classical biblical measure for measure.

Isaiah, a Judean, pines for the return of the idyllic, ancient, glorious days when the twelve tribes of Jacob were unified under the strong leadership of David and Solomon, reaching the zenith of its theological and geopolitical power and influence, worshiping one God in one centralized location, in one capital. In Isaiah's mind, the ultimate reunification of Judah and Israel must take place under a Judean monarch (and his future successors), a descendant of the Davidic dynasty (the root of Jesse). Reunification under an Israelite monarch, one not of the Judaic-Davidic line – with his capital in Samaria, not in Jerusalem, and without a centralized house of God in Jerusalem – would be both unacceptable and unimaginable.

It is within this context that the visions of Isaiah during Ahaz's and Hezekiah's reigns can be understood. This future king of the united Judah-Israel monarchy will have the spirit of God rest on him. He will also be wise and righteous (just like David):

> And the [1] wolf will dwell with the lamb, [2] the leopard shall lie down with the kid, [3] and the calf and the young lion and the fatling together, and a little child shall lead them, and [4] the cow and the bear shall graze together, their young ones shall lie down with each other and [6] the lion shall eat straw like the ox, and [7] the suckling child shall play on the hole of the asp, and [8] the weaned child shall put his hand on the basilisk's den. They will not hurt nor destroy on My holy mountain; for the earth shall be filled with the knowledge of God, just as the waters cover the seas. (Isaiah 11:6–9)

Although this vision may be understood in abstract futuristic universal terms, it most likely has a much more parochial real-time historical interpretation. All the animal pairs listed above are essentially pairs of aggressive hunting animals and passive prey, such as: wolf-lamb, leopard-kid, young lion-calf, bear-cow, lion-ox, asp-child, basilisk-child. These combinations of aggressor-prey animals (life forms) represent anthropomorphized poetic metaphors for the pairing and unification of Israel-Judah. In the time of King Ahaz, Israel is the aggressor hunting animal, threatening to conquer Judah, the passive animal prey.

Israel fails to conquer Judah during the reign of Ahaz, and is soon ultimately exiled during the reign of Hezekiah. Isaiah hopes for reunification of Israel and Judah in his lifetime during the time of Ahaz. Later on, during and after the reign of Hezekiah, after Israel is exiled, Isaiah continues to hope for the ultimate reunification of Judah and Israel at God's holy mountain, Zion-Jerusalem, where they reunite peacefully, and there will be no more war between them, such as the one taking place during the time of Ahaz. Isaiah also hopes that Israel returns from her Assyrian exile, which was inflicted during the time of Hezekiah.

This vision of a Judah-Israel unification takes on even greater poignancy and urgency after Judah's exile to Babylon, when Isaiah yearns for the ingathering of both Judah's and Israel's exiles and their reunification under God under one Judean king:

> And it will be on that day that the root of Jesse that stands for a sign unto nations, unto him shall the nations seek [Assyria, Syria, Babylon, Moab, Philistines, Edom, Ammon, etc.], and his place will be honored. And it will be on that day that God will set His hand the second time, to recover the remnant of His people that will be rescued from Assyria, and from Egypt, and from Pathros, and from Cush, and from Elam, and from Shinar, and from Hamath, and from the islands of the sea. And He will set up a sign for the nations, and will assemble the dispersed of Israel, and gather together the scattered of Judah from the four corners of the earth. The envy of Ephraim [Israel] will depart, and they that harass Judah will be cut off. Ephraim will not envy Judah, and Judah will not harass Ephraim. (Isaiah 11:10–13)

The prophet Ezekiel held similar hopes for the reunification of Judah and Israel, and used the metaphor of bringing two sticks together, representing Israel and Judah, respectively, then joining them into one stick – a unified monarchy (Ezekiel 37).

In this painting, Isaiah is seen emerging from the core of God's holy mountain, basking in God's light from above. Illustrated at the bottom of this mountain, which is overflowing with copious vineyards, flora, and anthropomorphized grasshoppers (described below), are the Judah-Israel animal pair metaphors described in Isaiah's prophecy, appearing in the same sequence mentioned in the text, from right to left.

During Ahaz's reign, when Judah is threatened by Israel and Syria, Isaiah tells Ahaz not to fear, that God will not allow Judah to be defeated by them, that ultimately both Syria and Israel will vanish and will be defeated by God's rod, Assyria.

Isaiah proceeds to give Ahaz a series of signs, or omens (*otot*). Isaiah takes the literary tact of naming children with run-on sentences that outline, or prophesy, the future. This linguistic-prophetic tool utilizes children as time markers (which they are to most people), to predict when (and sometimes how) future events will occur.

The time frame wherein the important prophesied event is to occur can be calculated by knowing the approximate age of the child's mother, or knowing when the child with the named ordained event will reach a particular developmental milestone, or by knowing the age reached when the child will obtain a certain position in life. With some other name prophecies, the time frame is less specific but its name prediction alludes to the resolution of the particular crisis of concern. Later on during Hezekiah's reign, Isaiah uses another accurate marker of time, a sundial, for similar prophetic extrapolations.

Isaiah specifically clarifies his intention of using children's names as prophetic tools: "Behold, I and the children whom God has given 'me' shall be for signs (*otot*) and wonders in Israel from the Lord of Hosts, Who dwells in the mountain of Zion" (8:18). It is likely that Isaiah speaks of the children given "me" as the collective royal "me" – that is, "us" ("Judah") – and is referring to all the children with prophetic names who he mentions as signs (*otot*), for example, "a child is born to us" (9:5). It is unlikely that

any of the children (all of them sons) mentioned in the book of Isaiah are his own.

The following four children (sons) are signs and prophecies of what indeed does occur in the future:

1) *She'ar-Yashuv* ("The remnant will return"): "Then God said to Isaiah go out to meet Ahaz with your son She'ar-Yashuv.... Keep calm, and be quiet; don't fear these two tails of smoking firebrands [Israel and Syria]" (7:2–4).

Isaiah later discusses how his son's name predicts the future:

> And it will be in that day that God will set His hand a second time to return the remnant of His people (*She'ar-Ammo*), that will remain from Assyria and from Egypt, and from Pathros and from Cush and from Elam and from Shinar and from Hamath and from the island of the seas; And He will set up a sign (*ot*) for the nations and He will assemble the dispersed of Israel, and gather together the scattered of Judah from the four corners of the earth. Ephraim (Israel) will not envy Judah, and Judah will not harass Ephraim. (Isaiah 11:11–13)

In essence the prophetic sign (*ot*) of this son's name, "She'ar-Yashuv," tells Ahaz and Judah not to fear being conquered by Israel, because Judah won't be conquered by Israel, and not to worry about aligning with Assyria despite the fact that this will lead to Israel's dissolution. In the end, the remnant of both Israel and Judah will return (She'ar Yashuv).

2) *Emmanuel* ("God is with us"): God asks Ahaz to ask for a sign (*ot*) from God, "And he said [to Ahaz] listen carefully the house of David.... Therefore God will give to 'you' [*lachem*, collective plural] a sign (*ot*); here is the pregnant young woman and she will give birth to a son, and she will call him Emmanuel. Curd and honey will he eat. He will know to refuse evil and to choose good. Before he knows to refuse evil and choose good, the land belonging to the two kings you are horrified of [Israel and Syria] will be forsaken" (7:13–17).

Thus, this son's name, Emmanuel, is an omen predicting (ongoing present tense) that "God is with us." Thus Ahaz/Judah should not fear Syria, Israel, or Assyria because after all, God is with us. "And he [Assyria] will sweep through Judah, he will even reach to his neck, and

the stretching out of his wings shall fill the breast of your land, Emmanuel [God is with us].… Listen all you in distant lands, gird yourselves you will be broken in pieces…take council together, it will be brought to naught. Speak the word, it will not stand because Emmanuel [God is with us]" (8:8–10).

The grammatical mirror image of the name "Emmanuel," i.e., the names that God uses to refer to Judah, in contradistinction to the name that Judah calls God by, are: a) *Itcha Ani*, "I am with you" (42:5); b) *Li Atah*, "You are Mine" (43:1); c) *Ami Atah*, "You are My nation" (51:16); and d) *Ami Hemah*, "They are My nation" (63:8). These grammatical name prophecies also come to fruition.

The prophetic name Emmanuel is essentially confirming that some time in the very near future, i.e., prior to the time when the cognitive developmental milestone of knowing to distinguish good from evil will be reached by a child who is about to be born to a young woman now pregnant (and somewhere between her first and third trimester), God is (and will be) with us. In other words, the name prophecy of "Emmanuel" will come to fruition in approximately the next three to five years when the child "Emmanuel" will be capable of distinguishing elementary good from evil; that is, when he grows to be approximately three to five years old. At that time God is (and will be) with us. He will not abandon you; you will not be conquered by Israel and Syria, and at this point Assyria will leave you alone. Likewise in the future even after the dispersal of Judah, God will say you are My nation, and I am with you – in other words, God is with us, "Emmanuel."

3) *Maher Shallal Chash Baz* ("Hasten to take the spoils, and take the prey"): "And I approached the prophetess, she conceived and bore a son, and God said to me call his name Maher Shallal Chash Baz. Because before the child has knowledge to call out to his father and mother, the riches of Damascus [Syria] and the spoils (*shellal*) of Samaria [Israel] will be carried away before the king of Assyria" (8:3–4).

The prophecy contained within this child's run-on name is again corroborated: "Oh Ashur [Assyria] the rod of my anger, in whose hand is a staff of my indignation, I do send against an ungodly nation, and against the people of my wrath do I give him charge to take spoil (*lishlol shallal*)

and to take the prey (*velavoz baz*), and to tread them down like mire of the streets" (10:5–6).

There are those who interpret the prophetess as being Isaiah's wife, and this child as Isaiah's son. The language of the text, however, "and I approached [her]" (*va'ekrav*) means just that; it does not mean "I came unto her," which in Hebrew would be *va'avo eleha*, and hence it is unlikely that this is his wife or child. Be that as it may, this son's run-on sentence name again predicts the downfall of Israel and Syria by the Assyrians. By specifying that the booty and prey will be taken quickly (*maher*), this name prophecy specifies that this event will take place in the near future – just as the combined specification of Emmanuel's mother's youth, and his early childhood milestone of distinguishing good and bad, specifies the relative proximity of the event which is being foretold by the son's name.

4) *Peleh Yoetz, El Gibor, Avi Ad, Sar-Shalom* ("Wonderful advisor, strong God, father forever, prince of peace"): a humdinger of a run-on name prophecy containing all the characteristics of God Whom Judah/Ahaz should trust in, so as not to fear defeat by Syria/Israel. This name prophecy is a considerably longer version of the other child/son sign (*ot*), Emmanuel.

"For a young boy is born to us, a son is given to us, and the government will be on his shoulder, and his name is called Peleh Yoetz, El Gibor, Avi Ad, Sar-Shalom. To increase the rulership, and that there be no end to peace, on David's throne and his kingdom, to establish and uphold it with justice and righteousness. From now and forever, the jealousy of God will perform this.… Aram from the east and Philistines from behind, and they devour Israel with a full mouth. For all His anger is not turned away, but His hand is still stretched out" (9:5–6, 11).

This is again comforting Judah that Israel will soon be destroyed, and will not conquer Judah. The above name prophecy is most likely also referencing Eliakim son of Hilkiyah (36:1–3) who later played an important administrative role in Hezekiah's court, carrying messages from the Assyrians to King Hezekiah. During Eliakim's time Isaiah tells King Hezekiah not to fear the Assyrian assault, and not to stand down: "And it will be in that day that I will call my servant Eliakim the son of Hilkiyah, and I will clothe him with your [Hezekiah's] robe, and bind him with your

girdle, and I will commit your government (*memshaltecha*) into his hand, and he will be a father (*av*) to the inhabitants of Jerusalem and the house of Judah" (22:20–21).

"And it was in the fourteenth year of King Hezekiah that Sennacherib, king of Assyria, came up against all the fortified cities of Judah and took them. And the king of Assyria sent Ravshakeh from Lachish to Jerusalem unto King Hezekiah with a great army… Then came Eliakim the son of Hilkiyah who was over the household (*al habayit*)" (36:1–3).

Assuming Eliakim son of Hilkiyah is the son referred to by the run-on prophecy-name Peleh Yoetz etc., and was born during the time of Ahaz's rule in approximately 710 BCE when Isaiah named him Peleh Yoetz etc., then during the fourteenth year of the Hezekiah's reign in 673 BCE he would be forty-three, a respectable age to be appointed administrator in Hezekiah's court. As a high administrator, like Joseph under Pharaoh, the government would be on Eliakim's shoulder. Also like Joseph he would be given symbols of royalty: a royal robe and girdle. Of course the run-on sentence name does not refer to Eliakim himself, but to the characteristics of God that he will manifest when this son's prophetic name comes to be, specifically, during Assyria's attempt to take Jerusalem. The four component names of this long run-on name are repeated in later chapters of the book of Isaiah and come to fruition:

1) *Peleh Yoetz* ("wonderful advisor"): "Oh Lord, You are my God, I will exalt You, I will praise Your name, for You have done wonderful (*peleh*) things, advice (*etzot*) from afar, faithfulness and truth" (25:1).
2) *El Gibor* ("strong God"): "A remnant will return, the remnant of Jacob to El Gibor" (10:21).
3) *Avi Ad* ("Father forever"): "But now, O Lord, You are our Father (*Avinu*)" (64:7).
4) *Sar Shalom* ("Prince of peace"): a) "For he said: Are not my princes (*Sarai*) together kings?" (10:8); b) "Behold, a king will reign in righteousness, and as for the princes (*Sarim*), they will rule in justice" (32:1); and c) "And the work of righteousness will be Shalom" (32:17).

When Hezekiah is king, and Jerusalem is threatened by the Assyrians, Isaiah tells him not to give in to their threats of subjugation. God promises to "defend this city to save it, for My own sake and for the sake of David My servant" (37:3). "Then an angel of God went out into the Assyrian camp and slew 185,000 men. So Sennacherib, king of Assyria, departed and went and returned to Nineveh. And it was during the time he was worshiping in the house of Nisroch his god, that Adrammelech and Sarezer his sons killed him with the sword, and they escaped to Ararat. And Esarhaddon his son reigned in his stead" (37:36–38). Note how the sons of Sennacherib spell Assyria's defeat, as opposed to the sons (prophetic omens) of Isaiah, who spell Judah's salvation.

When Hezekiah falls sick and is about to die, he appeals to God. God answers him that because he prayed, He will add fifteen years to his life: "'And I will deliver you and the city out of the hand of the king of Assyria, and I will defend this city. And this will be the sign (*ot*) to you from God that God will do what He said. I will return the shadow of the [sun]dial which has gone down on the dial of Ahaz by ten degrees.' So the sun returned ten degrees by which the degrees it was gone down" (38:6–8). Thus Isaiah during the reign of Hezekiah uses another kind of time tool, a sundial, for calculating the timing of his prophecies, just as he used children as time tools to predict the timing of prophecies during Ahaz's rule.

In this painting, the sundial is depicted underneath Isaiah's beard. The inner concentric rim of the sundial's base has the hour numbers written on it in ancient Hebrew. The next outer concentric rim has blue images depicting the monthly astrological signs, under which is written on the next outer concentric rim the names of their respective months in ancient Hebrew: Elul, Tishre, Cheshvan, Kislev, etc. The sun's shadow is depicted on the upper yellow concentric ring of the base.

After Hezekiah recovers from his illness, the son of Baladan, the king of Babylon, sends Hezekiah a gift celebrating his recovery. Hezekiah returns the favor by showing the delegation everything in his palace. Isaiah then tells Hezekiah that because of this, everything he showed the delegation will be taken away to Babylon, as will be his sons who will become officers in the Babylonian court. Thus, Isaiah prophesies the Babylonian conquest of Judah, and Judah's exile. Isaiah's prophecies also

extend forward in time to Persia's subsequent conquest of Babylon, and Cyrus's invitation to the exiled Judeans to return to Israel and rebuild the Temple: "I am He who tells Cyrus, My shepherd, to fulfill My desires, and tells him to rebuild Jerusalem and to lay the foundation for the Temple's sanctuary (*hechal*)" (44:28).

There are two specific individuals in the book of Isaiah that are labeled as being a Messiah. The first is Cyrus, king of Persia: "Thus spoke God to his Messiah (*Mashicho*, his anointed), to Cyrus, whose right hand I have strengthened to subdue nations before him, and to open up the loins of kings, and to open doors before him, and gates will not be closed for him" (45:1).

The second person referred to as Messiah is Isaiah himself: "The spirit of the Lord God is upon me, because God anointed (*mashach*) me to inform the meek, to bind up the brokenhearted, to proclaim liberty to the captives, and the opening of eyes of them that are shackled. To proclaim the year of God's will, and the day of vengeance of our God, to comfort all that mourn..." (61:1–2).

The term *Mashiach* (lit. "anointed one"; Messiah) in the book of Isaiah is used to define an individual who is consecrated to perform God's holy task. In Isaiah's case he is consecrated to enunciate God's plans. In Cyrus's case he is consecrated to bring salvation to the Judean exiles by bringing about their return home, and the rebuilding of God's Temple in Jerusalem. In other cases in Tanach the term Messiah refers to the physical anointing of oil upon a king's head when he ascends the throne. This symbolizes consecration to God's holy task of ruling Judah/Israel (there is no separation of Temple and monarchy).

Isaiah's prophecies, as mentioned above, alternate between competing visions of utter destruction and joyous salvation not only for Judah and Israel but also for the surrounding nations, and in the worst-case scenario, the entire world.

The specific nations that, according to Isaiah, will be utterly destroyed and humiliated include: 1) Babylon, by the Persians (chapter 12); 2) Philistines (14:29); 3) Moab (chapter 15); 4) Syria (chapter 17); 5) Land of the buzzing wings (chapter18); 6) Egypt (chapter 19); 7) Ethiopia (chapter 20); 8) Desert Sea (chapter 21); 9) Dumah (chapter 21); 19) Arabia (chapter 21); 11) Tyre (chapter 23); 12) Assyria (31:8); and 13) Edom (34:6).

If anyone may have been left out of the above list, they are certainly included in Isaiah's prophecies of universal destruction of all peoples and the entire earth:

"Behold, God makes the earth empty, and makes it waste, and turns it upside down, and scatters abroad its inhabitants...the earth will be utterly emptied and clean destroyed. For God has spoken this word. The earth faints and fades away; the lofty people of the earth do fail. The earth is also defiled under its inhabitants because they have transgressed the teachings, violated the statute, and broken the eternal covenant. Therefore a curse has devoured the earth, and they that dwell in it are found guilty. Therefore the inhabitants of the earth waste away..." (24:1–6).

"The foundations of the earth do shake, the earth is broken down, the earth is crumbled in pieces, the earth trembles and totters, the earth reels back and forth like a drunken man..." (24:19).

"For God has indignation against all the nations, and fury against all their armies; He has utterly destroyed them; He has delivered them to the slaughter. Their murdered will also be cast out, and the stench of their carcasses will come up, and the mountains will be melted with their blood, and all the army of heaven will collapse, and the heavens will be rolled together as a scroll, and all their armies will fall down" (34:2–4).

Despite these harsh words, which are meant to instill dread and incite repentance, it is the impression of overwhelming universal joyous salvation that shines radiantly forth from the book of Isaiah. It is this spirit that this painting attempts to capture. Illustrated in this painting is a sampling of all the peoples of the earth ascending the mountain of God from different cross-sectional swaths of the space-time continuum. Fulfilling Isaiah's prophecy, they all stream toward and ascend God's mountain in Jerusalem-Zion.

At the top of the mountain they will join with Isaiah and see and apprehend what he does. The peoples of the earth are all portrayed as anthropomorphized grasshoppers. This is inspired by the passage: "It is He that sits above the circle of the earth, and its inhabitants are like grasshoppers" (40:22). This is actually a brilliant poetic play on the Hebrew word *chug*, which is the root of the words "circle" (*chug*) and "grasshoppers" (*chagavim*). This sentence is written in dark purple on the seraph's lower wing rim on the left.

Thus in this painting all the peoples of the earth are illustrated to appear the way God perceives them from His vantage point in the heavens above, peeking down at them from between the wings of the seraphim. When He looks down upon the earth at human beings, they appear as grasshoppers in His eyes. Likewise in this painting the seraphim pick up on this theme, and are also illustrated as grasshopper-like. They each have six limbs associated with their six wings. Their limbs are quite long and simulate the hinged jointed appendages of grasshoppers. Their large-lensed eyes are similar to those of grasshoppers, and they also have tentacles.

A variegated sample of the different peoples of the earth selected from multiple scattered points in space and time who are illustrated in this painting include: American Indian, nineteenth-century Britain-American, Australian aborigine, Ancient Greek, Ancient Sumerian, Ancient Persian, Ancient Egyptian, Arab, Jew, Feudal Japanese, Feudal Chinese, Indian, and African.

The ancient Sumerian and ancient Egyptian, on the lower left and right hand sides of the paintings, respectively, are turning their swords into plowshares. The ancient Persian on the right has turned his spears in his arrow container into pruning hooks, as is written, "He will judge between the nations, and decide for many peoples; and they will beat their swords into plowshares, and their spears into pruning hooks; nation will not lift up sword against nation, and they will no longer learn any more war" (2:4).

This painting also attempts to distill the following passages:

"And it will be in the end of days that the mountain of God's house will be established as the top of the mountains, and will be exalted above the hills, and all nations will flow into it. And many peoples will go and say: Come and let us go to the mountain of God, to the house of the God of Jacob, and He will teach us His ways, and we will walk in His paths. For out of Zion will go forth the law and the word of God from Jerusalem" (2:2–4).

"And the glory of God will be revealed, and all flesh will see it together, for the mouth of God has spoken" (40:5).

"And the sons of strangers that join themselves to God, to worship Him, and to love the name of God, to be His servants, everyone that keeps the Sabbath from profaning it, and clings to My covenant, even them will I

bring to My holy mountain, and make them joyful in My house of prayer. Their burnt offerings and their sacrifices will be acceptable upon My altar, for My house will be called a house of prayer for all peoples, says God, who gathers the dispersed of Israel; I will yet gather others to him, beside those of him that are gathered" (56:6–8).

"For as the earth brings forth her growth, and as the garden causes the things that are sown in it to blossom, so God will cause victory and glory to blossom before all the nations" (61:11).

"For I know their works and their thoughts. The time is coming that I will gather all the nations and tongues; and they will come, and will see my glory" (66:18).

"And it will be that from one new moon to another, and from one Sabbath to another, will all flesh come to genuflect before Me, says God" (66:23).

Isaiah's kindness and loving embrace extends not only to human beings but to the entire animal kingdom, who are equally worthy and sentient in the eyes of God: "He that kills an ox is as if he slew a man; he that sacrifices a lamb is as if he broke a dog's neck…" (66:3). This underlines the prescient tenderness and gentleness of Isaiah's soul.

Likewise, Isaiah attempts to understand and explain the suffering of good people and gives his best explanation for their early demise: "The righteous perish, and no man takes it to heart, and just men are gathered up without anyone understanding that the righteous are removed from the evil to come" (57:1).

This painting also attempts to capture and convey the floral overabundance and fertility of God's mountain, which is bathed in light and blessings. Illustrated in the painting are an abundance of ripe anthropomorphized grapes symbolizing the people of Judah and Israel, who are singing the joys of salvation upon their return from exile. This image is inspired by the following passages:

"Thus says God: As when wine is found in the cluster, one says, 'Don't destroy it because a blessing is in it.' So I will do for My servants' sakes, that I will not destroy it all" (65:8).

"Because the vineyard of the God of Hosts is the house of Israel, and the men of Judah the plant of his delight" (5:7).

"Israel will blossom and bud. And the face of the world will be filled with fruitage" (27:6).

"And God will guide you always and quench your soul in draught, and strengthen your bones, and you will be like a watered garden, and like a spring of water whose waters do not fail" (58:11).

This painting also attempts to convey the joy of all of animated nature participating in God's salvation, including all the heavens, the flowers, the mountains, and the trees. Illustrated on the left- and right-hand sides of God's mountain are anthropomorphized trees clapping their hands, swaying their bodies, and singing in joy together with the singing grasshoppers and serenading clusters of grapes.

This image is inspired by the following passages:

"For you will go out with joy, and you will be led forth in peace, the mountains and the hills will break forth before you in song, and all the trees of the field will clap their hands" (55:12).

"Sing, you heavens, for God has done it; shout, you the lowest parts of the earth, mountains break forth into singing, the forest and every tree therein, because God redeemed Jacob, and glorifies Himself in Israel" (44:23).

"Sing, heavens, and be joyful, earth, and break forth into singing, mountains, because God comforted His people, and will have compassion upon His afflicted" (49:13).

A visual sense of the unfettered joy of salvation is further inspired by the following passages:

"And the ransomed of God will return and come unto Zion with song, and everlasting joy on their heads. They will obtain gladness and joy, and sorrow and sighing will flee away" (35:10; 51:11).

"The watchmen lifted up their voice, together they will sing, for they will see eye to eye, God returning to Zion. Break forth into joy, and sing together, waste places of Jerusalem, because God comforted His people, He redeemed Jerusalem" (52:8–10).

"But be glad and rejoice forever in that which I create, for I am creating a rejoicing Jerusalem whose people are joyous. And I will rejoice in Jerusalem and I will be joyous with My nation, and the voice of weeping will no longer be heard in her, nor the voice of crying" (65:18–19).

In this painting Isaiah's hands are raised and he appears to be the orchestral Maestro conducting this elegiac symphony of harmonizing humanized grasshoppers, grapes, and trees, while cute and magical animals languidly bask in the lights and sounds of universal salvation. Musical notes are illustrated, dancing on Isaiah's sleeves.

The painting is particularly colorful and bright, conveying the incandescent eternal light of God, and also conveying God's comforting words to Judah and Israel that they will be the light unto nations: "I, God, called you in righteousness, and have taken hold of your hand, and kept you and set you for a covenant of the people, for a light of the nations; to open the blind eyes…" (42:6–7).

"I will also give you for a light of the nations, to be My salvation unto the ends of the earth" (49:6).

"Arise, shine, for your light has come, and the glory of God shines upon you. For behold, the darkness will cover the earth, and fog the nations, but upon you God will shine, and His glory will appear upon you. And nations will walk at your light, and kings at the brightness of your luminescence" (60:1–3).

The conclusion of the Jewish Sabbath is celebrated (actually mourned) with a Havdalah ceremony. Saturday night is known as "Melaveh Malkah," which in Hebrew means "the mourning of the Sabbath bride." *Havdalah* in Hebrew means "division" – the separation between the Holy Sabbath and the profane weekday. This ritual is celebrated with a Havdalah candle, which is composed of multiple wicks. When lit, the wicks unite to form a torch-like flame. The Havdalah candle itself is composed of multiple braided strands of wax (like a rope has multiple strands of string). This ceremony is probably based on the passage, "And the light of Israel will be for a fire, and His holiness for a flame" (10:17).

Incorporated into this ceremony is a prayer uttered over wine, and it is accompanied by the smelling of pungent pleasant spices. The prayer is composed of the following passages from Isaiah: "Behold, God is my salvation, I will trust and I will not be afraid, for God is my strength and song, and He is become my salvation. Therefore with joy will you draw water out of the wells of salvation"(12:2–3).

As the joyful Sabbath ends, the Havdalah ceremony is meant to

assuage the sadness of its departure with words of hope and salvation. The blended unification of the braids and wicks of the Havdalah candle represents Isaiah's prophecy for the ingathering of the exiles, and the future reconciliation of Judah and Israel who upon their unification will create one unified torch together, a light unto the nations, a light created and sustained by God. This ceremony ushers out the Sabbath, which melts away into the mist of dusk, and provides the optimism of salvation needed to sustain people throughout the humdrum weekdays from one Sabbath to the next. As proclaimed in the final chapter of Isaiah: "And it will be, that from one new moon to the next, and from one Sabbath to the next, will all flesh come to genuflect before Me, says God" (66:23).

In this painting, the words from Isaiah recited during the Havdalah ceremony are written on the inner upper and middle wings of the seraphim.

It is no coincidence that there were more than twenty scrolls of the book of Isaiah discovered in the caves of Qumran within the collection of the Dead Sea scrolls, more copies than any other portion of the Bible. No doubt Isaiah was a great source of comfort for Jews of all ages from which they derived a great deal of joy and pleasure, particularly during the times of Roman persecution.

Many of the passages from Isaiah have been incorporated into the daily prayers and multiple weekly Haftarah readings of Jews and have been a source of constant hope for salvation, redemption, and God's unconditional love. The book of Isaiah is one of the great treasure troves of humanity. Its soaring poetry and high aspirations have been incorporated into the cultural, artistic, and theological lexicons of many of the peoples of the earth.

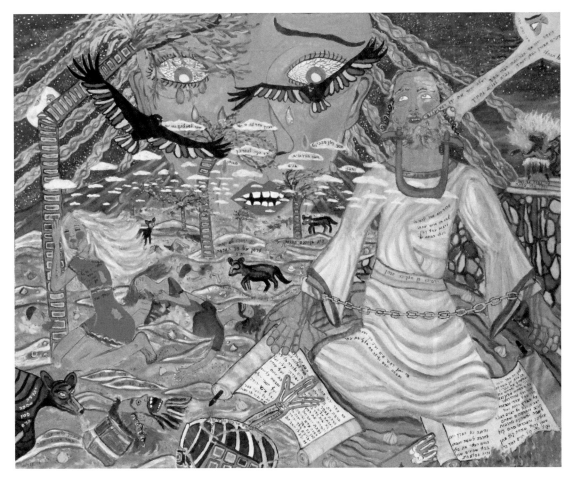

Jeremiah: 2008/64X48 inches/oil on canvas

The Book of Jeremiah: Jackals and Shackles

2

This painting visualizes the very dire prophecies uttered by the great seer Jeremiah, whose painful predictions of absolute Judean devastation and exile came to fruition in 586 BCE under the ruthless Babylonian conquest led by Nebuchadnezzar II. Jeremiah's career lasted roughly forty-four years, from 628 to 586 BCE, spanning the reigns of the Judean Kings Josiah, Jehoahaz, Jehoakim, and Zedekiah.

Jeremiah's name in Hebrew, Yirmeyahu, means "God lifts him up." He is the son of Hilkiyahu, which in Hebrew means "he who has a portion in God." He is of a priestly family.

It hadn't been very long ago that the Northern Israelites were conquered by Assyria, exiled for their sins, and ignominiously pushed off the cliff of history. According to God and Jeremiah, the Israelites, as bad as they were, were almost angelic compared to the Judeans, who are bad to the bone and rotten to the core.

They worship many false gods crafted from wood and stone, including Baal, Moloch, and the "Queen of Heaven." This latter female goddess, mentioned for the first time in Tanach, is most likely Isis, Inana, Ishtar, or a variant thereof. She is universally loved by the Judeans, as evidenced by the fact that "all the children collect wood for her, the fathers kindle the flames, and the mothers knead the dough with which to bake her sacrificial cakes" (7:18). Her ancient sculpted images, unearthed in Egypt, depict her as a seated mother lovingly suckling her son. She is the goddess of love and fertility.

25

The military and social alliances that blossomed between the Judeans and Egyptians during this era most likely paved the way for this renewed theological cross-fertilization. She is most likely not Ashera (who is more Canaanite/Mesopotamian), who also was intermittently worshiped alongside Baal by backsliding Israelites. Leafy Asherot (holy trees referencing Ashera) are mentioned separately in Jeremiah. Ashera, however, is never referred to as the Queen of Heaven, here or anywhere else in Tanach.

This iconic "heavenly mother and child" imagery was absorbed and transformed by Christianity, with Mary assuming maternal goddess (Queen of Heaven) status, and the infant Jesus assuming the suckling son of goddess (and god) status. The prevalent and very popular medieval and Renaissance Christian artistic portrayals of the "heavenly mother–divine child" illuminate what a powerful, seductive, and almost universal pull this symbolism has on the human heart and imagination. To a certain extent, this Christian imagery artistically and theologically recapitulated the illicit Judean Queen of Heaven worship, which in turn recapitulated the ancient Egyptian and Near Eastern Isis/Inana/Ishtar worship, which in turn most likely recapitulated even more ancient and primitive modes of "heavenly mother–holy child" worship.

To make matters even worse, the Judeans also worship Baal in "the valley of the son of Henom" (abbreviated as Ge-Henom, the valley of Henom, later to become the Hebrew appellation for Hell), sacrificially burning their very own children to Moloch on high places as part of Baal worship. While these practices are taking place, the Judeans still have the audacity to simultaneously offer sacrifices shamelessly to the God of Israel in His Temple. God abhors these sacrifices, which under the circumstances are rendered not only meaningless but also grotesque and mocking perversions of His worship. God, according to Jeremiah, compares Judah to a disloyal, whoring, adulterous wife. The prophet Hosea uses similar disparaging imagery describing the Northern Israelites.

The priests are no more ethical than the laymen, and probably show them the way. The prophets are all false and deceptive. Even worse than worshiping other gods, every single person is devoid of any semblance of human empathy and compassion. Adultery and senseless murder are

rampant. The widow, the orphan, and the poor are neglected and spat upon. People speak nicely to your face, but you can't believe a word they say; from the very young to the very old, they are consumed with greed.

Judea is likened to Sodom and Gomorrah. Whereas Abraham pleaded with God for Sodom and Gomorrah to be saved if he found a quorum of righteous people, God quite generously is willing to save Judea if Jeremiah can find even a single righteous person. No such luck.

Jeremiah pleads with the people to repent, to mend their ways, and thus avert destruction and exile. But, alas, "they have eyes but they do not see, they have ears but they do not hear" (5:21). "Can an Ethiopian change his skin? Can a leopard change his spots?" (13:23). Jeremiah preaches to the wind. God counsels him not to pray for this vile nation.

It is within this historical and theological context that God chooses Jeremiah as His human instrument, manipulating his vocal cords and mouth like a marionette to enunciate His divine feelings and future plans. In this painting Jeremiah is the large kneeling, pleading figure to the right. A sun-bright, yellow, heavenly hand descends and touches his lips. Written on the divine arm and finger in Hebrew are the words: "And God said to me, I have placed My words in your mouth…" (1:9); "Before I formed you in the womb, I knew you [when you came out of the womb I consecrated you (not written in this painting)]; I made you a prophet for the nations" (1:5); And God stretched out His hand and He touched my mouth" (1:9).

Jeremiah is a very reluctant prophet. By the words above, it is clear he has no choice but to preach the words of God, to vocally emit the divine repository implanted in his mouth against his will. It is distinctly God's will being expressed, not his own – the mark of a true, as opposed to a false, prophet. This is evident by the fact that Jeremiah is repeatedly humiliated, put in jail multiple times, goes into hiding because of his words, and is taunted with death threats without end.

In this painting Jeremiah is portrayed in shackles representing the many times he was imprisoned for his efforts. His shackles are tight, cutting his wrists, causing them to bleed. He is kneeling and sinking in a pit that he was once thrown into and abandoned to die of starvation, but saved at the nick of time. The manner in which the Judeans treat him is the same way the Babylonians ultimately treat them, marching the Judean survivors off

to Babylon in shackles, where they are thrown into the pit of exile – a classical biblical "measure for measure" approach.

Jeremiah's circumstance is highly similar to Joseph's, whose brothers throw him into a pit to be sold into slavery, punishing him for expressing prophecies they didn't want to hear. Years later it is his brothers who are thrown into the pit of Egyptian slavery. In the end God saves Joseph, and ultimately his brothers. Likewise, God rescues Jeremiah from the pit, and eventually returns the Judeans back home from the Babylonian pit of exile.

Contrast God's words above with Jeremiah's reflections on being the lucky unfortunate chosen prophet, expressed in Hebrew on his right upper torso in this painting: "Cursed is the day that I was born" (20:14). "Why did I come out of the womb to witness all this pain and suffering, so that all my days I am consumed with shame?" (20:18). Written in red Yiddish on his green collar is the expression "It's tough to be a Jew." Written in red Hebrew on his green belt is his name "Jeremiah son of Hilkiyahu, the Priest."

Written on his left bottom robe in this painting are the words "Who will provide my head with water and my eyes with a fountain of tears, so that I may cry day and night over the killed daughters of my nation?" (8:23).

When God first initiates Jeremiah, He asks him, "What do you see?" (1:11, 13) Jeremiah answers, "I see a seething pot and its face is from the north" (1:13). These words are written on top of the mountain to Jeremiah's right, underneath the seething boiling pot, out of which emerges Nebuchadnezzar II on a horse. God explains to Jeremiah that this seething pot represents Babylon who will come from the north, devastate Judea, and torch Jerusalem. In this painting, boiling hot steam ominously emanates from the seething black pot.

Granted, Jeremiah asks the leaders and people of Judea to repent in order to save them from destruction. This is benign and sincere enough. But this is not the only thing that Jeremiah requests of them.

In this painting, Jeremiah is illustrated wearing a wooden oxen yoke. He wears this to metaphorically act out the message that when the Babylonians come to town, the Jews should allow themselves to be yoked like oxen and taken passively to Babylon without a fight. In other words, they should lay down their arms and surrender to Babylon. Jeremiah

promises that if they peacefully submit, their lives will be spared, they will prosper in Babylon, and in seventy years they will return. If they do not submit, they will be slaughtered.

As bad as the Judeans may be morally, it is inconceivable that any proud nation, if they believe they have a fighting chance, would agree to surrender to an invading army. In fact, such a statement, and such actions in Judea or in any other nation, would be and were considered traitorous. Understandably, Jeremiah was accused of being a traitor and working for the Babylonians. In fact, after Nebuchadnezzar's victory, Jeremiah was released from prison by the invaders, treated respectfully, and was told he could live anywhere he wanted as a reward for his pro-Babylonian stance. Hence it is not surprising that Jeremiah is constantly thrown into jail and that he must go into hiding in between incarcerations. These punitive measures against him were politically, rather than theologically, motivated. While Jerusalem was sacked, he was placed under house arrest so as not to preach surrender to the soldiers and destroy their fighting morale. Jeremiah's ultimate fate is unknown. Most likely, he was assassinated.

Even if the Judeans wanted to believe Jeremiah, it is inconceivable that any nation facing national collapse would agree to surrender, which during that time period would mean certain slavery and exile. Why not fight to the last dying breath to prevent this, and worry about repenting your sins later? It would seem quite unbelievable to almost anyone that the fierce Nebuchadnezzar would make nice to a nation if only they open their gates to him, bare their necks for the placement of a yoke, and "bah" like sheep. This was certainly not in the Judean's historical experience, no matter how many times Jeremiah said and promised otherwise.

It is no wonder that God told Jeremiah: "You will preach to them, but they won't listen to you" (7:27). No kidding. It's one thing to contemplate not worshiping idols and improving one's morality; it's quite another to consider surrendering when it would most likely lead to suicide.

God, however, in the book of Jeremiah and in Tanach in general, views things through a different lens. God liberated the Israelites from Egypt, gave them the Ten Commandments, and delivered them to the Promised Land. The Israelites squandered this opportunity and did not live up to God's high expectations. This isn't the first time this happened to God with

respect to the Israelites or with humanity in general. God is into renewals, acknowledging His mistakes and starting from scratch.

After God created the world and saw that men were evil, He regretted His creation. He thus starts from scratch. He destroys the entire world with a flood, with the exception of one decent man, Noah, along with his family; they survive in an Ark and repopulate the world. God destroys Sodom and Gomorrah but rescues Lot and his daughters, who for a while believe they are the sole survivors in the world, and do a bit of repopulating of their own. Likewise, God now concludes beyond a shadow of a doubt that the Judeans are absolutely evil, no different from antediluvian humanity or the denizens of Sodom and Gomorrah. Their only grace is their righteous forefathers and foremothers from whom they were hewn; due to their ancestry, the people are potentially salvageable.

He must start from scratch once again. The land, Jerusalem, the Temple, all temporal dwellings – they must all go. They must cease to exist. They've entirely lost their original meaning to both God and the Jews. The land must be torched, scorched, and rendered uninhabitable. The Temple must be destroyed, and its holy vessels, now mere objects, shall be utilized at Balthazar's orgiastic feasts to amuse and inebriate the Babylonian rulers and their concubines (refer to the book of Daniel).

Any human being who remains in the land must perish. Their only salvation is to leave and go into exile, to go back to neo-Egypt (Babylon), to retrace Abraham's footsteps, to go backwards, return to Abraham's pre-monotheistic birthplace, and re-begin what he had begun. They must re-lose their liberty and return to slavery, so to speak, where they can relearn what they have forgotten, where they can be refashioned on the anvil of oppression, and recreate a more purified and noble theological state of mind. They must return to the desert not for forty but for seventy years. They must re-embark on Noah's ark and navigate on turbulent waters. Their feet will not be allowed to touch the hallowed ground that they have taken for granted. They are to become Luftmenchen. Redemption will be theirs only after suffering near annihilation and a total reversal of their unappreciated good fortunes.

It is, in fact, in Babylon where the Jews are faced with redefining their new, minority-status identity, and it is in Babylon where the grand

and intricate theological and intellectual superstructure of the Babylonian Talmud was created, published, studied, and widely disseminated. The Talmud, a jewel of razor-sharp logic, law, and lore became a renewed Torah, a portable Jewry of the mind, independent of time or space, of Holy Land or parochial Temple. Carried in the heart, and transported in the soul, it preserved Jewish civilization throughout the Babylonian exile, the Roman exile, and all other exiles, for many millennia thereafter. It led to a Renaissance of the Jewish religion, charting the trajectory of Judaism in the turbulent waters of exile and life. Somehow the sense of distance from the Promised Land and the pangs of exile strengthened the sense of loss of what once was, rekindled buried cherished emotions, and heightened the need for renewal and rededication. All this seems counterintuitive, but could only be foreseen by God, prophets, madmen, and fools.

Jeremiah dictates God's messages to his faithful scribe, Baruch ben Neriah, who writes down his words on a scroll to be delivered to the king of Judea. In this painting, illustrated in the far right underneath Jeremiah's knee, is this scroll. Written in Hebrew on this scroll is a textual sample of its probable content:

> Therefore, so said the God of Hosts: Because you did not listen to My words, I have sent and taken all the Northern families, says God, and to Nebuchadnezzar, king of Babylon, My servant, and I will bring them against this land, and its inhabitants, and all these surrounding nations, and I will destroy them, and make them an astonishment, and a hissing, and an eternal desolation. And I will remove from them the sound of joy, the sound of happiness, the voice of the bridegroom, the voice of the bride, the sound of the millstones and the light of the candle. And this whole land will be desolation and a waste, and these nations will serve the king of Babylon for seventy years. And it will be…. (Jeremiah 25:8–12)

When this scroll was delivered to King Jehoakim, after reading the first few paragraphs, he cut it up and threw it into the fire. Neither he nor anyone else in his presence was scared, nor did any of them tear their clothes. This burning scroll is illustrated on the bottom right of this painting.

When Jeremiah heard that this scroll was destroyed, he dictated an

identical scroll with additional words, and had it delivered once again. This second scroll is illustrated on the bottom middle of the painting; underneath Jeremiah. Written on it are the Hebrew words:

> So says God: You have burned this scroll, saying, "Why did you write on this that the king of Babylon is surely coming and will destroy this land, and render it uninhabitable for both man and beast?" Therefore so says God concerning Jehoakim, king of Judah: He will have no one to sit upon David's throne, and his dead body will be cast out in the day to the heat, and in the night to the frost. I will visit upon him and his seed and his servants their iniquity, and I will bring unto them and the inhabitants of Jerusalem and all the people of Judah all the bad things that I have pronounced against them, but they did not listen to. (Jeremiah 36:29–31)

In the background of this painting, to Jeremiah's left, is the visualized prophecy and reality of Judah's destruction and desolation. The girl to the far left in the red minidress, with blue hair blowing in the wind, represents the adulterous whore, Judah. Tears mixed with liquefied mascara and rouge are running down her sad and lonely face. Written on her dress in Hebrew are the words: "On top of every tall mountain and under every leafy tree she went to whore around" (3:6).

She is leaning on a leafy tree (an Ashera, perhaps), which is being snapped by the destructive wind of God. Judea has been set aflame and reduced to sand dunes. Young and old corpses are strewn across the deserted landscape, morbidly fulfilling Jeremiah's prophecies.

Written in blue Hebrew on multiple sand dunes from top to bottom are the following prophecies:

"The valley of Ben-Henom [will be renamed] the valley of slaughter" (19:6): Jeremiah prophesies that there will be so many corpses after the destruction that they will have to bury them in the valley of Ben-Henom, where they had once sacrificed and burned their children to Baal and Moloch, and it will be renamed the valley of slaughter.

"Corpses will be strewn from one end of the land to the other. They will not be gathered, and they won't be buried. They will be like piles of excrement on the face of the earth" (25:33).

"And the corpses of this nation will be food for the birds of the sky and the animals of the earth" (7:33). Notice the two black ravens and the multiple salivating black jackals in the painting, roaming and scavenging for dinner amongst the corpse-strewn Judean landscape.

"They have eyes, but they do not see. They have ears but they do not hear" (5:21).

Written in white letters on the salivating jackal to the far left of the painting is the prophecy: "Judah is laid waste. She is the dwelling place of jackals" (10:22).

In the middle bottom of the painting is the half-decayed corpse of the high priest (*kohen hagadol*) with his skeletonized fingers frozen in priestly benediction. His miter retains its gold band, which reads: "Holy to God." His holy breastplate, embedded with the stones of the twelve tribes, has become threadbare from decay and is being blown away by the wind, symbolizing Israel's dispersion into the wind like grains of sand.

Written in red letters on the priest's sternum are the words "From the prophet to the priest, they are all liars" (6:13). Written on his forearm's ulna and radius bones are the words: "And they removed the bones…of the priests…. And they placed them under the sun and the moon" (8:1–2). In this painting, the moon is hiding behind the breaking tree in the sky's upper left, and the sun shines on the upper right.

Scattered throughout the sand dunes in the painting are broken blue shards of an urn that Jeremiah shattered in order to metaphorically demonstrate how Judea will be shattered and dispersed by the Babylonians. Also scattered throughout the sand dunes in this painting are green figs, which refer to another of Jeremiah's metaphors. God shows Jeremiah two baskets of figs: one basket contains fresh beautiful figs, and the other basket contains rotten figs. God tells Jeremiah that the beautiful figs represent the Jews who leave Israel, and the bad figs represent the Jews who stay in Israel. The scattered figs in this painting represent scattered, broken Jews, like the shattered urn shards.

Amidst the gloom and doom of devastation and destruction, Jeremiah and God hold out a candle of hope and reassure Judah that despite the severity of this judgment, God still loves them. "Thus says God: A voice is heard in Ramah, lamentation and bitter weeping, Rachel weeping for her

children. She refuses to be comforted for her children because they are no more" (31:15).

In this painting, Rachel is illustrated as the enlarged background face weeping for her children. She appears to have been awakened by the overpowering stench of blood and death, and the screeching, howling sounds of jackals and the wind. Her spirit is emerging from the land itself. Her braided locks engulf the sky. Written in white letters on two blue tears flowing down the middle of her face are her imagined crying words: "My sons are no more."

Written in purple letters on the white clouds traversing her face are God's words responding to her lamentations: "Refrain your voice from weeping, Rachel, and your eyes from tears. For your work will be rewarded, says God. And they will return from the land of the enemy. And there is hope for your future. And your children will return to their own borders" (31:15–16). God continues (not written in the painting), "Therefore My heart yearns for him [Ephraim], I will surely have compassion on him, says God" (31:20).

In this painting Rachel's oversized face magnifies her sense of incomprehensible shock and inconsolable suffering, watching the unwatchable and imagining the unimaginable. The landscape is strewn "with corpses from one end of the land to the other" (25:33). It will be thousands of years later until an almost identical scene is revisited in Nazi death camps all across Europe, where children are sacrificed in the Gehennom furnaces of Moloch; where mounds of human corpses span the visible horizon and are too numerous to count; where decayed skeletal ghosts drape the land like lumps of excrement; where the dead are neither gathered nor buried; where they are food for the birds and beasts.

Did Rachel cry then too? Was she ever consoled?

One wonders why a matriarch, not a patriarch, is mentioned – and why a matriarch who was not the mother of Judah. Judah's mother was Leah.

This probably refers back to the Judean illicit worship of the Queen of Heaven. The Judeans clearly had a need for a maternal style of divine love capable of providing mercy and consolation. What Jeremiah and God are trying to tell the Judeans is that this role is already fulfilled by their own maternal matriarch, whose spirit still lives and permeates heaven and

earth, who still loves them, cares for them, and mourns for them. There was no need to rely on any foreign maternal goddess when they had a loving spiritual mother of their own. Rachel was chosen rather than Leah, because she was the more beautiful of the matriarchs (it's all about marketing), and the one most loved by the great patriarch Jacob, and thus more likely accepted as a substitute for the Queen of Heaven.

Toward the end of the book of Jeremiah, there is a theological reckoning for all the other nations. If God says that Judea is so evil because they worship other gods, and are so immoral, then why are all those other cruel, bloodthirsty, pagan nonbelievers, who are not the epitome of morality, allowed to get away with murder? Why is Judah the only nation picked on for divine, ugly retribution? The answer provided by Jeremiah is that all these other nations will indeed be utterly destroyed. But as opposed to Judea, their destruction will be permanent. Judea's remnant bud will blossom again and return to the land, because God, as much as He wants to, is incapable of forsaking him.

The other nations that are reckoned with include: Philistine, Moab, Ammon, Edom, Damascus, Kadar, Hazor, and last but not least, Babylon.

> Therefore says the God of Israel: I will punish the king of Babylon and his land, as I have punished the king of Assyria. And I will bring Israel back to his pasture, and he will feed on Carmel and Bashan, and his soul will be satisfied upon the hills of Ephraim and in Gilead. In those days and in that time, says God, the iniquity of Israel will be sought for, and there will be none, and the sins of Judah, and they will not be found; for I will pardon the remnant that I leave. (Jeremiah 50:18–20)

> Therefore, the days come when I will judge the idols of Babylon, and her whole land will be ashamed; and all her corpses will fall in the midst of her. Then the heaven and the earth, and all that is therein will sing for joy over Babylon; for the spoilers will come unto her from the North, says God. As Babylon has caused the murdered of Israel to fall, so at Babylon will fall the murdered of the land…. Remember God from afar, and let Jerusalem arise in your hearts. (Jeremiah 51:47–50)

Only an exceptional prophet such as Jeremiah has the ability to suppress the stench of death, and the prescience to see hope arise from smoke and ashes.

Many are the torments of mankind.

Great is the suffering of humanity.

A dull ray of hope attempts

to pierce the veil of gloom,

and illuminate the darkness.

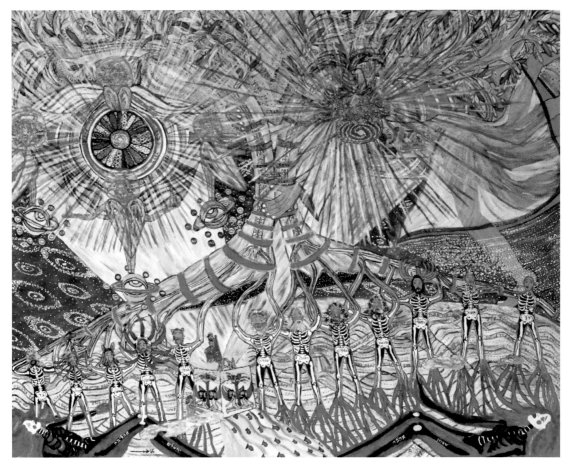

Ezekiel: 2010/60X48 inches/oil on canvas

Ezekiel's Brain:
Flotations and Rotations
in the River of Time

3

3

This painting attempts to transport you into the teletransporting visionary mind of the great prophet Ezekiel son of Buzi HaCohen, who was exiled to Babylon along with his fellow Judeans in the sixth century BCE. Of all the prophets, Ezekiel's visions are the most phantasmagoric and visually explosive.

Ezekiel's brain is thoroughly on fire. Every one of his physical senses – sight, hearing, touch, taste, smell, and sensual (see endnotes A, I–VI, below) – are unified, heightened, and exponentially magnified (details below). Simultaneously his mind mathematically and musically ascends and extends into infinity, while it also simultaneously experiences an extrasensory perception of out-of-body flight through space and time via a mystical portal linked with the mind of God: "And the form of a hand was put forth, and I was taken by a lock of my head, and a wind lifted me between earth and heaven and brought me to Jerusalem [from Babylon] *within the visions of God* to the door of the inner gate…" (8:3). Hence Ezekiel's visions have coalesced with, and/or are part and parcel of, God's visions (also see endnote A, VII).

In this painting, Ezekiel's multiple prophecies are visually fused into a single mosaic, which constitutes his very colorful mind-bending countenance. Ezekiel's large fantastical face, which reflects the inner thoughts and flights of his brain, occupies the vast majority of this canvas.

His face, depending upon one's relative time perspective, can be viewed either as an inner-space electromagnetic struggle against gravitational

forces to achieve a unified cohesion of multiple elements/prophecies/moral stories when a visionary experience comes into his mind, or alternatively, as a competing opposing entropic need to disassociate these same elements when a vision exits his thoughts; or alternatively yet, as a gravitational and electromagnetic yin-yang balance of these opposing forces whereby his brain somehow manages to achieve a fragile state of stable equilibrium, when his mind is always open to invite the next visionary experience. Each separate prophetic visual component of this panoramic facial mosaic will be detailed below.

In this painting both right and left eyes of Ezekiel's face mosaic are either emitting or receiving infinite "splendorous" light rays in accordance with his description of God: "And I saw and there was a likeness like the appearance of fire from his loins downward, and from his loins and above, like the appearance of radiating rays of splendor (*zohar*) like an eye (*ayin*) of lightning" (8:2).

Ezekiel's visions comprise the esoteric foundation of all Kabbalah. The *Zohar*, "The Book of Splendor" – one of Jewish mysticism's primary texts interpreting the Torah – derives its name from the above passage.

Ezekiel's first of many multisensory and synesthetic theophanies begins with the heavens opening up in Babylon, the land of Jewish exile, above the river of Khabur, which in Hebrew is spelled kaf, vet, resh (1:1).These Hebrew letters transliterated into English letters are C-V-R. Whereas the Khabur River in physical reality is the largest tributary to the Euphrates, the word c-v-r in Hebrew means "already was" or "that which has passed." It is a word signifying the continuous flow of time, a present (eternal) past-tense time word. Thus the "river of C-V-R" can be loosely translated as the "river of time." Hence it is no mere coincidence that Ezekiel's teletransportation visions are often associated with this river, and it most likely signifies a physical-mystical portal linked to his mind's journeys through space and time.

Ezekiel's name in Hebrew, Yechezkel (Ye-CHZK-el) means "God will strengthen." This name is directly derived from the text: "Because the entire house of Israel has a strong (CH-Z-K) forehead, and is stiff-hearted; behold I have made your face strong (CH-Z-K) against their faces, and your forehead strong (CH-Z-K) against their foreheads; as a diamond (*shamir*)

stronger than stone (*tzur*) I have made your forehead..." (3:7–9). These words are written in Hebrew in this painting on Ezekiel's mid-forehead face mosaic. God must strengthen Ezekiel in order for him to relay some very harsh (CH-Z-K) rebuking words, and ensure that he not fear physical and political repercussions.

In Ezekiel's first vision, the sky throne of God is described as having the appearance of *even sapir*, or sapphire stone, which is structurally and geometrically similar to a diamond. In this painting these words are written in Hebrew on Ezekiel's mid-forehead face mosaic above the words describing his diamond forehead. The hexagonal geometric symmetry between Ezekiel's diamond (*shamir*) face and God's sapphire (*sapir*) sky throne is illustrated in this painting and will be described further below. These two words describe similar objects and are therefore linguistically similar, and the Hebrew passages referring to them are placed one on top of the other.

Ezekiel is the son of Buzi. The root word of Buzi in Hebrew, b-z-h, means "despised." He is the son of a currently despised and exiled nation (soon to be remediated). This name is also directly taken from multiple sources in the text: "I will even deal with you as you have done, you [Israel] that despised (*bazah*) the oath to break the covenant (*brit*)" (16:59). "Seeing he despised (*bazah*) the oath by breaking the *brit*…" (17:18). "As I live, surely, says God, My oath that he despised (*bazah*) and My *brit* (covenant) that he broke, I will even bring it upon his own head" (17:19). "You despised (*bazit*) My holy things…" (22:8). "An assembly shall be brought up against them and they shall be made a horror and a spoil (*lavaz*)" (23:46).

In the opening chapter, Ezekiel has his first theophany, which is a synesthetic amalgamation of sound, touch, and sight, with each sequential sense transmuting into the next. First there is the word of God, the *sound* of His voice, followed by (and transmuted into) the *touch* of the hand of God, followed by (and transmuted into) the *vision* of God: "The word of God [transmitted by speech or *sound* and received by hearing] came to Ezekiel…and there the hand of God was upon him [*touch*]" (1:3). "And I saw [*sight*] and a stormy wind came from the North" (1:4).

Like the two major prophets who preceded him, Isaiah and Jeremiah, Ezekiel is initiated into service by the physical, tactile touch of God's hand.

This theophany is illustrated to the left of this painting. It broadly represents the right side of Ezekiel's mosaic face.

The initial superficial appearance of Ezekiel's first prophetic experience constitutes a hazy inchoate cloud, yet harboring exceptional internal and external luminescence: "A big cloud and a fire, flashing up, so that brightness was round about it. And in the midst of it there was lightning within the fire" (1:4). He further describes the appearance of God as "the appearance of the rainbow in a cloud on a rainy day; so was the appearance of the brightness round about. This was the appearance of the likeness of the glory of God. And I saw it and I fell upon my face, and I heard a voice speak" (1:28).

The sequence of this sensory transmutation is now exactly reversed from when his experience first began: *sight* ("I saw") is transformed back into *touch* ("I fell upon my face"), which is transformed back into *sound* ("I heard a voice speak"). This implies undulating brain waves of active synesthetic experiences.

The emanating light rays from the center of this eye on the left of the painting are meant to symbolize the rainbow-colored light emanations emitted by the glory of God, and hence every color frequency of the light spectrum (violet, indigo, blue, green, yellow, orange, and red) is represented. These colored rays also attempt to replicate the distinctive appearance of the upper essence of God, which is the color of electrum and lightning, and the lower essence of God, which is like fire, as described by Ezekiel: "And I saw as the color of lightning [electrum] as the appearance of fire round about enclosing it, from the appearance of his loins and above, and from his loins and below I saw it as the appearance of fire, and there was brightness round about him" (1:27).

Hence in this painting the color rays of blue and purple predominantly emanate from the upper half of Ezekiel's right eye (left), and the colors orange, red, and yellow (fire) predominantly emanate from the lower half of his right eye.

In his mind's eye Ezekiel manages to penetrate this blurry haze, and he makes out the likeness of four interlocking unusual creatures in the midst of this luminescent cloud. Above them there is the likeness of a throne with the appearance of a sapphire stone, and upon the throne is God.

These creatures are portrayed on the left of the painting surrounding Ezekiel's right eye, which symbolizes God. They are painted in the orange-yellow-red color of fire as stated: "Their appearance was like coals of fire, burning like the appearance of torches; it flashed up and down among the living creatures and there was brightness to the fire" (11:13).

Each creature has four limbs – two arms and two brass-sparkling straight legs (calf-like); fours wings; and four faces.

> The total number of faces (4), wings (4), and limbs (4) per individual creature is **3 x 4 = 12**.

> The total number of faces in the 4-creature entourage is **4 x 4 = 16**.

> The total number of wings in the 4-creature entourage is **4 x 4 = 16**.
> The total number of limbs in the 4-creature entourage is **4 x 4 = 16**.

> The total number of faces, wings, and limbs in the 4-creature entourage is **3 x (4 x 4)** or **3 x 4^2** or **12 x 4 = 48** (which also happens to be the number of chapters in the book of Ezekiel)

Each of the four creatures has a wheel beside (underneath) it. The wheel is in fact a wheel within a wheel, i.e., there are two wheels (an inner and an outer wheel) per creature (1:16).

> The number of wheels in the 4-creature entourage is **2 x 4 = 8**.

> The total number of faces, wings, limbs, and wheels per individual creature is **14**.

> The total number of faces, wings, limbs, and wheels in the 4-creature entourage is **4 x 14 = 56**.

> The total number of eyes per individual creature is **2 x 4 (faces) = 8**.

> The total number of faces, wings, limbs, wheels, and eyes per individual creature is **22**.

> The total number of faces, wings, limbs, wheels, and eyes in the 4-creature entourage is **4 x 22 = 88.**

If we add the multiple unknown numbers of eyes associated with each of the wheels ("their rings were full of eyes round about"; 1:18), then the total number of creature body subcomponents escalates even further.

Hence we see that within Ezekiel's vision there is a finite arithmetic progression involving ascending multiplications (x) of the basic unit of four. The number four itself is symbolic of the infinite: the four-letter tetragrammaton name of God (Y-H-V-H), which also represents the "four corners" of the earth (*arba kanfot*), i.e., the entire infinite expanse of the universe, or in other words, four is a numerical abbreviation for infinity. Hence this seemingly finite arithmetic progression is now mathematically transformed into an infinite arithmetic progression:

2 x 4 = 8

3 x 4 = 12

4 x 4 = 16

12 x 4 = 48

14 x 4 = 56

22 x 4 = 88

Infinity x 4 = *En Sof* (the mystical name of God meaning "without end")

Specifically the four faces of each creature are those of:

1) A man,

2) A lion,

3) An eagle, and

4) An ox.

In later theophanies, the four faces of the creatures described by Ezekiel are slightly different, and are those of:

1) A man

2) A lion,

3) An eagle, and

4) A cherub.

The ox of the first theophany is replaced by a cherub in later theophanies. Furthermore, in the later theophanies each creature is generically referred to as a cherub: "This is the living creature that I saw under the God of Israel on the Khabur River, and I knew that they were cherubim" (10:20).

It thus becomes clear that Ezekiel's multiple theophanies comprising four four-faced cherubic creatures is a visual multiplicative expansion of the two original Tabernacle-Temple single-faced cherubs which sat atop the Ark containing the Tablets of the Law. Each of those two cherubs has one face and two wings. These are the same or similar cherubs as the ones who stood with flaming swords guarding the entrance to the Garden of Eden, as described in Genesis. They are now guarding the entrance to the Ark within which reside the two Tablets, which are a modified version of the two Eden trees, the Tree of Life and the Tree of Knowledge (the Torah is a "tree of life to those who hold on to it"; Proverbs 3:13).

Toward the end of the book of Ezekiel, Ezekiel has a prophetic vision of a future Temple that has cherub images imprinted on the Temple walls and doors. Each of these two cherubs has two faces: the face of a cherub and the face of a young lion. These images are illustrated in this painting on the walls of the square-shaped Temple located at the bottom left. In this future cherub representation, the faces of the man and eagle are eliminated. Each two-faced cherub faces an image of a palm tree (41:18–19) again harkening back to the cherubs guarding Eden wherein reside the Trees of Knowledge and Life.

If we look at all of Ezekiel's creature imagery, the lion is the only animal that exists in every version of his creature-cherub menageries.

We may now analyze the mathematical progression of the number of faces in all three of Ezekiel's cherubic visions/memories:

The number of faces per individual cherub in the original Tabernacle-Temple = **1**.

The number of faces per individual creature in Ezekiel's future temple = **2**.

The number of faces per individual creature in his theophanies = **4**.

Hence, the arithmetic progression of cherub faces is **1, 2,** and **4**. In this progression each progressive number is multiplied by **2**. This is an arithmetic multiplication progression.

The total number of creature/cherub faces in the original Tabernacle-Temple (past) is **2**.

The total number of creature/cherub faces in Ezekiel's (future) Temple is **4**.

The total number of creature/cherub faces in Ezekiel's (present) theophanies is **16**.

This numerical progression is thus **2, 4,** and **16**. Each number is the exponential to the second power of each proceeding number, i.e., 2 squared is 4, and 4 squared is 16.

Hence Ezekiel's mind when contemplating successive cherubic faces in the past, present, and future (not necessarily in that order) works in a polynomial progression of **2**: **2 x 2 = 4**, and **4 x 4 = 16**.

This polynomial progression is similar (but not identical) to the frequencies found in the superoctaves of musical scales. A musical scale is a set of pitches describing music. Each pitch corresponds to a frequency in cycles/second. An octave is the interval of repetition in a musical scale. The octave of any pitch refers to twice the frequency of a given pitch. Superoctaves are pitches found at frequencies of 4, 8, and 16 times the fundamental frequency.

This acoustic pattern of multiplicative repetitions found in music over discrete cycles of time is encoded in Ezekiel's visual-auditory theophany experience:

"And I heard the voice of their wings like the voice of *many* waters like the voice of Shaddai, and when they went, like the voice of a tumult, like the voice of a camp, when they stood their wings descended. And there was a voice from above the sky on top of their heads" (1:24–25). "And His voice was like the voice of *many* waters, and the earth shone from His glory" (43:2).

This also harks back to creation in the book of Genesis: "And the spirit of God hovered [playfully] on the face of the waters [manifesting as sound]" (Genesis 1:2). Ezekiel himself broadly interprets the mathematical nature of the sound he hears: "As for the wheels, they were called in my hearing the wheelwork" (10:13).

This polynomial musical-scale progression occurs simultaneously with the numerical encoded visualization of the arithmetic multiplication progression of the cherubim's body segments (detailed above). The perception of syncopated music with incremental infinite frequencies also serves to express and symbolize the modality of time. Hence during Ezekiel's prophetic visions, he is simultaneously seeing, hearing, and subconsciously arithmetically calculating the mathematical ascent and descent of time in synesthetic unity and simultaneity. He is also simultaneously experiencing a sensation of ascent and flight by both the wind and hand of God within the visions of God.

Other mathematical arithmetic progressions mentioned above include **2 x 4, 3 x 4, 4 x 4, 14 x 4, 22 x 4**, etc.

Thus, the whole sum of Ezekiel's theophanic multisensory experiences constitutes different types of baroque-like ascending mathematical infinite progressions, whether polynomial or exponential, which symbolize and express his ascent to infinitely higher and higher spiritual planes, as stated "*vatisa oti ruach*," "and a wind/spirit lifted/transported me" (11:1).

Hence mathematical insight buried deep in Ezekiel's brain employing innumerable synaptic connections is another essential portal allowing him to accomplish his teleportation mystical journeys.

The hyper activation of Ezekiel's frontal, temporal, parietal, and occipital lobes, as well as his limbic system, as demonstrated in this book, provides insight into the inner workings of the mind of the super mystic, i.e., a Major Prophet.

Ezekiel could only be capable of seeing each of the four faces of each creature if their heads were constantly rotating like a heavenly globe atop a vertical axis. Thus, in essence, the creatures' constantly rotating single heads, each with four faces, represent a natural gravitational law of the universe that is inherent in planets, moons, solar systems, galaxies, and subatomic particles. The creatures' heads rotate along a stationary vertical

axis – straight legs and bodies – which in turn are capable of moving up, down, and sideways (1:12). The bodies themselves do not rotate. In this painting, the orange globe around each of the cherub's four-faced heads represents this state of rotation.

Each of these creatures has beside him (underneath) a wheel rotating within a wheel, which has its very own life force (1:21). These wheels are depicted in this painting to the left and are illustrated as a single planet (a three-dimensional wheel) surrounded by a single Saturn-like ring (a two-dimensional wheel). This wheel within a wheel symbolizes both rotation and revolution. The combinations of rotating creature heads, above the vertical axis body that can move up, down, and sideways, and the rotating wheels within revolving wheels below the vertical axis of the creatures' bodies, comprise motion occurring in Euclidean and Cartesian space. If we include Ezekiel's time journeys to the future and the past, these movements also comprise movement within Einsteinian space.

The multiple moons/planetoids rotating around each wheel within a wheel in this painting symbolize the multiplicity of eyes described within these wheels (1:18).

In this painting, as described in the text, two of every creature's wings interlock with their neighboring creature's wings, forming a tight protecting circle (or *chuppah*: a wedding canopy with four posts) around God. This implied symbol of matrimony is later fleshed out by Ezekiel's visionary parables describing the matrimony between God and Israel (to be described below). A *chuppah* in matrimony symbolizes the future couple's home, which in ancient times was a tent. "Tent" in Hebrew is *ohel*, which is the root of the names "Oholah" and Oholibah" (chapter 23), whose symbolism will be discussed in detail below.

The other two (out of four) cherub wings that do not interlock cover their individual bodies. In this painting the colors of the interlocking waved wings are oceanic aqua and blue. This is because when their wings flutter Ezekiel interpretively hears the sound of the voice of many waters, which he equates with the voice of God: "And I heard the voice of their wings like the voice of many waters" (1:23). This association must be that of supremely magnified sounds of natural oceanic waves, which Ezekiel is familiar with in ordinary reality. This concept may also be an immediate

association from the concept of God in the book of Genesis where "the spirit of God hovers over the face of the [oceanic] waters," as mentioned above.

The central pupil of the right eye (on the left) of this painting has a rotating cosmos symbolizing divinity. The iris of the eye consists of multicolored petals with hexagonal patterns representing the sapphire geometry of God's heavenly throne.

The iris of the eye is surrounded by multiple colored circles within circles arrayed within x and y axes. The emanating rays of light occupy the z axis. The combination of these three axes attempts to achieve a three-dimensional representation of Ezekiel's divine vision.

What is the symbolism of the four different creature-cherub faces that Ezekiel perceives? These creatures include a human being (Adam), an eagle, a lion, and an ox or cherub. It is possible that Ezekiel was influenced by pagan imagery painted and sculpted in the royal Babylonian palaces that he was exposed to, but most likely each being must have been highly symbolic within his own Jewish tradition. Below are some possibilities.

Man: Man (Human/Adam) was created in God's image, and hence is a reflection of God's glory and thus a suitable escort for God. Furthermore, Ezekiel is constantly referred to as son of man (*ben-Adam*, in Hebrew).

Eagle: God compares the powerful Babylonian empire to a mighty eagle with powerful wings who took the top of the cedar (17:3). Later on in this parable God says that "I will crop off from the topmost of its [the cedar's] young twigs a tender one" (17:22). Hence by association of actions (taking the top of a cedar) God not only compares Babylon to an eagle, he compares himself to the most powerful eagle of all. Thus the eagle, like mankind, is a metaphorical reflection of God.

Moses draws a similar God-Eagle analogy in his final address to Israel: "As an eagle that stirs up her nest, hovers over her young, spreads abroad her wings, takes them, and bears them on her pinions" (Deut. 32:11). In this analogy it is God's protective, maternal traits that are highlighted.

We'll forget for the moment about the powerful Egyptian god Horus, who in Egyptian theology is artistically rendered as an eagle.

Lion: God is compared to a lion by multiple prophets. God's voice,

which Ezekiel is particularly attuned to, is frequently compared to a lion's roar (see Amos). Ezekiel is also addressing the exiled Judeans. Jacob on his deathbed blessing compared Judah to a lion, and hence the lion is also a symbol of Judah.

Ox: Twelve oxen surrounded a water basin in Solomon's Temple, which Ezekiel along with all of Israel viewed all the time. The ox or bull was a powerful Egyptian deity and is also related to the golden calf. One can only assume that the inclusion of the ox symbolizes the humiliation, defeat, domestication, and victory over this symbol (in Solomon's Temple as well). Its inclusion in this menagerie might symbolize the ox's (and its worshipers') subservience to God.

The original pictographic proto-Sinaitic Hebrew letter aleph is a picture of an "ox." In those ancient times in Canaan, like in Egypt, the ox (symbolizing power and strength) was worshiped as a god. The Phoenician/Canaanite generic name for god, "El," in this pictographic language combines the alphabetic pictographic image of an ox-god (Hebrew letter aleph) with the alphabetic pictographic image of an ox goad (Hebrew letter lamed), which hieroglyphically spells out aleph-lamed – "El," god (ox) the stern teacher (who holds and uses the ox goad). Ezekiel may have instinctively realized this irony, and therefore replaced the ox with a cherub in his later theophanies.

Cherub: Cherubs within the context of biblical narrative probably anteceded the creation of humanity. They originally guarded the Garden of Eden. They later guard the Ark and its cherished contents. Ezekiel in fact generically refers to all his theophonic creatures as cherubs. They represent God's eternal loyal servants. They exist solely to serve God, as opposed to humans, who have freedom of choice.

It is obvious that Ezekiel's multiple conceptions of the cherubim, be they of the original Tabernacle-Temple, be they of his theophanies, or be they of his vision of the future Temple, they are not and never were mere passive, stationary, idle (no pun intended) creatures who are just sitting there on top of the Ark of the Covenant like mannequins allowing the voice of God to pass between them (in the Temple) or above them (in the theophanies). Invisible to the human eye (except Ezekiel's) they are quite busy. They are guardians of the highest order. They escort and transport

God's metaphysical presence back and forth between His heavenly and earthly abodes. When He descends down to earth, or when He ascends, "the heavens open up" (like sliding double doors).

Not only do these creatures use their wings to fly, they are also capable of using their arms and hands if needed, for example, to provide coals and flames to other magical creatures: "And the cherub stretched forth his hand from between the cherubim into the fire that was between the cherubim, and took thereof, and put it into the hands of him that was clothed in linen, who took it and went out" (10:7). The bottom cherub in this painting, beneath the Ezekiel mosaic-face eye on the left, is illustrated extending his arms out offering flames for the taking as described in the text.

King David had a very similar dynamic notion of cherubim vis-à-vis God. He conceived of God as a warrior emitting arrows of lightning while being transported back and forth between heaven and earth on the shoulders of a single flying cherub (illustrated in *David III*, 2008; www. NahumHaLevi.com).

Ezekiel's cherubim are very much alive with their own life force, as are their accompanying wheels (the cherubim's own escorts) which have their very own and possibly separate life force, and are saturated with countless eyes, initiating and generating motion. The wheels – or, as Ezekiel's ears understand them, the wheelwork – seem to function as gyroscopic directional sensors conducting vehicular transportation.

The cherubim form a protective interlocking covering of wings surrounding God's radiating presence. In Hebrew, "wings" are *kenafayim* (K-N-F-Y-M). Each creature has four *kenafayim*. This is the male plural of the root word "*kanaf*" spelled K-N-F (wing) in Hebrew, which has a double meaning. *Kanaf* also means "corner." The female plural of this word is *kenafot* (K-N-F-T). The "four corners" of the world (*arba kanfot* in Hebrew) symbolize the totality of the universe. This terminology is referenced in Ezekiel, when God speaks of bringing an end to the Land of Israel, to the entire world (*arba kanfot ha'aretz*) (7:3).

There is an interesting play of words using the double meaning of K-N-F with respect to the cherubim. They each have four K-N-F-Y-M (wings), and each occupies one of four corners (K-N-F-T) of God's personal universe within a circular surrounding array.

The Hebrew terminology *arba kanfot* – "four corners" (of the world) – is also used to describe the tallit, the ritual fringed prayer shawl that Jewish people wrap around themselves during prayer. Tzitzit (ritual fringes) dangle from each of the four corners of the tallit. A smaller version of the big tallit is the little tallit, which is worn constantly under one's clothing irrespective of prayer time, and is simply referred to as the *arba kanfot* ("the four corners").

This concept leads us to the right side of this painting, the left side of Ezekiel's mosaic-face. On the right side of the painting Ezekiel's entire body is portrayed as he sees himself through his own mind's eye. God's hand is lifting him up by a "lock of hair," in Hebrew *tzitzit* (8:3–4), and is transporting him up, up, and away where he flies at an altitude somewhere midway between the mountainous landscape of Israel (earth) and the heavens above.

It is apparent that the Hebrew word *tzitzit* has the dual meaning of both "ritual fringes" and a "lock of hair" (natural fringes). Because tzitzit have multiple hairlike long fringes and really look like a lock of hair, it is most likely that the word tzitzit does not actually have a dual meaning, but rather "tzitzit" means, visually speaking, "lock of hair."

According to the specifications set forth by the Torah, tzitzit should be the color of *techelet* (a blue dye). The color blue was chosen to initiate a set of linked mental associations. When one looks at one's blue tzitzit fringes, one is supposed to form a mental association between the blue fringes and the blue heavens above wherein God resides, and thereby form another mental association of then reminding oneself of and remembering God's laws. Each of the "four corners" (*arba kanfot*) of the tallit has its own lock of tzitzit-hair. Hence every individual wearing (wrapped within) a tallit is contained within the four corners of his own individual private universe-world.

Ezekiel, well aware of the biblical command of wearing tzitzit, visually associated looking at his own blue tzitzit (ritual hair-fringes) and thinking about the blue heavens above, with actually being lifted up by his strengthened forehead's tzitzit (hair lock) and metaphysically transported to heaven. He continues this association by literally seeing God circumferentially surrounded by four creatures who form the "four

corners" (*arba kanfot*) of God's immediate world. The four corners surround God via four interlocking *arba kenafayim* ("wings").

In a mystical metaphysical sense, God himself is wrapped in a tallit (composed of cherubim wings). This tallit has four cherubic creatures on each of its *arba kanfot* ("four corners"). When tzitzit fly beside an ambulating human being they can very much look like fluttering wings. Hence another one of the cherubim's functions is to enwrap God with a heavenly tallit. Another one of the functions alluded to above is also enwrapping God with a *chuppah*, a matrimony canopy, or an *ohel* (a "tent" or "home"), preparing him as a bridegroom for his matrimony to Israel upon his arrival in his earthly Temple-*ohel* abode (details below). Incidentally, the most basic time-honored *chuppah* (Jewish wedding canopy) is constructed using four poles suspending an outstretched tallit by its four corners (*arba kanfot*).

Thus by uttering the word tzitzit (like *om* in contemporary mystical parlance) or by catching a glimpse of tzitzit, Ezekiel can set off a chain reaction of mental associations in his mind that allows him to enter another mystical portal to initiate his mind flight. If we borrow Ezekiel's interpretation of tzitzit and its association with divine visions, then when people look at their own tzitzit they can conceivably commune with God by imagining that their ritual fringes are their own locks of forehead hair on the four corners of their own self-contained world whereby they are spiritually uplifted by and to God via this visual-mental association. Hence Ezekiel, for the first time since this biblical law was proscribed, provides the mystical-visual foundation of the biblical commandment of tzitzit.

Let us now focus further on the details of Ezekiel's head and body to the right of the painting. Ezekiel is portrayed here as having multiple faces, just like the cherubic creatures. This image is actually a photo-like static fused image montage of his head circumferentially rotating in clockwise and counterclockwise directions (depending on one's relative perspective) just as hypothesized above regarding the movement of the cherubim's faces. Thus this illustrates sequential images of Ezekiel's single rotating face captured in sequential arcs of rotation.

This aesthetic concept is derived from multiple textual references to Ezekiel rotating his face: "Place [rotate] your face to the hills of

Israel" (6:1), and "Raise your eyes in the Northern direction" (8:5), as well as multiple similar sources referring to the rotation of his face in different physical directions or metaphysical planes; see 21:2, 21:7, 25:3, 28:21, 29:2, and 35:3. Furthermore, Ezekiel is always seeing Israel from Babylon, and Babylon from Israel, and his head (at least in his mind) would be constantly turning to and fro (for additional references see endnotes B).

In this painting, Ezekiel's multifaceted, rotating head forms the iris of his mind's (face mosaic's) left eye (right in the painting), which can be seen in the obscured light-ray-covered background to the right of his multi-rotating face. The colors of this eye are identical to the circumferential rings surround the eye to the left of this painting, thereby creating an aesthetic optical symmetry.

In this painting, Ezekiel's fused blue beard sprouting from all his rotating faces forms the pupil of his grand face mosaic eye, in the midst of which rotates a cosmic galaxy that is parallel and symmetric to the rotating cosmic galaxy of the pupil of his other eye, which symbolizes God's essence, as discussed above.

Ezekiel's cheeks in this painting are inscribed with multicolored hexagonal diamond patterns. This correlates with and is symmetric with the hexagonal geometric sapphire patterns on the iris of his right eye. This pattern symbolizes God's transformation of his forehead and face into a hardened diamond, which has a hexagonal geometric pattern, just like the pattern of his other eye which symbolizes the hexagonal geometric sapphire throne of heaven (discussed above).

Illustrated circumferentially around Ezekiel's eye to the right of this painting are multiple incoming light rays spanning the entire color spectrum; they symbolize infinite visions (composed of light rays) penetrating his mind through his multiple eyes (just like the multiple eyes of the wheels within the wheels, and the multiple eyes of the cherubic faces). The splendorous rays (*zohar*) emanating from the glory of God on the left side of the painting are received by Ezekiel's eyes on the right side of the painting, as are all other infinite light rays being emitted from infinite visual images circumferentially surrounding his rotating face(s).

One can appreciate Ezekiel's inner abdominal anatomy through his

transparent torso on the right of this painting. This anatomy consists of his stomach, liver, gall bladder, and small and large intestines.

God presents a scroll to Ezekiel and instructs him to eat it: "'And you son of man, listen to what I tell you…open your mouth and eat what I give you.' And I saw, and there was a hand extended toward me, and in it was the scroll of a book. He spread it before me and it was written on its front and back 'lamentations, and moaning, and woe'" (2:8–10). These three words are written in Hebrew in this painting and are illustrated traveling down Ezekiel's intestinal tract. "Lamentations" are in his stomach, "moaning" is in his small intestine, and "woe" is in his large intestine. The text continues: "'Cause your belly to eat, and fill your bowels with this roll that I give you.' Then [says Ezekiel] I ate it, and it was like honey for sweetness in my mouth" (3:3). This is an example of Ezekiel's heightened sense of taste.

After Ezekiel eats and digests these words, in time they will have to be excreted, and Israel will be free of lamentation, moaning, and woe. In an analogous parable prophecy God tells Ezekiel to prepare for himself food with dung in order to symbolize to Israel how awful their exiled lives will taste (4:9–12).

In this painting, on the right, Ezekiel is portrayed with multiple legs with progressively increasing (or decreasing) angles of knee flexion; these convey a sense of dynamic motion as his body lifts off, or lands upon, the face of the earth, depending on one's time perspective. A tornado-like multi-starred cyclone is illustrated beneath and around Ezekiel's legs, which propels his celestial flight as stated: "and a spirit/wind lifted me up" (11:1).

Ezekiel's prophecies, like those of the other Hebrew prophets, are relayed to Israel via a shower of arrows dipped and drenched in words of painful admonitions (*tochachah*), randomly interspersed with occasional small anodynal medicinal doses of consolation (*nechamah*). These doses are progressively presented with increased frequency, until they displace the admonitions altogether, and ultimately crescendo into an intense and overwhelming sensation of hope and optimism, which craftily paves the way for national remorse, divine forgiveness and ultimate redemption. All the prophets – and Ezekiel is no exception – succeed via their distinctive

charisma and passion, and by their complete mastery of poetry, oratory, and pitch-perfect theatric presentation.

The first thirty-six chapters of Ezekiel are a rather brutal outlining of the cause-and-effect relationship between Judah's horrible sins, which cause their near total destruction and exile. Ezekiel is appointed as a watchman, and conveys God's admonitions through multiple parables and prophecies.

The sins of Judah consist not only of idolatry, involving the worship of strange gods such as Tammuz and the sun (12:18), but also include breaking the covenant (*brit*) with God in every conceivable way, not to mention their terrible social sins of neglecting strangers, orphans, and widows (22:6).

For their grave sins, Judah and Israel are severely punished.

This punishment, outlined in repetitive, horrific, chilling, and ironically beautiful poetic imagery of death and suffering, includes the destruction of Israel and Judah by famine, hunger, sword, fire, and wild animals, and the utter desolation of the Land of Israel. Only a small remnant shall survive (6:8). This is in contradistinction to all of Israel's enemies – including Ammon, Moab, Edom, Philistine, Tyre, Sidon, and Egypt – who will be totally wasted (chapters 25–32).

A very picturesque fate is meted out to Gog and Magog, who after terrifying Israel will go down in extreme ignominy (chapters 38 and 39). This prophecy is illustrated in the painting *Sukkoth* (2004; www.NahumHaLevi.com).

As mentioned above, the stingy, measly morsels of *nechamah* (consolation), which in no way douse the flames of admonition (16:60, 18:31, 20:41–44, 28:25, 34:11, 34:23, 36:8) are randomly interspersed in the first thirty-six chapters, and become progressively more frequent and sweeter, reaching a crescendo with the later chapters (beginning with chapter 37). At that point Ezekiel's admonition is completely transformed into the poetic imagery of sublime grace, optimism, physical and spiritual resurrection, and national restoration.

One of Judah's punishments includes the scattering of their bones around their places of idolatry: "And I will lay all the carcasses of the children of Israel before their idols; and I will scatter your bones round

about your alters" (6:5); "Woe to the city of blood! I will also make the pile great, heaping on the wood, kindling the fire, that the flesh may be consumed; and preparing the mixture that the bones will also be burned; then I will set it empty on the coals..." (24:9–11).

In Ezekiel's consolatory visions, God reverses this terrible fate by regenerating and resurrecting the moribund skeletons of the entire corpus of Israel. These scattered resuscitated bones are returned to the Land of Israel where they belong, reconstituting the people of Israel and reuniting them with the Land of Israel, thereby cementing the eternal inextinguishable bond between the people and the Land.

Specifically, Ezekiel is teletransported to a valley that is filled with bones: "The hand of God was on me, and He carried me out within the spirit/wind of God and placed me in the midst of the valley, and it was full of bones" (37:1). It is likely that this valley contains the very same scattered bones mentioned above (6:5 and 24:10).

"And the bones were *many* on the valley and they were *very* dry" (37:2), that is, they constituted the vast majority of Israel (only a small remnant survived), and they had been dead for a long time. Ezekiel then prophesies to the bones, and God says: "I will lay sinews upon you, and will bring up flesh upon you, and cover you with skin, and put breath in you, and you shall live." This act of re-creation is analogous to the original act of creation, which is completed when God breathes life into Adam's nostrils.

Ezekiel continues: "As I prophesied, there was a noise [*ra'ash*: just like the noise of the fluttering cherubim wings] and behold a commotion, and the bones came together, bone to its bone. And I beheld, and lo, there were sinews upon them, and flesh came up, and skin covered them above; but there was no breath in them."

Ezekiel then prophesied on the breath:

> Come from the four winds [from the four corners of the earth], O wind, and breath upon these slain, that they may live.... And the breath came into them, and they lived, and they stood upon their feet, a very great army. Then He said unto me: Son of man these bones are the whole house of Israel; behold they say our bones are dried

up, and our hope is lost; we are clean cut off. Therefore prophesy
and say unto them: Thus says God: Behold I will open your graves,
and cause you to come up out of your graves, O My people, and I
will bring you into the Land of Israel, and you will know that I am
God.... And I will put My spirit in you, and I will place you in your
own land, and you will know that I am God Who has spoken, and
performed it, says God. (Ezekiel 37:9–14)

This profoundly beautiful consolatory prophecy is visualized at the bottom
of this painting. Twelve skeletons, representing the twelve tribes of Israel,
are illustrated with skin and sinews growing on their bones. They are
illustrated in the process of being elevated by God, Who stands them up
on their feet: "And they lived, and they stood upon their feet, a very great
army" (37:10).

In an analogous manner, God is always standing Ezekiel upon his feet:
"And when He spoke to me a spirit entered me, and it stood me on my
feet" (2:2). This implies that in a sense, each time Ezekiel is having a
vision, his ordinary life is rejuvenated and resuscitated, as his mind stands
on its spiritual feet.

At the bottom of this painting, the twelve resuscitating tribal skeletons
are arising like a phoenix from the two female skeletal corpses beneath
them. These female corpses symbolize the dry dead bones of the nations of
Judah and Israel, the two sister nations, from whose scattered bones these
twelve skeletons are reconstructed.

Oholah, the female corpse on the right, represents Israel and its capital
Samaria (written in Hebrew on her thigh and calf). Oholibah, the female
corpse on the left, represents Judah and its capital Jerusalem (written in
Hebrew on her thigh and calf). *Ohel* in Hebrew means "tent." This is a
direct reference to Jacob and is in fact a synonym for Jacob (Israel), who
was referred to as a man "who dwells in tents," meaning he is learned, in
contradistinction to Esau, who is a "man of the hunt."

Jacob (Israel) was divided into two nations after the end of Solomon's
reign: Israel (North) and Judah (South). The Hebrew root of the word *leba*
is L-B which means "heart" or "flame"; hence *leba* means "beloved."
Oholibah, Judah, is the most beloved nation because it is David's nation,

and in its territory resides the capital of Jerusalem and the Temple. Oholah and Oholibah are analogous to Jacob's (Israel's) two wives, Leah (the older, less-loved sister bride) and Rachel (the younger, most-loved sister bride). The symbolism of Oholah and Oholibah as described by Ezekiel will be discussed in greater detail below.

In this painting, the regenerating, resuscitating, resurrecting twelve skeleton tribes of Israel are sprouting in the valley against the backdrop of the mountain ranges of Israel. The text quoted above (37:11–13) describing this phenomenon is written in red letters on the mountains of Israel from right to left.

Each tribe is represented by their totem animal/blessing that Jacob-Israel blessed them with on his deathbed. The tribes and their totemic identifications from right to left of this painting are the following: 1) Dan: snake, 2) Asher: olive tree, 3) Naphtali: hind or deer, 4) Manasseh: grape vine, 5) Ephraim: grape vine, 6) Reuben: unsteady waters, 7) Judah: lion, 8) Benjamin: wolf, 9) Simeon: sword (violent), 10) Issachar: donkey, 11) Zebulun: mariner, and 12) Gad: soldier.

The bottom portion of this painting gives an aerial global view of Israel from a very high altitude. Illustrated on the western edge of the world is the Mediterranean Sea as it curves with the global edge. The right of this painting is north, the left is south. The Mediterranean is located toward the west. A black arrow pointing to the Hebrew letter tzadik for *Tzafon*, "North," is illustrated beneath Oholibah's knees on the left, providing cartographic directional orientation. The north pointing arrow is pointing to the right.

The names of each of the twelve tribes are written in black letters on their respective pelvic bones. The tribe of Levi is not included in the twelve tribes because they do not have their own designated land. They were dispersed in Israel, but in Ezekiel's vision they reside predominantly around the Temple area in Jerusalem. They are symbolized by their blessing kohanic hands extending above the open roof of the cuboidal Temple, which is illustrated on the bottom left of this painting. The name Levi is written in Hebrew on these hands.

The king of Israel (of the united tribes of Judah and Israel) who lives in Jerusalem adjacent to the Temple is illustrated above the Temple sitting

on his throne. The word *prince* is written in Hebrew on his torso.

Immediately after Ezekiel prophesies over the dry bones, he has an analogous prophecy regarding the reunification of Judah and Israel and their restoration as a single nation.

He is told to take two trees (*etzim*). On one tree he inscribes: "For Judah and for the children of Israel his friends," and on the second tree he inscribes: "For Joseph, tree of Ephraim, and the entire house of Israel his friends" (37:16). He is then instructed to "join them one to the other into one tree, and they shall be one in your hands" (37:17). God then explains: "I will take the children of Israel from among the nations that they were in, and I will assemble them from around and I will bring them to their land. I will make them into one nation in the land, in the hills of Israel, and they will have one king for all of them, and they will no longer be two nations, and they will no longer be divided into two kingdoms anymore" (37:21–22).

This prophecy is visually portrayed in the middle center of this painting. The two trees are being physically united by the flying Ezekiel's superhuman arms and hands: "And they shall be one in your hands." This prophecy is visually fused in this painting with the dry bones prophecy. The resuscitating bones are fused with individualized tribal roots of these two trees. The tree on the right constitutes the Kingdom of Israel, and its dangling upper roots are composed of the right and left arms of each of its six tribes: Dan, Asher, Naphtali, Manasseh, Ephraim, and Reuben (right to left).

The tree on the left constitutes the Kingdom of Judah, composed of their collective constituent six tribal upper roots (arms); this kingdom includes the tribes: Judah, Benjamin, Simeon, Issachar, Zebulun, and Gad (right to left). The geographic localization of these tribes represents a totally new tribal reorganization within the Northern and Southern Kingdoms, which will be described in detail below.

In this painting, all of the twelve tribal skeleton arm bones are morphing into upper tree roots. In both left and right trees, the twelve arms of each of its constituent six tribes coalesce as they enter each tree trunk to create a unified, ascending, centrally located large arm bone being nourished by blood-filled resuscitating red capillaries. Both left and right arms terminate

with the formation of a hand at the top of the tree.

The two hands together, one from the left tree and the other from the right tree, symbolically constitute the left and right arms, which emanate from a now single unified tree trunk – a single human torso from which branch out left and right arms, symbolizing a single reconstituted nation, i.e., a resurrected single body. This prophecy is thus extremely metaphorically similar to the valley of the dead bones prophecy symbolizing both resurrection of Israel and national restoration and reunification.

In this painting, these two trees, as they unite, simultaneously create Ezekiel's large facial mosaic nose. Each tree terminates in multiple branches with multiple sprouting leaves (symbolizing rejuvenation), which curve and arch around Ezekiel's face-mosaic left and right eyes, forming his eyebrows.

Written in blue letters on the tree to the right is "For Joseph, tree of Ephraim, and the entire house of Israel his friends." Written on the tree to the left are the words: "For Judah and for the children of Israel his friends." Bridging the two trees forming the bridge of Ezekiel's nose are the Hebrew words: "And they shall be one in your hands."

This painting also gives the impression that the tribal skeletons are being pulled up by their roots/bones by the flying all-powerful Ezekiel. The explanatory text of this prophecy is written in red letters on the mountains of Israel from right to left at the bottom of the painting (37:20).

The juxtaposition of Ezekiel's valley of the bones prophecy and that of the unification of two trees implies a visual association between ordinary resurrection found in nature and the extraordinary resurrection of man. He compares the tree branches in nature with the tree branch-like fossils of man. After winter, during spring, dead trees naturally sprout leaves. In Ezekiel's prophecy dead bones (human tree branches) miraculously sprout skin and muscles, which are man's natural exterior (leaf-like) covering. When the skin and muscles decompose, all that is left are the decaying dead branches of bone.

Suspended on the bottom of this painting, geographically situated within Israel's dry mountainous topography from left to right (south to north), are the three bodies of water: the Salt (Dead) Sea (on the Temple's left); the Kinneret (Sea of Galilee; in between the Asher and Naphtali

skeletons); and Lake Huleh (in between Asher and Dan skeletons). The major body of water on the west is the Great Sea (Mediterranean Sea).

Let us now focus in detail on the symbolism of Oholah and Oholibah at the bottom right and left of this painting. One of the many sins that Israel is guilty of is "straying" after other gods with their hearts and minds. The Hebrew word for "straying" is *zenut* (root word *zonah*: Z-N-H), as stated: "And the surviving escapees shall remember Me amongst the nations where they are captives, how I have been anguished with their straying heart (*libam hazoneh*), which has departed from Me, and with their eyes that stray (*hazonot*) after idols…" (6:9).

Ezekiel plays with the double meaning of *zonah,* which not only means "stray" (verb) but also means "whore" (noun). A whore is typically (at least biblically) someone who "strays" from the straight path, and causes others to "stray." Ezekiel applies this concept to the behavior of Israel and Judah. Because these two nations have "strayed" he compares them to, and labels them as, sister whores, Oholah and Oholibah.

Israel and Judah are not only younger and older genetic sisters, they are also sister brides married to a single bridegroom, God. After their matrimony, they each become disloyal, by not only committing adultery with one lover, but indiscriminately with many lovers, for money – these two sisters in both blood and matrimony are now also ignominious sisters in whoredom.

In Ezekiel's initial metaphoric description of God's love for His people, he sensuously portrays Israel as God's Lolita bride. This portrait is written with such explicit eroticism that it would make the author of the Song of Songs blush. This again illustrates Ezekiel's heightened brain activity, including his archaic limbic system. There is a midrash that hypothesizes that Ezekiel (like Jeremiah) is a descendant of Joshua and his wife, Rachav, who previously had been a prostitute in Jericho. It is possible that this speculative family background may have subconsciously influenced this selective, possibly submerged, symbolism.

In his own words:

> On the day that you were born your umbilical cord was not cut, neither were you washed in water for cleansing; you were neither

salted nor swaddled. No eye pitied you to do any of these to you, to have compassion upon you, but you were cast out in an open field, in the loathsomeness of your life, on the day of your birth.

And when I passed over you and saw you wallowing in your own blood, I told you, "In your blood, live." I caused you to increase like the blossoms of the field, and you increased and grew up, and became beautiful. Your breasts formed [reached puberty], and your hair [pubescent] sprouted, and you were naked and bare.

And I passed over you and I saw you, and behold your time was the time of love, and I spread My wings (*kenafi*) upon you and I covered your nakedness, and I swore to you, and I entered [metaphor] a covenant with you, said God, and you became Mine. I then washed you with water, cleansed you of blood, and I anointed you with oil....

But you trusted in your beauty and you prostituted (*vatizni*) your name, and you poured out your harlotry (*taznutayich*) on everyone that passed by.... Moreover you took the sons and daughters that you had borne to Me and you sacrificed them to be eaten, and this is the least of your harlotries. You slaughtered My sons...and throughout all these abominations and harlotries you never remembered the days of your youth when you were naked and bare and wallowing in your own blood....

How weak is your heart, says God, that you do all these things, the actions of a wanton harlot (*zonah*).... The wife that commits adultery, that takes strangers instead of your husband.... Therefore harlot (*zonah*), hear the word of God...." (Ezekiel 16:4–35)

What an explicit erotic description of Israel's relationship with God. God finds the female infant, Israel, He watches her grow up, and when she reaches puberty, He spreads His wings upon her, and marries her by consummating the sexual relationship. He fathers her children. She cares nothing for her husband, God, and sleeps with others, and cares even less for their children, who she sacrifices and slaughters. God is the Nabakovian male groom, and Israel is his Lolita child bride who doubly betrays both

her status as adopted daughter and lawfully wedded wife. The sexual explicitness is again evidence of Ezekiel's hyper-activated brain. Isaiah and Hosea also compared Israel to God's wife, but not as explicitly.

This topic is too interesting for Ezekiel to veer from. He returns to this analogy and analyzes it further, clarifying and expanding upon the metaphor.

> And the word of God said to me: Son of man, there were two women, daughters of a single mother. They committed harlotry (*vatiznena*) in Egypt in their youth. There they were beaten, and their virgin breasts were bruised. And their names were Oholah, the elder one, and Oholibah her sister, and they became Mine and they [both] bore Me sons and daughters. Their names: Samaria (Israel) is Oholah and Jerusalem (Judah) is Oholibah.

> And Oholah whored around beneath Me and she doted on her lovers, on the Assyrians...and she bestowed her harlotries upon them, the choicest men of Assyria.... Neither has she left her harlotries brought from Egypt; for in her youth they lay with her, and they bruised her virgin breasts, and they poured out their lust into her.... Wherefore I delivered her into the hands of her lovers, into the hands of the Assyrians upon whom she doted. These uncovered her nakedness; they took her, her sons and her daughters, and slew her by the sword....

> And her sister Oholibah saw this, yet was more corrupt in her doting than her, and in her harlotries more than her sister. She doted upon the Assyrians, governors and rulers, warriors, horsemen riding upon horses, all of them handsome young men.... And I saw she was defiled...and she increased her harlotries...and the Babylonians came to her in the bed of love, and they defiled her with their lust, and she was polluted with them, and her life was alienated from them. So she uncovered her harlotries and uncovered her nakedness, and My soul was alienated from her like it was alienated from her sister....

> Yet she multiplied her harlotries, remembering the days of her youth,

wherein she had played the harlot in the land of Egypt… Therefore Oholibah, thus says God: I will raise up your lovers against you from whom your soul is alienated and I will bring them against you on every side. The Babylonians, and all the Caldeans, Pekod, Shoa, and Koa, and all the Assyrians with them, handsome young men…and they will come against you with armies, chariots, and wheels and with assembly of peoples…and I will set My jealousy against you, and they will deal with you in fury, they will take away your nose and ears, and your residue will fall by sword, they will take your sons and your daughters and your residue will be devoured by fire. They will strip you of your clothes and take away your fair jewels. This is how I will make lewdness to cease from you, and your harlotry brought from the land of Egypt so that you will not lift up your eyes toward them, nor remember Egypt any more…

Thus says God: You will drink of your sister's cup which is deep and large. You will be for a scorn and derision; it is filled to the brim. You will be filled with drunkenness and sorrow with the cup of astonishment, with the cup of your sister Samaria…says God. Because you have forgotten Me and cast Me behind your back, therefore you will bear your lewdness and your harlotries…. Still they commit harlotries with her; for everyone went into her, as men go into a harlot so they went into Oholah and Oholibah, the lewd women…they are adulteresses and blood is in their hands….

For thus says God: an assembly will be brought up against them and they will be made a horror and a spoil. And the assembly will stone them with stones, and dispatch them with their swords, their sons and daughter will be murdered and their houses will be burned down by fire" (Ezekiel 23:1–48)

Presumably after their houses are burned down, their charred bones and residue will be scattered throughout the land. Hence Oholah is on the bottom right of this painting encompassing the breadth of Northern Israel, and Oholibah is on the bottom left encompassing the land of Judah. It is from the dead *zonah* skeleton bones of Oholah and Oholibah that the

roots of the twelve tribes of Judah and Israel are re-sprouting. Flowing into and nourishing these twelve tribal skeletons is blood and nutrients derived from the fossilized bodies of Oholah and Oholibah, delivered via branched umbilical-like roots. The twelve tribes are thus like seeds planted in the ground. They blossom into a fertilized leafy tree with the fertilizing ashes of Oholah and Oholibah.

The red-colored Oholah and Oholibah in this painting constitute Ezekiel's face mosaic mouth. Red symbolizes both these women nations' red bloody deaths and scarlet red whoredom. Ruby red is also the color of Ezekiel's lips.

In a later mind journey, the hand of God brings Ezekiel from Babylon back to Israel, and places him on a very high mountain where he can discern the foundation or construction of a city in the south (Negev) (40:2). He is shown this vision explicitly to report back to the people of Israel. There he meets a man who has the appearance of brass (just like a cherub) with a line of flax in his hand and a measuring reed (40:3). This man tells him to see with his eyes, and to hear with his ears, and to place his heart upon all that is shown to him so that he can accurately report back to Israel what their glorious future will be.

Ezekiel is then given precise details of the dimensions of the newly reconstructed Temple and surrounding areas, as well as the number of stairs and gates, and sundry dimensions of all Temple-associated objects, yards, courtyards, etc. The majority of these measurements are in cubits. These measurements constitute another mathematical mind portal that links the arithmetic dimensions of heaven and earth. This is analogous to Ezekiel's original vision of the cherubim, which employs arithmetic and exponential progressions to stretch his mind to infinity and beyond.

The following cubit numbers mentioned in the text are here arranged arithmetically (not in the order of the text):

0.5, 1, 2, 3, 4, 5, 6, 7, 8, 10, 11, 12, 14, 20, 25, 33, 50, 60, 70, 90, 100, 1,000, 4,500, 5,000, 18,000, 20,000, and 25,000 (chapters 40–48)

This arithmetic progression expands from less than one (0.5), to single digits, to multiple digits, to hundreds, to thousands, to tens of thousands, etc.

Whether these dimensions are real or imagined, this series of numbers

constitutes yet another mathematical portal enabling Ezekiel to access his prophetic teletransportation.

During this mind trip, Ezekiel also sees a completely new and altered apportioning of the tribal land allotments within the geographic boundaries of Israel. Each tribe is to be allotted horizontal swaths of territory apportioned vertically from north to south. Each swath spans the entire east-west expanse.

Compare the tribal land allotment of Ezekiel's vision to the original tribal allotment, below:

Ezekiel's new tribal allotment, from north to south:

– North –

Dan

Asher

Naphtali

Manasseh

Ephraim

Reuben

Judah

– West – (King and Levites and Temple) – East –

Benjamin

Simeon

Issachar

Zebulun

Gad

– South –

Furthermore, the following gates of Jerusalem are inscribed with the names of the following tribes:

Northern gate:

Reuben, Judah, and Levi

Western gate: Eastern gate:

Simeon, Issachar, and Joseph (Ephraim and Manasseh),

Zebulun Benjamin, and Dan

Southern gate:

Gad, Asher, and Naphtali

Tribal allotment upon Joshua's conquest of Israel from north to south, and from east to west, is as follows:

– North –

– West – – East –

Asher Naphtali

Zebulon Issachar

Manasseh Manasseh

Dan Ephraim Gad

Benjamin

Judah Reuben

Simeon

– South –

Ezekiel not only envisions the resurrection of Judah and Israel, and their reunification under one restored Davidic monarch as in the days of old, he also successfully analyzes the root cause of their post-Solomonic rupture, and creates a reunification solution by envisioning a geographic reshuffling of the tribal allotments via land redistribution and population exchanges.

Note that the tribes from the north, such as Zebulun and Issachar under Joshua's allotment, are moved south from Israel into Judah under Ezekiel's allotment. This represents an exchange of tribal lands between

the kingdoms of Judah and Israel. There are also population exchanges within the Kingdom of Judah. For example, going from north to south under Joshua's allotment are the tribes Benjamin, Judah, and Simeon. Under Ezekiel's allotment from north to south the allotment is Judah, Benjamin, and Simeon.

Furthermore, the Jerusalem gate (north, south, east, and west) inscriptions of the tribal names around Jerusalem reflect yet another reshuffling of tribal geographic location, and differs entirely from Joshua's and Ezekiel's previous tribal allotment. Hence, Ezekiel is implying that the old tribal alliances based on their geographic associations created alliances that ultimately led to sharp political divisions, which led to the splintering of Judah and Israel.

By reshuffling the deck, old alliances are broken, and new alliances are created. Northern and Southern Kingdom populations intermesh and assimilate into each other creating true unification of the entire people. Ezekiel is providing real-world political and demographic plans on the methods necessary to actualize national unity. Camouflaging his ideas in a mystical prophecy gives his plans a divine imprimatur.

The Temple and surrounding courtyard space are metaphorically illustrated as a cube at the bottom of this painting in between the Judah and Benjamin skeletons. Painted on the walls of the Temple are images of the two-faced cherubim facing palm trees. Each cherub has two faces: one face is a young lion (*kefir*) and the other face is a cherub. Inscribed on the Temple within the palm trees in Hebrew are the words "God is there" as stated in the very last words of the book: "And the name of the city from that day shall be 'God is there'" (48:35).

Levitical hands are extended above the Temple rooftop. These hands represent the tribe of Levi, who live around the Temple, and specifically the Levites who are the descendants of the levitical Tzadok family branch, the righteous Levites who never sinned or deviated from their mission (44:15). These Levites are appropriately named. *Tzadok* in Hebrew means "righteous."

In this painting, a single monarch who governs over the united tribes and is a descendant of David is portrayed suspended in space above the Temple. His throned abode is also in the Temple vicinity.

During Ezekiel's mind trip to Jerusalem, when he envisions the new Temple, he once again sees the image of God that he had previously seen over the river Khabur: "And behold, the glory of God of Israel came from the way of the east, and his voice was like the sound of many waters, and the earth did shine with His glory. And the appearance of the vision which I saw was like the vision that I saw when I came to destroy the city, and the visions were like the visions that I saw by the river of Khabur, and I fell upon my face" (43:2–4).

This highlights that the projected destination of God's and the cherubim's journey to earth is the Temple in Jerusalem. Illustrated on the mid-right of this painting is a holographic-like projected trajectory of God and the cherubim navigating toward and into the Temple. This rainbow-blue-colored light beam path is the channel or wormhole whereby the cherubim and God enter the Temple. Each of the four cherubim will occupy one of the four corners of the Temple and will fill the entire Temple with God's glory. This very same trajectory is used for lift-off and ascent from the Temple to heaven. This light-beam path forms the lateral aspect of Ezekiel's face mosaic on the left.

In this painting, an almost parallel and opposite beam of light is channeled through the Levitical blessing hands, which emanate from the middle of the Temple, and is being projected heavenwards. This divine light force, together with the tornado wind beneath Ezekiel's feet, propels him upward. This beam forms the right aspect of Ezekiel's mosaic face.

In this painting, multiple obliquely orienting galaxies bordering these beams of light on the left and the right are being pushed aside as the heavens open up for God's speeding chariot, which bursts through the gates of heaven, displacing natural space and time along with the ordinary laws of physics.

Situated to the left of the Temple in this painting is the mysterious brass man, illustrated with one eye, who is busy measuring the dimensions of Temple's foundation and its surrounding gates and courtyards (40:3).

Also illustrated in this painting is fresh, healthy water gushing out of the right side of the Temple, nourishing the Land of Israel. Fertile schools of red fish swim in this water, as stated:

He brought me back into the door of the house, and behold waters gushed out from under the threshold of the house eastward, and the waters came down from under.... Now upon my return, behold upon the river bank there were very many trees on this side and the other. Then he said to me: "These waters gush out toward the eastern region and will descend into the *aravah*, and when they will enter into the sea, into the sea of putrid waters, the waters will be healed. And it will be that every living creature which swarms to wherever the river will come, will live, and there will be many fish because these waters came there, and all things wherever the river comes will be healed." (Ezekiel 47:1, 7–9)

The palm trees illustrated on the Temple walls of this painting represent the many trees on the different banks of the river discussed in the text.

Ezekiel is most certainly a great prophet who perfectly fits the description outlined in Deuteronomy: "I will raise them a prophet from among their brethren like you, and I will put My words in his mouth, and he will speak unto them all that I will command him" (Deut. 18:18). That he is a great mystic, there cannot be any doubt. But what can we extract from the text about who Ezekiel, the flesh-and-blood human being, was, and what his real-life experiences were that transformed him and informed his mystical journeys?

He appears to be a man who lived a typical, comfortable life until he was forcefully ejected from his home, evicted from his land, and exiled to a foreign country. He most likely witnessed with his own eyes the fiery destruction of the Temple where he served as a loyal priest. He watched helplessly as Judah recapitulated the same fate meted out to Israel by the Assyrians.

The once fertile and beautiful lands of Israel and Judah of his youth were now nothing but a desolate heap of ashes. Piles of decaying corpses draped the landscape as far as the human eye could see. Those who barely escaped and managed to survive the Babylonian catastrophe (*shoah*) were hungry, ill, weak, desperate, and dispirited. All of them lost spouses, children, and other close relatives in this cataclysm.

The Temple, a major source of comfort and consolation, is no longer. Routine communication with God is therefore cut off. In Babylon, Ezekiel and his fellow Judeans live as a subjugated minority, and are viewed with a mixture of suspicion and contempt. Ezekiel, formerly a priest, is officially unemployed sans Temple. These are the cold hard facts, not a mystical vision. This is the nightmare of Ezekiel's new reality. With such few survivors, the physical continuity of the Jewish people and of the Jewish religion is questionable at best. It appears to Ezekiel that his generation quite possibly constitutes the last dying gasp of Judaism.

As Ezekiel grapples with the meaning of this loss, he simultaneously begins planning how to practically resuscitate his people, how to instill hope in their hearts and convince them that their lot is only temporary. For Judaism to survive, he has to convince them that they will return to Israel, that the Temple will be rebuilt, and that their monarchy will be restored.

They must and will return to the height of their spiritual and political power as in the days of David and Solomon. They will anoint one king who will rule over all twelve tribes. This reunification will grant them the military power to defend against any future invaders. No longer will they be split into two peoples and engage in petty internal civil wars that gnaw away at their broken pieces. This old politics is what allowed them to be chewed off by foreign invaders piece by piece to begin with.

Ezekiel begins to dream himself out of this nightmare. He envisions the future, how things ought to be, how they will be. But before doing so he comes to understand and fathom the root causes of the catastrophe that befell his people. He will not accept that the end is near (7:2 and 7:5). How can it be? These are the people who stood at Sinai, who miraculously came out of Egypt, transformed the Land of Israel, built a Temple, professed a rich and complex religion, and constructed a vibrant culture.

Based on everything Ezekiel was ever taught, he understood that good things only happen to good people and bad things only happen to bad people. When sins are committed, a multiplicity of ritualistic sacrifices are proffered to acknowledge remorse and prevent their repetition, and to ensure that good things happen in the future.

Thus Ezekiel takes an account and enumerates all his people's sins that led to God's justifiable anger and their just punishment. This was all in the

past. But now, how do they express remorse in the absence of the Temple, in a foreign land, in order to wash away their sins? How, in all practicality, can they live? "Now, son of man, tell the house of Israel, "You have said, 'Our errors and our sins are upon us and we pine away in them, and how will be able to live?'" Tell them: As I live, says God, I have no pleasure in the death of the evil person, but if he turns his way from evil, he will live. Return, return from your evil ways, and why should the house of Israel die?" (33:10–11).

In exile, the Temple is not a necessity for communicating with God: "Tell them: Thus says God: Although I have placed them far away amongst the nations [exiled them], and although I have scattered them amongst many lands, I will be for them a 'miniature temple' (*mikdash me'at*) in all the lands that they dwell in. Thus say, this is what God said: I will gather you from the nations and collect you from the lands in which you are dispersed and I will give you the Land of Israel" (11:16–18).

Thus Ezekiel tells Israel to ask forgiveness of God, and to simply turn away from evil and do good. Temple sacrifices in exile are not the theological be-all and end-all. Return to God with good actions and good intentions. Wherever you go, God is in your hearts and mind, and is your "small temple," your *mikdash me'at*. Rabbis interpreted these words to literally mean "small temples," which was the basis for erecting "synagogues," which in Greek means "gathering places." Other Abrahamaic faiths borrowed this concept and built churches and mosques, their small temples.

Ezekiel crystallizes and summarizes the essence of the Jewish question circa the sixth century BCE: Catastrophe was visited upon us because we were evil. Turn away from evil, and God will forgive us. Practically speaking, you can do this with good actions in the absence of good sacrifices, and hence you don't need the Temple in exile. Although upon return to Israel, a new and improved Temple will be rebuilt.

Most importantly, Ezekiel counsels Israel not to lose hope, because in his mind he just traveled to the future and that future is breathtaking and glorious. In his mind, the slaughtered of Israel and Judah arise from the dust, and will soon join up with the returning exiles of both Judah and Israel, where they will cohabit in the rebuilt Land of Israel under a unified

restored monarchy. Their tribal allocations will be reshuffled, populations will be transferred, and the peoples will intermingle and assimilate into each other. There will be no more civil war.

The Temple will be rebuilt without a doubt. Not only that, but the measurements have already been calculated and submitted, and the architectural plans are already drawn up. Just do not lose sight of these facts, and do not wallow in your own self-pity. The time for wallowing (the fifth year of the captivity of King Jehoiachin; 1:2) is over. It is time to get practical.

Therefore, the mystical brass man drawing the architectural Temple plans instructs Ezekiel: "Son of man, see with your eyes and hear with your ears and concentrate fully on all I say; place your heart on everything that I am about to show you, because I brought you here in order to show you, and tell everything you see to the house of Israel" (40:3–5).

The ultimate point of Ezekiel's visions is to demonstrate to Israel in their darkest hour that they should not now or ever give up hope. Even though this is the time of their greatest despair, when they think they are lost as a people and adrift without God and without Temple, they should know that if Ezekiel sees a future rebuilt Temple in his mind, they should see the same. They should have confidence that his vision will undoubtedly, ultimately, be transformed into reality.

Thus even though Ezekiel was a powerful mystic and a prophet, more importantly and practically, he was a post-exilic political leader. With his visions he planted the seeds of hope, redemption, and restoration within Israel. His visions had to be powerful and colorful to emotionally engage, impact, and mobilize the people into action. They were, and they did.

Isaiah set out to accomplish very similar goals with his stirring poetry:

> For God has called you as a wife forsaken and grieved in spirit; and a wife of youth, can she be rejected? says God. For a small moment I have forsaken you; but with great compassion will I gather you. In a little wrath I hid my face from you for a moment; but with everlasting kindness will I have compassion on you, says God the redeemer.... For the mountains may depart, and the hills be removed; but my kindness will not depart from you, neither will My covenant

of peace be removed, says the God Who has compassion on you. (Isaiah 54:6–10)

It is only because of prophets like Ezekiel and Isaiah that Israel reevaluated itself ethically and morally, and never, ever lost hope of returning to Israel and rebuilding the Temple. It is because of Ezekiel's and Isaiah's (and other prophets') influence that when Cyrus invited the Jews to return to Israel and rebuild the Temple, there were practicing Jews left who heard that call and who were waiting to pounce on that opportunity.

Thanks to Ezekiel and other prophets like him, the people of Israel never lost hope, and for the most part, they never assimilated into their surrounding alien culture. They internalized Ezekiel's visions and made them their own. They built small temples and carried God with them in the temples of their minds. Ultimately, over the next millennium, they constructed the most intricate and exquisite Temple to God with words, not walls: the Babylonian Talmud, which is even more complex and detailed than all of Ezekiel's visions put together, and like sapphires and diamonds reflect the mind and glory of God. Ezekiel quite literally provided the exiled Jews with a renewed theological, communal, and political foundation for their continuity in strange lands – not only for one or two generations after him, but for millennia of painful Jewish exile after the destruction of the Second Temple.

His honey-soaked prophecies foretelling the ingathering of exiles returning to the Land of Israel resonated with Jews throughout their many millennia of exile, ultimately reaching Theodore Herzl's ears in the nineteenth century – he who begat visions of renewal and spoke of the return to Zion by saying: "If you will it, it is not a dream." It is Ezekiel who first dreamt it, and it is the collective unified spirit of the people who willed it time and time again. Recurrent dreams of Zion, which once upon a time lived only in between Ezekiel's ears, recurrently turned into recurrent realities.

Ezekiel the mystical dreamer, who moonlighted as an accidental politician, peers out at us through the prism of time and space, as his eyes light up this painting's canvas.

Elements of some of Ezekiel's prophecies, which are read in the Haftarahs of the major holidays, are also included in the paintings *Sukkoth*, 2004; *Passover*, 2004; and *Shavuot*, 2004 (www.NahumHaLevi.com).

Notes

A) Sample references of Ezekiel's heightened senses:

I) Vision:

 1) And I saw, and behold a stormy wind came from the North (1:4).

 2) And I saw as the color of electrum (1:27).

 3) This had the appearance of the bow that is in the cloud on the day of the rain, so was the appearance of the brightness round about. This was the appearance of the likeness of the glory of God (1:27–28).

 4) I appointed you as a watchman for the house of Israel (3:17).

II) Hearing:

 1) And I heard the voice of their wings like the voice of many waters, like the voice of Shaddai, and when they went like the voice of a tumult like the voice of a camp, when they stood their wings descended. And there was a voice from above the sky on top of their heads (1:24–25).

 2) And I heard a voice speak (1:28).

 3) And I heard that which spoke to me (2:2).

 4) And you, son of man, hear [listen to] that which I speak to you [present tense] (2:8).

 5) Everything that I speak to you take into your heart, and with your ears hear [listen] (3:10).

 6) I have appointed you a watchman (3:17).

 7) Then he called in my ears in a loud voice saying… (9:1).

 8) As for the wheels they were called within my ears *galgal*, the wheelwork (10:13).

 9) And His voice was like the voice of many waters and the earth shone from His glory (43:2).

 10) Son of man, place your heart and see with your eyes, and with your ears hear and all the things I tell you (44:5).

III) Taste and Gastronomic:

 1) Open your mouth and eat that which I give you (2:8).

 2) And He said to me, son of man, your stomach will eat, and your intestines will be filled with this scroll that I give you. I then ate it and it was like honey for sweetness in my mouth (3:1).

3) And the food that you eat shall be by weight twenty shekels a day, from time to time you shall eat it (4:10).

IV) Touch:

 1) And upon him there was the hand of God (1:3).

 2) And behold a hand was put forth to me (2:9).

 3) And the hand of God was upon me very strongly (3:14).

 4) And the hand of God was upon me there (3:22).

 5) And the hand of God fell upon me there (8:1).

 6) And on this day the hand of God was upon me and brought me there (40:1).

V) Olfaction:

 1) And a thick cloud of incense went up (8:11).

 2) They put the branch to their nose (8:17).

VI) Sensual:

 1) Chapter 16.

 2) Chapter 23.

VII) Extrasensory out-of-body ascent elevation/transportation:

 1) And a spirit [wind] entered me, and stood me up upon my feet, and I heard that which He spoke to me (2:2).

 2) Then a wind [spirit] lifted me up [and transported me] and I heard behind me a very loud noise [voice]: Bless the glory of God from His place (3:12).

 3) And a wind/spirit entered me and stood me upon my feet, spoke to me and said: Go shut yourself within your house (3:24).

 4) And the form of a hand was put forth, and it took me by a lock of my head, and a wind/spirit transported/elevated me between the earth and heaven and brought me to Jerusalem within the visions of God to the door of the gate of the inner court, that faced the north, where there was the seat of jealousy which provokes jealousy. And behold, there was the glory of the God of Israel, just like the vision that I saw in the valley (8:3–4).

 5) And a wind/spirit lifted me up [transported me] and brought me to Chaldea in the exile in a vision within the spirit /wind of God. And the vision that I saw was lifted from upon me. And I spoke to the exile[d] all the things that God showed me (11:24–25).

 6) In the visions of God he brought me to the Land of Israel and he placed me on a very high mountain (40:2).

B) Sample references about Ezekiel's rotation of head and eyes:

 1) And the word of God said, son of man, place [turn] your face just toward the mountains of Israel and prophesy to them (6:1).

2) Son of man lift [turn] your eyes in the northern direction (8:5).

3) Turn away your faces from all your abominations (14:6).

4) Set [turn] your face to Mount Seir (34:1).

Chazak Chazak Venitchazek
on the three major latter prophets

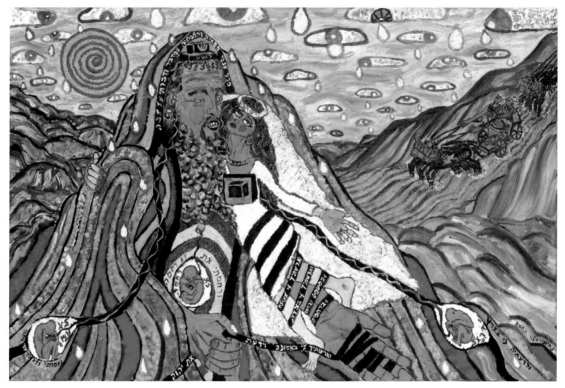
Hoseashtein: 2007/36X24 inches/oil on canvas

The Bride of Hoseashtein: Betrothal and Exile

4

4

This painting is about the prophet Hosea, son of Beeri, and his wife
Gomer, daughter of Diblaim, and their three children, Jezreel, Lo-Ammi,
and Lo-Ruhamma. The couple's marriage as outlined by Hosea himself
is a metaphor for the intense and lopsided relationship between God and
Israel. The book of Hosea is a profoundly sad and tragic poetic work of
admonition that accurately prophesies the absolute end of the Northern
Kingdom of Israel and their defeat by the Assyrians in roughly 735 BCE.
The Israelites are soon to be ignominiously marched off to Assyria, where
and whence they will fade from the crumbling pages of history.

 The frozen memory of their ghostly disappearance will be enshrined
in legend, and mythologically ensconced in the guise of "the ten lost tribes
of Israel." The powerful theological and literary legacy of Israel is now left
in the fragile hands of their not-so-perfect Southern brethren, the Judahites
(Jews), who are themselves steeped in moral decay, and are, and always
will be, one hair's breadth away from imminent extinction, exile, and
divine abandonment, though not necessarily in that order.

 God tells Hosea to marry a prostitute by the name of Gomer. By so
doing Hosea will empathize and personally experience God's suffering
and humiliation wrought by His whoring, cuckolding, adulterous bride,
Israel. God feels much betrayed. He raised and nurtured Israel from
infancy, took her by the hand and taught her how to walk, professed his
deep, unconditional, and unending love, and then chose her as his lawfully

wedded wife. But does Israel remember or care? No. She gallivants off (not only once, mind you) with Baal, that other Semitic, sexy, and loose deity.

Gomer gives birth sequentially to three children, whose names are reflections of God's curses upon them. They have not all necessarily been fathered by Hosea. The first child is a son named "Jezreel" (*Yizra-el*, "God will plant): "For I will break the kingdom of Israel in the valley of Jezreel" (1:4). Gomer then gives birth to a daughter, "Lo-Ruhamma" ("I will not have mercy on her"): "For I will no longer have mercy on Israel or forgive him"(1:6). She then gives birth to another son, "Lo-Ammi" ("Not my nation"): "For you are not My people, and I will not be your God" (1:9).

Based on the analogy above, this painting fuses God and Hosea, and also fuses Hosea's bride, Gomer, and God's bride, Israel. Hosea, which means "savior" in Hebrew, is the huge figure in the center left of the painting. He is the son of "Beeri." The root of this name in Hebrew is "Be'ur or "explanation." Thus Hosea literally is the "clarifier" or "explainer" of God.

Hosea-God in this painting is wearing phylacteries on his head and arm (significance to be discussed below). He is wearing a tallit, a prayer shawl, over his head. His tallit is integrated with and melded into the geometry of the mountain. Hosea is portrayed as an anthropomorphized mountain, as though he is emerging or being birthed from its rocky crevices and crags. The mountain is, of course, God, Who is referred to in scripture as *Tzur* or "Rock" (of salvation). "Rock" translated into Yiddish or German is *shtein*, meaning "stone," hence the title of this painting – the bride of "Hoseashtein," i.e., Hosea-Rock, Hosea-God. The black furrows in the mountain are homologous to the black stripes of the tallit. The letter shin (sh), which stands for "*Shaddai*," God's name, is written in yellow letters on his head phylactery box. Underneath the shin, written in yellow letters, is the name "Hosea."

Two of Hosea's children are being embryologically incubated in the midst of both left and right phylactery straps, which descend from the head phylactery box. Their umbilical cords ascend up to the head phylactery box via these straps and absorb divine knowledge from the words of God inscribed on the box's four inner parchments.

The embryonic son on the right is Jezreel, whose name is written in purple letters within his white amniotic-fluid-filled sac. The embryonic

son on the left is Lo-Ammi, whose name is also written in purple letters on his white amniotic sac. His embryonic daughter, Lo-Ruhamma, is being birthed and nourished within his oceanic heart, and is attached umbilically to his beard. Her name is written in purple letters on her white amniotic sac. They all appear to be dangling precipitously, blowing in the wind, representing the pendulous swaying uncertainty of their ultimate fates. They pointedly receive no spiritual umbilical nourishment from their mother.

To the right of Hosea-God is the fused Gomer-Israel bride decked out in flowing white bridal gown and veil. She is wearing her wedding ring. The name Gomer is written in aqua letters on her gold necklace. The Hebrew word *gomer* means "finished," "complete," or alternatively "done for." She is the daughter of "Diblaim" (1:3). In Hebrew this means "cake of figs" which is usually a symbol for atonement. The name "Israel" is written in blue letters on the headband of her veil.

Alas, despite Israel's unfettered adultery, disloyalty, and brazen acts of prostitution, God's love for her burns eternally, and can never be extinguished no matter how extreme her sins. He may have to punish her, exile her, make her suffer to feel a small part of His hurt, but He will never abandon her. He will be patient and wait for all eternity, if that is what it takes for her to return to Him filled with His knowledge and love. Deep inside He knows that she will acknowledge Him as her one true husband, for God is "God and not man" (11:9).

God, in the book of Hosea, is the ultimate jealous romantic. He knows just how to get His misbehaving bride back from the jaws of Baal. "Behold, I will lure her, and I will lead her into the desert, and I will speak to her heart" (2:16). These words are written in white and yellow letters on God-Hosea's tallit above his head phylactery box. The text then continues, "And on that day, says God , you will call Me 'my husband' (*Ishi*) not 'my Baal'" (2:18). Here the word "Baal" is used as a double entendre meaning both the name of the god Baal and the word used for a subjugating (not loving) husband.

In the painting, God's-Hosea's face is nuzzled against Gomer's-Israel's face, speaking to her heart. Now that he has captured her attention and she has once again fallen under his spell, God whispers to her His romantic

proposal: "And I will betroth thee unto Me forever, and I will betroth thee unto Me in righteousness, and in justice and in kindness and compassion. And I will betroth thee unto Me in faithfulness, and you will know God" (2:21–22). How can she say no to that?

These romantic nuptial promises are written in white on Hosea's-God's arm-strap phylacteries. These very words are uttered every day by practicing Jews upon wrapping the arm phylacteries around their hands and fingers (notably the marital ring finger), committing themselves daily to God. Each wrap and turn is accompanied by an additional parsed betrothal statement from the book of Hosea.

The wrapping of the betrothing phylactery straps symbolizes the marriage – the physical and spiritual unification between God (the physical phylactery boxes and straps, which contain the word/spirit/essence of God) and man's mortal flesh – in particular his head, which contains his thinking brain; his heart; and his arm which swings into action. Thus, in this painting, God is binding his wife, Israel (i.e., unifying with and marrying her) to his arm with his phylactery straps. The same betrothal promises made in the book of Hosea, and repeated every morning while donning tefillin (phylacteries), are also uttered at every Jewish nuptial ceremony. The physical binding of the bride Israel to God is in a sense homologous to the binding of Isaac as an offer to God, and has similar spiritual but substantially less romantic undertones.

God, Who had previously cursed Hosea's children through their names, now reverses these curses by changing their names or the meaning of their names. With respect to Jezreel, God now says, "I will now plant her for Myself in the land" (2:25). In this painting, these words are written in black letters to the right of the Jezreel embryo. With respect to Lo-Ammi, He now says, "And I will say to that no-nation, you are My nation" (2:25). These words are written underneath Lo-Ammi in black letters to the left of the painting. With respect to Lo-Ruhamma He now says, "And I will have compassion on the one without compassion" (2:25). These words are written in blue letters above Lo-Ruhamma in the center of the painting beneath Hosea's beard. God concludes His blessing by then saying, "And he will say this is my God" (2:25). These words are written in red letters in the center of the painting underneath Hosea's beard.

Hosea is the first prophet to eroticize the relationship between God and Israel. What he is saying is that there can be no more powerful and ecstatic expression of spiritual love than one that is sexual in nature, be that between man and woman, or man and God. He has hit the nail on the head from the perspective of brain anatomy and physiology. The seats of heightened religious and sexual ecstasy both lay buried deep in the brain perched side by side within the primitive limbic system, where hypersexual and religious synapses and neurochemicals excite, intermingle, and ignite.

Hosea's divine eroticism directly influenced the mature adult imagery described in the Song of Songs, which is another biblical tract that ranks high on the list of the most powerful and brilliant erotic love poetry ever composed in all of world literature. It too uses the metaphor of the sexual love of man and woman as a metaphor for the love of God and Israel.

This interpretation is taken to supreme heights in Kabbalistic literature, in particular that of Isaac Luria's. Luria imagined five Kabbalistic spheres pairing off into male and female spheres, two being called *abba* (father) and *ima* (mother), and imagined their physical and spiritual conjugation within the heavenly spheres.

In the background right of the painting, Assyrian soldiers with their black, evil horses and chariots are rushing down the hills soon to capture and expel the Northern Kingdom of Israel. Written in yellow letters on the leading horse is "Assyria."

In the background is the mountainous desert terrain where God-Hosea has taken His bride to enchant her with sweet words in order to betroth her. The heavenly clouds with sentient eyes are showering Hosea-God and Gomer-Israel with their doleful tears as they await and witness the coming destruction. Hosea-God protects Gomer-Israel from the rain with His tallit and tefillin, reassuring her that when the Assyrians come and take her away, she need not worry, He will wait for her.

Today, we hear echoes of Hosea's prophecy as the ancient tribes of Manasseh and Ephraim find their way back to their desert betrothal homeland in the twenty-first century, twenty-four hundred years after disappearing from history. Ephraim's beaten figure reemerges in the mist and returns to the loving embrace of her patient husband, as foretold millennia ago by the great prophet Hosea.

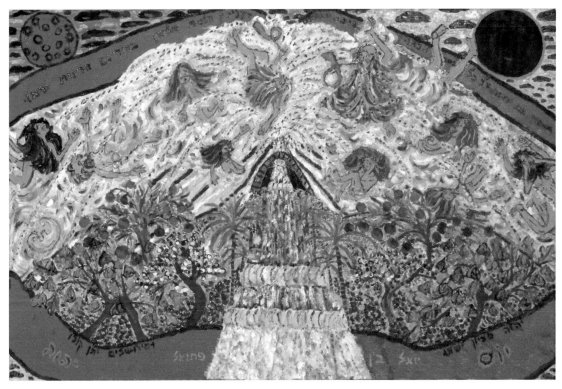

Joel: 2007/36X24 inches/oil on canvas

Joel: Devastation versus Exaltation

5

5

This painting visually interprets the prophecy of Joel, son of Pethuel. His prophecy consists of two polar opposite, hyper-extreme, divinely mandated conditions entirely dependent on Judah's moral choices. In the absence of repentance there will be a state of defeat and exile, accompanied by depressingly unimaginable, absolute devastation and destruction. With repentance there is salvation and an ingathering of exiles accompanied by manically unimaginable, arboreal fertility, agricultural abundance, and spiritual ecstasy (illustrated and visualized in this painting). The choice is entirely in Judah's hands.

Joel begins describing but not specifically naming an invading nation, mighty and without number, that leaves the land so devastated that "whatever the palmer worm hasn't eaten, the locust has, and that which the locust hasn't eaten, the canker worm has, and that which the canker worm has left, the caterpillar has eaten" (1:3). "The field is wasted and the land mourns, for the corn is wasted, the wine is dried up, and the oil languishes" (1:10). "The vine is dried up, the fig tree is bare; the pomegranate tree, the palm tree, the fig tree and the apple tree; even all the trees of the field are withered" (1:12). Most important of all, "Joy is withered from the sons of men" (1:12). "The water of the brooks is dried up" (1:20). "The Day of God is at hand, and as destruction from God it will come" (1:15).

Yet even now, says God, "Turn to Me with all your hearts, with fasting, with crying and with lamentation; and tear your hearts and not your garments" (2:12). It appears from the possibility of repentance that this destructive vision, the Day of God, may not have actually happened,

but easily could. If Judah repents, Joel says, not only can they avert the Day of God; they will experience its polar opposite, God's hyper-extreme munificence.

The historical date of Joel's vision is uncertain and controversial. He does not mention specific kings' names or the name of the devastating army that overtakes Judah. Perhaps this takes place right after Israel's humiliating and well-publicized expulsion by the Assyrians. The real and present danger of impending Assyrian conquest hangs over the Southern Kingdom of Judah like Damocles' sword, unless Judah get their act together and repent.

If they do not repent, Judah need only look north to see what exile looks like, and into Joel's mind to visualize their wretched future fate. If they begin to sincerely repent, blow the shofar in Zion, fast and call a solemn assembly, God will then take pity on His people, and He will shower them with a cornucopia of material and spiritual rewards.

This painting attempts to visualize the key elements of the portion of the prophecy that states, "I will pour out My spirit on all flesh, and your sons and daughters will prophesy. Your old men will dream dreams, and your young will see visions" (3:1). These words are written in black and speckled yellow letters on the upper lips of the all-encompassing fused mouth of Joel-God. The free-associative idea of this vision taking place in an anthropomorphized mouth stems from the text's words describing all of God's gifts. The flowing of water, milk, and wine, the emanation of God's voice from Zion, and the pouring (exhalation) of God's spirit on all flesh, all free associate back to a mouth that projects and articulates sound, and breathes out air or spirit. The pouring of divine spirit on all flesh harks back to God's exhalation of divine breath from His mouth into Adam's and Eve's nostrils.

Illustrated within Joel's-God's mouth are men and women, young and old, being uplifted and somersaulted by God's gentle yet turbulent spirit. Some are holding their hands to their heads, hearing and seeing prophecies that might be too much for an ordinary human to bear. Others stretch out their arms allowing themselves to be bathed by the divine spirit. All their quizzical facial expressions convey the dreaming of dreams, and the surreal visualization of visions. Two men in the upper center of the painting have

shofars, which they have blown or will blow as the prophecy predicts. The embryo on the lower left of the painting illustrates that no living flesh is too young to be instilled with the prophetic spirit.

Illustrated at the center of the painting is a fountain emanating from the mountain-house of God, as stated in the text, "A fountain will come forth from the house of God, and will water the valley of Shitim" (4:18). The upwardly exploding fountain mixes with the heavenly breath, facilitating the anti-gravitational ascent and flotation of the people instilled with God's poured-out spirit. Also illustrated is the visualization of the prophetic words, "The mountains are dropping down sweet wine, the hills are flowing with milk, and all the brooks of Judah are flowing with water" (4:18).

A cascading waterfall is seen streaming downward, emanating from the mountain's cave door entrance (oropharynx), flowing out of his mouth, over his lower lip, and in the process, watering the land, allowing profound fertilization and luxuriant growth of palm trees, apple trees, olive trees, and fig trees – a veritable cornucopia. The vine is full of grapes, and there are plenty of mature olive trees, and hence there is an abundance of wine and oil.

The meaning of the name "Joel" is "great is God." He is the son of "Pethuel" (1:1), which means "God opens," which is precisely what God is doing in this prophecy. He is opening up the wellsprings of His heart with an explosive outpouring of life-giving and saving water and spirit, granting not only the spark of life that He infused into Adam and Eve, and hence all mankind, but in addition He exhales prophetic fervor unto all flesh, which hitherto has been granted to only a few select individuals. In this painting all this is emanating from God's exhaling open mouth. The name Joel ben Pethuel is written in yellow on the mouth's lower lips at the mid-bottom of the painting.

Above and outside the upper lips of the mouth on the upper right is the sun turning into darkness, and on the upper left, the moon turning into blood on the Day of God. The stars, not visualized, have retracted their brightness. Furthermore, God will show the wonders of blood, fire, and pillars of smoke in the sky on the Day of God. This is conveyed in the colors of the surrounding sky.

On the lower lip on both bottom left and right is written "the Day of God" (3:4) in red-orange Hebrew. Written in black on the upper part of the lower lips, left and right, are the words "And God from Zion will roar forth, and from Jerusalem His voice will be uttered" (4:16). The entire inner contents of the Joel-God mouth illustrate Jerusalem, with the mountain (house) of God in its center. The voice of God emanating from Jerusalem is metaphorically implied by this painting.

We may not know the exact historical era that Joel had his vision, but we do know that the entirety of his prophecy, in its manic and depressive extremes, resonates rays of light and shades of darkness throughout the peaks and valleys of Judah's bumpy and tempestuous history.

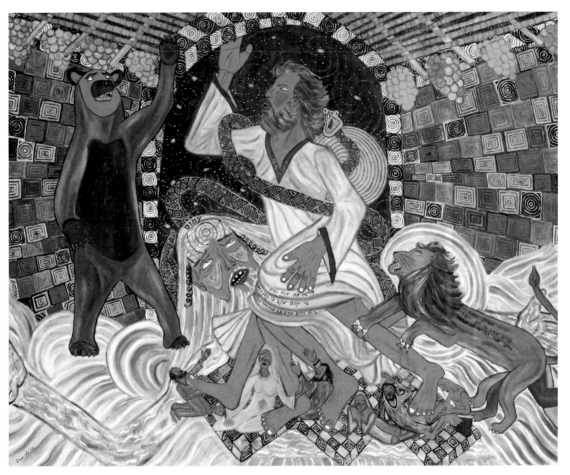

Amos: 2009/64X48 inches/oil on canvas

The Book of Amos: Streaming Social Sentience

6

This painting attempts to visually distill the essence of Amos's powerful prophecies, and his pleas for what is contemporarily called "social justice."

Amos emerged from an agrarian background in Tekoah, Judea, during the eighth century BCE. He prophesied to Israel in approximately 750 BCE during the reigns of King Jeroboam II of Israel and King Uzziah of Judah. He is the older contemporary of the prophets Isaiah and Hosea.

More so than any of the other prophets, the most egregious sin that Amos rails against, and the one that irks both him and God above and beyond Israel's other, lesser concurrent sins of idolatry and the perfunctory performance of rituals divorced from true devotion, is the indiscriminate abuse of the poor and downtrodden. According to Amos, God's retribution for this unforgiveable behavior is the ignoble end of the Kingdom of Israel, and their denigrating exile to Assyria and thence to oblivion.

The central frenzied figure illustrated in this painting, who is garbed in a flowing blue robe, and is seen panting and running, represents the wealthy Kingdom of Israel. He is illustrated with multiple legs, which represent rapid motion in a two-dimensional plane. The reason he is running quickly is discussed below. Underneath each of his feet are beggars: the poor, the weak, the disadvantaged, and the disenfranchised. They are the lowest rung of society living on the edge calling out for help, but are unheard, unseen, ignored, and oppressed. They are the crushed and trampled refuse of a pampered, throw-away society.

This aspect of the painting is based on the text: "They sell the righteous for silver, and the needy for a pair of shoes. They pant after the dust of the

earth on the head of the poor, and turn aside the way of the humble…" (2:6–7). "Hear these words, you cows of Bashan that are in the mountain of Samaria, who oppress the poor, who crush the needy…" (4:1). "For I know how manifold your transgressions are, and how mighty are your sins; you that afflict the just, you that take a ransom and that turn aside the needy at the gate" (5:12).

In this painting, the pleading poor people in the time of Amos are pawns placed on chessboards, moved randomly at will, and pushed over the edge into an abyss: "Hear this, you that swallow the needy, and destroy the poor of the land, asking when will the new moon be gone that we may sell grain, and the Sabbath that we may set forth corn? That we may buy the poor for silver and the needy for a pair of shoes, and sell the refuse of the corn" (8:5–6).

For its iniquities, Israel is to be punished by a cataclysmic and near-fatal seismic event – by the Assyrian empire who will unleash its wrath and leave the Land of Israel desolate and in shambles, and most of her people dead, and the remainder in exile. Amos's metaphor for this crushing punishment is an earthquake. This is a classical biblical measure-for-measure retribution – *midah keneged midah* – vis-à-vis Israel's mistreatment of the poor. In other words, those that crush others will themselves be crushed.

The conceptual underpinning of Amos's prophetic modus operandi was inspired by an actual earthquake (in Hebrew *ra'ash*, literally a "great noise") which occurred two years into the future, and is explicitly introduced in the very first sentence of Amos (1:1). This is further elaborated upon throughout the entire book. The invoked poetic, visual, and auditory earthquake expressions and their sequela are formulated based upon the multiple sensory perceptions of an earthquake that Amos must have experienced firsthand. For Amos there is no greater supernatural representation of God's awesome wrath directed against mankind's evil than an earthquake.

An earthquake is the result of seismic tectonic shifts that cause subterranean tremors, which in turn can topple dwellings while simultaneously emitting a significant vibratory disturbance, perceived in the form of voluminous auditory noise transmitted for quite some distance. In addition, if the epicenter of the earthquake is underneath a

body of water near a coastal shore, it can cause a tsunami, major flooding, and the sinking of cities as well as volcanic eruptions. Thus earthquakes can be felt, seen, and heard. Additional mechanisms of destruction and fatality secondarily induced by earthquakes include fire, thirst, starvation, confrontation with displaced frightened and hungry beasts, and a host of natural diseases.

Some of these divinely directed cataclysmic manifestations are portrayed in this painting. The prophet Amos, who is illustrated to the left of Israel, is looking up and excoriating him. Amos's name is written in purple letters on his forehead. His prophetic powers represent the greatest of all the forces of nature unleashed by God. His forehead is emanating mental concentric prophetic bursts of energy. He is the embodiment of a raging tsunami who is called forth by God to arise from the depths and execute God's will. He is a mighty stream emerging from the deep waters, displacing, undermining, and destroying the rickety and flimsy foundation upon which Israel is treading. Amos here becomes the visual embodiment of the words "And Justice will well up like water, and righteousness like a mighty stream" (5:24).

In this painting, Amos's eruptive actions are causing Israel's house to collapse and ultimately sink into oblivion. This is inspired by the text: "It will rise up wholly like the river, and it will be troubled and sink again like the river of Egypt" (8:8). "For the Lord, the God of Hosts, is He Who toughens the land and it melts, and all that live in it mourn, and it entirely rises up like the river, and sinks again like the river of Egypt. It is He Who builds His upper chambers in heaven and founded His vault on earth, He Who calls to the waters of the sea, and pours them out on the face of the earth; God is His name" (9:5–6).

Also illustrated in this painting are additional secondary earthquake embodiments of the forces of nature, which include marauding, hungry, displaced animals foraging on the day of reckoning, "The Day of God." These animals include a racing lion chasing Israel from right to left, a bear approaching Israel from his left, and a snake wrapping around him from the center, getting ready to bite and poison him. On this ominous day, illustrated in the painting, the sun descends at noontime, and the brightness of day is converted into darkness as would occur during a cataclysmic event.

This imagery is based on the text: "Woe unto you who desire the Day of God (*Yom Hashem*)! What is the Day of God? It is darkness, and not light. It is as if a man fled from a lion, and was confronted by a bear, and then he entered his home, and placed his hand on the wall, and a snake bit him. Won't the Day of God be darkness, and not light, even very dark, without any brightness in it?" (5:18–20). "And they that hide from My sight in the bottom of the sea, I will instruct the snake, and he will bite them" (9:3). "And it will be on that day, says God, that I will bring in the sun at noon, and I will darken the earth on a bright day" (8:9).

Earthquake tremors are alluded to via different metaphors throughout the text. Amos comes from the town of Tekoa (1:1). The root of "Tekoa" is T-K-A, meaning "to blow a great sound" (blast) through a shofar (a trumpet). In essence Amos's prophecy is a roar, just like an earthquake tremor, just like the shofar blast, a *tekiah* on the Day of Atonement. This is a reference to a wake-up call, which sets the tone for the entire book. This is further alluded to by the words, "If a shofar is blasted in the city, won't a nation tremble in fear?" (3:6).

God too roars in the form of an earthquake: "God will come roaring from Zion, and from Jerusalem He will unleash His voice" (1:2). Nature, an extension of God's power, in the form of a lion also announces the earthquake. "Does a lion roar in the forest, and he does not have a prey? …If a lion roars, who does not fear? God speaks, and who does not prophesy?" (3:4, 8). In this painting, these words are written in purple letters on the lion's body.

Illustrated in this painting are the multicolored walls and doorposts of Israel's stately house, which is shaking at its very foundations. Earthquake- and tsunami-induced tremors are represented by the reverberating circles and squares emanating from the house's bricks and stones. As stated in the text, "Behold, I will make it creak under you, just like the cart that is full of sheaves creaks" (2:13). "Behold, God commands, and the larger house will be blasted into splinters, and the small house into chips" (6:11). "Will not the land tremble for this, and everyone who dwells there shall mourn?" (8:8). "I saw God standing by the altar, and He said: 'Strike the capitals that the posts may shake, and smash them into pieces in the head of all of them'" (9:1). "Therefore because you trample on the poor, and take from

him exactions of wheat, you have built houses of hewn stone but you will not live in them, you have planted pleasant vineyards, but you will not drink their wine" (5:11). The grapes illustrated in the painting will fall, and splatter, and will not be enjoyed.

Other secondary earthquake manifestations that are alluded to in Amos include fire, hunger, and thirst: "God showed me, and He called a fight with fire, and it devoured the great deep, and it ate up the land" (7:4). "Behold the days are coming, says God, that I will send a famine in the land, not a famine of bread, and not a thirst for water, but of hearing the words of God" (8:11).

The general oratorical architecture of Amos's prophecies is the structural prototype that will later be reproduced by Isaiah, Hosea, Jeremiah, Joel, and other prophets. In order to induce repentance, Amos baits and switches his captive audience with alternating, lengthy, frightening bursts of *tochachah* (rebuke) and very small doses of *nechamah* (consolation). The book of Amos is roughly 95 percent *tochachah* and 5 percent *nechamah*. This is a carrots-and-stick approach to repentant prophecy, heavy on the stick.

The *tochachah* begins with the title of the book itself, which also happens to be the name of the prophet, "Amos." The meaning of the name Amos is somewhat obscure and controversial. The most common definition is "burdened," derived from the second syllable of Amos, "Mos," meaning he was "burdened by the sins of Israel." However, this terminology doesn't make sense. "Burden" in Hebrew is *masah*, but it is never used again in the text. In contradistinction, the word *masah* is employed repeatedly in Isaiah, and Isaiah is not called Amos.

Most likely the name Amos is a contraction (fusion) of two separate words wherein the first word ends with the Hebrew letter mem (M), and the second word begins with the Hebrew letter mem (M). Two letters of mem (MM) are considered superfluous, and the combined two words are contracted into one by using a single letter mem. Two separate word combinations are the likely etiology of the name Amos:

1) *Am* ("nation") and *ma'os* ("rejected" or "hated"), spelling *Amos*, meaning that Israel is a nation *rejected* and *hated* by God because

of its transgressions. The concept of the rejected and hated nation is corroborated by the text: *al **ma'os**am et Torat Hashem* ("because they have *rejected* God's Torah"; 2:4) and *Saneiti, ma'asti chagechem* ("I despise and *hate* your festivals"; 5:21).

2) *Am* ("nation") and *ot* ("symbol"), spelling *Amos*, meaning that Israel is a *symbolic nation*, and will go down in history as a *symbol*, a cautionary tale of what happens to people who transgress God's will.

The first part of Amos's *tochachah* consists of lumping together the sins of Israel and Judah, and their respective punishments, with those of the surrounding nations of Damascus, Gaza, Tyre, Edom, Ammon, and Moab. This is a great insult. Amos is telling Israel that they have lost any scintilla of special chosen status. Their sins have demoted them to the ordinary, to the unelected. From God's point of view they are to be judged alongside and with all the nations into whom they shall shortly melt.

Amos castigates Israel, telling them that despite all of God's cautionary warnings they still have not returned to God. He pleads with them "to seek God in order to live." These words are written in purple letters next to Amos's mouth in the painting on Israel's lower robe. Amos's pleas are ignored.

After outlining all the terrible punishments God will bestow upon Israel, and after emphatically telling them that God will never change his mind, Amos then proceeds to inform them that upon hearing God's punitive plans, he pleads with God in typical Abrahamic fashion, saying, "Oh Lord, God, please forgive; who will sustain [stand up] Jacob, for he is small?" (7:2). In this painting, these words are also written in purple letters in front of Amos's mouth on Israel's lower blue robe. As a result of Amos's intervention, "God repented concerning this; it will not be, God said" (7:3). After God informs Amos of yet another devastating scenario, Amos repeats the same question: "Oh Lord, God, please stop; who will sustain [stand up] Jacob, for he is small? God repented; this also will not be, God said" (7:5–6).

The *nechamah* (consolation) becomes even sweeter at the end of the book when God announces, "On that day I will raise up (*akim*) David's

fallen sukkah, and close up its breaches, and I will raise up his ruins, and I will build it as in the days of eternity" (9:11). These words are written in purple letters underneath Amos's mouth on Israel's lower robe. The Hebrew word *akim* ("raise up" the house of David, which has fallen), is the answer to Amos's question "Who will raise up Jacob, who is small?" Clearly God answers that He has taken that onus upon Himself.

Illustrated in this painting on either side of the doorposts are bamboos forming the roof (*sechach*) of Israel's house, giving it the appearance of a sukkah. A sukkah is a temporary dwelling (booth) that Jews set up during the holiday of Sukkot. It memorializes and symbolizes the fragile dwellings that Israel lived in during their sojourn in the Sinai Desert. Because of the sukkahs' fragility, their integrity in the face of the unkindly forces of nature is entirely dependent on God's munificence.

Israel's house is portrayed in this painting as being a sukkah despite being built with stones and mortar. This represents the fragility of even Israel's most fortified dwellings at the time of Amos, and in fact of all domiciles throughout history. All people's dwellings, in all places and at all times, no matter how sturdy they are, are really sukkot. No matter how impervious they are, they cannot withstand natural disasters such as earthquakes, tornados, or great floods. Indeed because of Israel's social sins their palaces were transformed into sukkot; "Therefore because you trample on the poor, and take from him exactions of wheat, you have built houses of hewn stone but you will not live in them, you have planted pleasant vineyards, but you will not drink their wine" (5:11). The grandest of castles can instantaneously crumble into dust during a natural catastrophe, such as an earthquake, or a man-made cataclysm, such as the Assyrian invasion – all of which are fated and ordained by God.

The grapes in the painting hanging from the sukkah underneath its *sechach* (roof) are typical vegetation that are hung from sukkot. The grape clusters also symbolize Israel, who is compared to a basket of "summer fruit" (8:1) by Amos.

The universal words of Amos are destined to remain potent and relevant for as long as mankind exists. There will always be rich and poor, haves and have-nots; this is an eternal given. It is ordained by the inherent subtle differences in human DNA and by the Heisenbergian uncertainty

of an individual's personal circumstances, fate, and sheer luck. Amos's eternal message is that any religion, no matter how beautiful and intricate its rituals might be, isn't worth a fig if it abandons its disadvantaged brothers and sisters. Those who abandon the poor today, with a slightly different roll of the dice, may very well find themselves the nouveau poor of tomorrow.

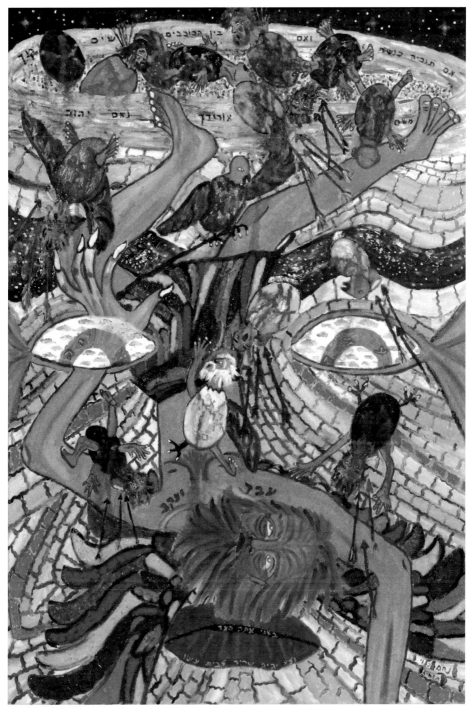

Obadiah: 2007/24X36 inches/oil on canvas

Obadiah: The Pride and Fall of Esau

7

7

This painting illustrates the prophet Obadiah's vision of the utter and absolute destruction of Esau's family line, and the fall of his nation state, Edom, as he and his people are interchangeably called. The book of Obadiah is the shortest prophetic book, being only one chapter long and containing twenty-one verses. The prophecy takes place during or shortly after the Babylonian expulsion of the Southern Kingdom. Judah's fresh, stinging exilic wound is now vigorously salted by their brother Esau's final and most bitter betrayal.

It has been a long and tortuous relationship for Isaac's twin boys, from their initial in-utero battles that continued throughout their lives and were extended by their descendants, long after they departed, for nearly a millennium. Their sibling rivalry was birthed and forged on the anvil of the competing marital relationship between their parents, Isaac and Rebecca.

This is not only a story of Esau's end; it is also the story of what appears momentarily to be Jacob's demise. The Northern Kingdom, composed of ten out of twelve tribes of Jacob, has already vanished, antedating Esau's death. The Southern Kingdom, composed of the two remaining tribes of Jacob, is now being expelled by the Babylonians, and it appears to the world, and especially to Esau, that it is the end of them, and hence the absolute destruction of Jacob.

This is a historical experience that the Edomites savor with great relish and celebrate with gusto, finally tasting absolute supremacy and victory over their rival brother Jacob with whom they have competed over land, inheritance, blessings, and power, and most importantly – the biggest prize

of all – elusive paternal love. Jacob's conniving may have gotten him the firstborn blessing, but in the end it is Esau who snatches victory from the jaws of defeat by living to witness the death and destruction of his little back-stabbing brother, or so it seems.

In this painting, Obadiah is portrayed as the huge, cracked, mountainous background face (explanation below). The entire book of Obadiah admonishes Edom for their terrible behavior vis-à-vis their brother Jacob, and because of this they will be utterly destroyed. "There will not be a single survivor from the house of Esau" (1:18) is written in yellow letters on Obadiah's bottom lip at the bottom of the painting.

Obadiah and God are particularly irked that when Edom's brother Judah is in trouble with the Babylonians; not only do they not help, they take part in dividing the spoils:

> For the violence done to your brother Jacob, shame will cover you.… In the day that you stood aloof when foreigners entered into his gates, and cast lots upon Jerusalem, you were just like them. You should not have rejoiced over the children of Judah in the day of their destruction, neither should you have spoken proudly on the day of their distress. You should not have entered into the gate of My people, and you should not have laid hands on their things. Neither should you have stood in the crossway to cut off those that tried to escape; neither should you have delivered those that did remain in the day of distress. (Obadiah 1:10–14)

The visual inspiration for this painting is based on the analogy drawn by Obadiah between Esau and his children, the nation of Edom, and an eagle and his nest. "The pride of your heart has beguiled you, you that dwell in the clefts of the rock [Obadiah's face in this painting]. 'My habitation is high,' he said in his heart. 'Who will bring me down to earth?'" (1:3) (not written in this painting).

"If you make your nest as high as an eagle and if amidst the stars you will place your nest, from there I will bring you down, says God" (1:4) (written in blue letters on the upper eagle's nest in this painting).

In this painting, Esau is the winged central figure with an eagle-talon-like left hand. He is falling down, brought down by God, from his heavenly

abode, which is perched atop a very high mountain, which happens to be Obadiah's head. The nest, inhabited by the Esau eagle and his eggs, represents the entire nation of Edom. The nest is being violently shaken and stirred by a divinely ordained mountain quake; in this case the shake of Obadiah's head. As a result, the nest's entire contents – eagle, eggs, and eaglets – teeter and fall out of their habitat, and plunge to their certain deaths, spelling the end of their tribe.

The Edomite eaglets are in different stages of gestation. Some lay cocooned and un-hatched inside their eggs. Others are at different hatching stages with some only having their heads piercing their shells. Others also have other hatching appendages including hands, hands and legs, wings, wings and feet, and other permutations of the above. Many of the baby eaglets are born with different varieties of mixed and matched eagle and human appendages. Many are born with an Edomite backpack filled with arrows. As they are plummeting downward, upside down, their arrows due to gravity fall down separately. All the eggs, no matter what gestational stage they're at, are cracked. They are all bleeding blood and/or seeping yolk, symbolizing their divine individual and collective breakage. None of them are unbroken; all will die.

They all fall to their deaths alongside their winged progenitor.

The significance of Esau's wings is twofold. He is compared to an eagle, hence he has wings. Furthermore, this also symbolizes that he is the angel that Jacob wrestled with (see painting *Labor Day: Jacob and Esau*, 2004; www.NahumHaLevi.com). Hence he is also a falling fallen angel.

The name Obadiah in Hebrew is linguistically linked to one of Esau's names, and hence the name Obadiah is not merely coincidental. In Hebrew, Obadiah's name is spelled E-V-D-Y-H, or broken down to its two root components; "*EVeD*" (slave or servant), of *YH* (God). This parsed name is written in yellow and red letters on Obadiah's blue irises of his eyes. The term *eved* can have quite negative connotations – as in a slave, or a slave in Egypt. Alternatively *eved* can have positive spiritual connotations, as in *eved* (servant) of God. Thus the word *eved*, depending on the grammatical context, can be either pejorative or complimentary.

Esau in Tanach is twice referred to as an *eved*. When his mother is pregnant with him and Jacob, she beseeches God, who tells her that two

nations are struggling within her, and that the elder will serve (*YaEVD*) the younger.

When Isaac blesses both Jacob and Esau, he tells each of them that Esau will serve (*YaEVD*) Jacob. Hence Esau is an *eved* of Jacob in as much as Obadiah is an *eved* of God. In this painting, this appellation of Esau's is written in red letters on his torso. Hence both Obadiah and Esau are *eved*s. One is an honored servant, and the other is a despised slave. Thus the object of Obadiah's prophecy is also the root of his name.

The text also has an interesting linguistic play on the name Edom. It contextually uses the word *edam* for "destruction," drawing an analogy between the definition of Edom and his impending destruction. Both these words are written in green letters on the shell of the central white eaglet. Edom is written downward on the right, and *edam* is written downward on the left, both words sharing the same first and last letters. One could take the different root definitions of Edom one step further. The root of the word Edom is also *adam*, "man," who is both destructive and destructible.

Written in the black space in between Obadiah's upper and lower lips are the words of Obadiah's admonition to Esau. "You are much despised" (1:2). In response, Esau is illustrated with tears welling in his eyes.

Indeed, Esau is probably the greatest tragic figure in the Bible. Jacob finagles both birthright and primo blessing from him, yet when Esau meets up with Jacob many years later, he embraces Jacob, kisses him, forgives, and forgets. Truly, he is the son of Abraham and Isaac. But Esau's descendants are not as forgiving. They can never forgive Jacob's multiple slights to their great father, nor can they forgive or forget. Hence they cannot and will not extend any semblance of filial assistance or love to their brother's descendants.

And how exactly did Jacob assist Esau? In what way did Jacob ever make up for what was unjustly taken from Esau? How did Jacob ever make amends? What exactly does Edom owe Jacob? Doesn't filial love go both ways? Esau mightily loved his father; nevertheless it was Esau who was exiled from heart, hearth, and home by the alliance forged between Jacob and his mother. A millennium later, Esau is both cursed and doomed by God because he could not bring himself to forgive Jacob for having come

between him and his father. Dancing on Jacob's grave (albeit prematurely) was one of the many jealous acts of vengeance that Esau thought was well deserved. Throughout Esau's existence he is and always was a sad, noble, and tragic figure.

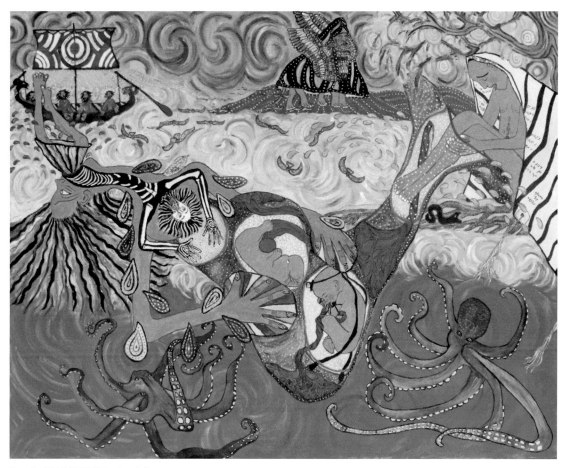

Jonah: 2010/64X48 inches/oil on canvas

Jonah: The Breadth and Depth of Turbulence

8

8

This painting attempts to visually capture the inner turbulence of the prophet Jonah's soul alongside the outer turbulence of his oppressed life. Jonah son of Amittai was a prophet in the Northern Kingdom of Israel; he was most active during the reign of Jereboam II from 786–746 BCE, roughly twenty-five years prior to the fall of Israel to the Assyrians in 722–721 BCE.

It is generally assumed that Jonah's name is derived from the very commonly employed Hebrew definition of "Jonah," which means "dove," as first mentioned in the tale of Noah. The characterization of being dove-like implies a sense of freedom of flight, an inability to be contained, restrained, or controlled. It implies a creature of peace, at peace. The prophet Jonah not only has none of these personality traits, he is in fact the polar opposite. The alternative and far lesser-known and employed definition of the word "Jonah" is "oppression." This is the real etymological root of the prophet Jonah's name. He is indeed oppressed and hence quite depressed, for very good reason, as will be described in detail below.

The definition of the word "Jonah" (in Hebrew *Yonah*), meaning "oppression," is employed on multiple occasions in Tanach.

1) "Because of the fierceness of the oppressing (*yonah*) sword, and because of his fierce anger" (Jeremiah 25:38),

2) "For fear of the oppressing (*yonah*) sword" (Jeremiah 50:16, and 46:16), and

113

3) "Woe to her that is filthy and polluted, the city of oppression (*hayonah*)" (Zephaniah 3:1).

In order to fully comprehend Jonah's motivations and thought processes throughout this book, which superficially appear somewhat incomprehensible, it is important to know where he comes from, and the historical political context of his day.

There is a midrash that identifies Jonah as the son of the widow (*almanah*) who was revived after his death by Elijah the Prophet. This child, in the text, is never referred to by name (I Kings 17:17–19). He is merely called the son of the widow or of the woman. Neither his father's nor his family's name is mentioned. There are multiple textual parallels between this child's experiences and that of Jonah's, as well as linguistic corollaries that strongly buttress this hypothetical midrashic identification.

To understand the basis of Jonah's presumed identification with the son of the widow, it is first important to briefly summarize the well-known story of the book of Jonah.

Jonah is told by God to go to the city of Nineveh in order to induce its inhabitants to repent their sins. Jonah doesn't like this idea, so he boards a ship en route to Tarshish, far away from Nineveh, in an attempt to escape from God, and his mission. God creates a great tempest, threatening the lives of all the sailors on board including Jonah, who decides to go below deck so that he can sleep through the event, and hopefully never wake up. The sailors awaken him, and after casting lots, they squeeze out of Jonah that he is running away from God, the Creator of the land and sea, and it is He who is the source of this terrifying meteorological turbulence. Therefore, if they throw him overboard, the sea will be stilled and their lives will be saved. The sailors pick him up and throw him overboard, the sea calms down, and consequently, the vessel and crew are saved.

God prepares a big fish that swallows Jonah whole. While inside the big fish for three days and three nights, Jonah repents his sins, prays, and when he concludes with the words "Salvation is of God," the equivalent of "open sesame," he is vomited out of the fish on to dry land upon God's command. Now, when asked by God to go to Nineveh, he does not tarry and goes without complaints. He tells them that in forty days they will be

destroyed unless they repent, and they do, much to Jonah's consternation. They are saved from God's wrath.

Let us now return to the details of Jonah's childhood origins: his childhood premature death and miraculous resuscitation.

> And it came to pass after these things that the son of the woman [previously referred to as the widow], the head of the household, fell sick; and his sickness was so sore, that there was no breath left in him. And she said to Elijah: "What do I have to do with you, man of God? Did you come here to remind me of my sins, and to kill my son?" And Elijah said: "Give me your son." He took him from her bosom, and he took him up to the upper chamber where he was staying, and laid him on his bed…. And he stretched himself upon the child three times, and he called unto God and said: "God, return this child's life back into him." God listened to the voice of Elijah, and the life of the child came back to him, and he lived. And Elijah took the child and delivered him to his mother, and said: "See, your son lives." And the woman said to Elijah: "Now I know that you are a man of God, and the words of God in your mouth are true (*emet*)." (I Kings 17:17–19, 21–24)

Jonah's three days and nights in the big fish are equivalent to the three times that Elijah stretches himself upon the child, which are also equivalent to his mother's (the widow's) three trimesters of pregnancy; that is, these three day/nights are a symbolic recapitulation of the original gestation process. Three days is also equivalent to the three lives that Jonah experiences: 1) his natural birth, 2) his first rebirth with Elijah's assistance, and 3) his second and last re-rebirth in the big fish.

Just like God answered Elijah the Prophet for a renewal of Jonah's childhood life, he answered the prophet Jonah's prayers for a renewal of his own life while he was re-gestating in the belly (uterus) of the "*dagah*" (female fish), who herself swims in the great sea, the briny birthing amniotic fluid of all life on earth.

The text implies that Jonah had momentarily expired in the big fish: "From the stomach of death (*she'ol*) I cried and you answered me" (2:3). "I went down to the bottom of the mountains, the earth with her bars

closed upon me forever, and you brought up my life from the pit" (2:7). "When my life fainted from within me [when I died], I remembered God" (2:8).

At the end of Jonah's three days and nights' prayer session, he concludes with the words "Salvation is of God" (2:10). At this point God commands the fish to vomit Jonah out. The words "salvation is of God" are reminiscent of – and recapitulate – Jonah's mother's words to Elijah the Prophet: "The words in your mouth are true (*emet*)." Thus when Jonah utters the absolute truth, that salvation stems from God, it is at this point that God agrees to save him yet again.

This is the meaning of the remainder of Jonah's name "Ben-Amittai," which in Hebrew means "son of My truth." In the Elijah-Jonah story, the child is merely referred to as the son of the widow or of the woman. Jonah is the son of God's truth ("Ben-Amittai") – of the true words of God that emanated from Elijah's lips, which resuscitated his life the first time. The first two Hebrew letters of the word *emet*, "truth" (A-M-T) are also incorporated into his mother's Hebrew appellation, *al**m**anah*.

It is also interesting to note that the name Jonah is subliminally incorporated into three crucial Hebrew words in the book of Jonah that propel the arc of the story:

> 1) The first word, repeated four times in the text, is V-Y-M-N, pronounced "*vayaman*," which means in Hebrew "and he prepared." It is used to refer to the preparation by God of four of nature's elements to manipulate Jonah to perform God's will. The four elements include a big fish (2:1), a *kikayon* (a gourd, 4:2), a worm (4:7), and an east wind (4:8). The text specifically states in all cases that God prepared preexisting natural elements (non-sentient plant and sentient animal, water- and land-based life, and inanimate meteorological physical forces) in contradistinction to his de-novo creation of new elements. God specifically manipulated preexisting animate and inanimate forces in order to bend Jonah to his will. This fulfills the textbook definition of the word "oppression" (the meaning of "*Yonah*," Hebrew for "Jonah"): "A condition marked by unjust severity or arbitrary behavior." Whether or not God's behavior

toward Jonah was unjust or arbitrary is arguable and controversial and will be elaborated upon below.

If we jumble around the letters of the Hebrew word V-Y-M-N we get "Y-V-N-M," which in Hebrew spells "Y-V-N (Jonah) / M." The Hebrew letter mem (M) pictographically represents *mayim*, meaning "water." Hence the word V-Y-M-N, when read as Y-V-N-M, translates into "Jonah-water," which in one word encapsulates the essence of the book of Jonah. The Hebrew letter mem also numerically translates into forty. Thus Y-V-N-M can also be read as "Jonah-forty." Forty is the number of days that Nineveh has to repent. These equations are written in Hebrew on Jonah's tallit (prayer shawl) to the far right of this painting underneath the third black stripe from the top.

The text does not explicitly state "*vayaman* Jonah," i.e. that "Jonah was prepared" by God. In fact, it is really Jonah who God prepares above and beyond all the other four elements of nature. He is but the fifth, and most important, element of nature: the animate, sentient human element, prepared to save the Assyrian people, God's ultimate goal in this book, which is but the first step toward achieving the real, yet as far as this book is concerned, covert plan, of which both Jonah and God are very well aware (discussed below). Jonah has a very long history of being divinely prepared. He was initially prepared in his mother's, the widow's, womb. After he was born, and died prematurely, he was prepared again with the help of Elijah at his mother's request, on Elijah's bed. After he was swallowed by the big fish, and died again, for the second time, he was prepared yet again – this time, directly by God.

2) The second word in the book that incorporates Jonah's name is A-N-Y-H, pronounced *aniyah*, which in Hebrew means "boat." If we jumble around the letters of A-N-Y-H we get A-Y-N-H, or "a Yonah." "A" (aleph) is the first letter of *emet*, "truth." Thus "A / Y-N-H" can be read as "*emet* (true) – Jonah," in other words "Jonah son of Amittai" (my truth). These equations are written in Hebrew on Jonah's tallit to the far right of this painting underneath the first black stripe from the top.

3) The third word in the book that incorporates Jonah's name is N-Y-N-V-H, pronounced in Hebrew "*Nineveh*." If we jumble around these letters we get "N / Y-V-N-H," pronounced "N Yonah." The letter nun (N) numerically translates into the number 50. Thus N / Y-V-N-H can be read as "fifty Jonah." Using old-fashioned *gematria* (Aramaic for geometry, but really arithmetic), the letter nun (N=50) is arithmetically equal to the letter yud (y=10) plus the letter mem (M=40). The Hebrew letters Y-M are pronounced *yam*, which means "sea." Thus N-Y-N-V-H when jumbled and read as N / Y-V-N-H, means "Jonah at sea." The word Nineveh, which is mentioned seven times in the book, also quite remarkably encapsulates the essence of the story – Jonah at sea. These equations are written in Hebrew on Jonah's tallit to the far right of this painting underneath the second stripe from the top.

Let us now focus on the visual aspects of this painting.

The story of Jonah chronologically unfolds upon viewing the painting from left to right. Illustrated in the upper left-hand corner of the painting is the boat that Jonah boards en route to Tarshish, represented by the green land mass behind the vessel. The sailors on board the boat are portrayed in the process of throwing Jonah overboard into the turbulent sea. Written in Hebrew at the upper center of the boat's sail are the words "God cast (*hetil*) a great wind" (1:4).This great turbulent wind that created the tumult within the sea is illustrated and symbolized in the upper purplish sky background.

Written in Hebrew on the lower center of the boat's sail are Jonah's words spoken to the sailors, which incorporate the same verb (*hetil*, "cast") mentioned above: "Cast me (*hatiluni*) into the sea" (1:12). These are the instructions Jonah gives the sailors so that they may save their lives. The Hebrew words *el hayam*, which is spelled A-L H-Y-M, can have different interpretations based on whether we read these letters as a combination of two words (A-L and H-Y-M) or just one word (A-L-H-Y-M).

Even if we read these letters as two words, two different definitions of the entire phrase can be derived based on the two different definitions of the first Hebrew word, *el. El* can either mean "into" or "God." Hence the words *el hayam* can mean "into the sea," as mentioned above, or alternatively

"God of the seas." Thus Jonah's statement "*hatiluni* A-L H-Y-M" can also be read and translated as "Cast me out, O God of the seas!"

Alternatively A-L-H-Y-M can also be read and pronounced as one word, "*Elohim*," or simply "God." Thus if we read and pronounce A-L-H-Y-M as *Elohim*, there are yet two additional alternative interpretations of Jonah's statement "*hatiluni* A-L-H-Y-M":

1) "O God, cast me out!", and

2) "Cast me toward [or into] Elo-him [God]!"

Illustrated in this painting beneath the boat is Jonah in the process of being swallowed by the big fish. The big fish is illustrated as a huge mermaid feminine creature. This is because the creature is referred to both as *dag* (2:1), defined as a generic fish, and *dagah* (2:2), the feminine grammatical form for fish.

Furthermore, it is stated that Jonah prayed to God from "within the female fish's insides" (*mime'e hadagah*; 2:2). Although the Hebrew word *me'ayim* generically means "the insides of a hollow organ," it is often used to describe the insides of a pregnant woman, or the insides of a woman's womb, as was used to describe Rachel's womb in Genesis 25:23: "Two nations are in your 'belly' (*vitnech*), and two nations from your 'insides' (*me'ayich*) shall be separated...." In this sentence the word *me'ayim* ("the insides") and *beten* ("stomach") within the context of a pregnant woman are used interchangeably referring to Rachel's uterus. Likewise, in the book of Jonah the interchangeable terminology used to refer to the insides of the big fish is *me'e* (2:1) and *beten* (2:3), which implies "womb." These words were the inspiration for the essential concept of portraying a big female pregnant fish in this painting. This concept was also visually incorporated into the painting *Yom Kippur* (2003; www.NahumHaLevi.com), which fuses Jonah and the Yom Kippur he-goat sacrifice.

Illustrated in this painting, on the left, is the initial phase of Jonah being swallowed by the fish. His upside-down legs, which are not yet fully inside the fish's body, are kicking and struggling. His torso, the portion already swallowed by the fish, is being elongated as it descends down the fish's esophagus. This portion of Jonah's body is illustrated in black and

white. His skeletal bones appear transparent and one gets the impression of viewing him as an x-ray image. His pupils are dilated, symbolizing that during the initial moments of his ingestion by the fish, he dies, his flesh instantaneously decomposes, and then he is no more.

Subsequently, almost as soon as he dies, he begins to re-germinate in an amniotic sac within the depths of the piscatorial uterus. Illustrated within the fish, from left to right, are three captured chronological static images of amniotic sacs inhabited by Jonah embryos during each of his three chronological trimesters of re-birth. Each trimester embryo is attached to a placenta which grows in size alongside Jonah with each subsequent trimester. Time elapses when viewing these embryos from left to right. Each trimester's amniotic sac chronologically parallels Jonah's directional trajectory as outlined in the story.

After Jonah dies, the first and earliest embryo (as well as the second trimester embryo) descends deeper into the fish uterus, paralleling Jonah's descending trajectory early in the story. He descends into the ship (1:3). He then descends to the bottom of the ship below deck (1:5), and he then descends to the bottom of the mountains underneath the sea (2:6).

In this painting the first-trimester Jonah embryo is illustrated at a very early stage of gestation. Transparent brain arterioles are actively sprouting. His embryonic fingers and toes are still webbed in their early development. This is similar to the pregnant fish's webbed hands, which are illustrated above and below this embryo, hugging and soothing her actively erupting abdomen. This parallel between the webbed fish hands-fins and the early webbed human hands emphasizes the unity of nature, and the biological principle of ontology recapitulating phylogeny. This first-trimester amniotic inhabitation represents day and night one (I) of Jonah's journey/time in the fish.

The second-trimester Jonah embryo portrayed beneath, and to the right, of the first-trimester embryo, is more fully developed. His limbs and appendages now appear fully human with developed and separated digits. He is busily engaged in prayer, wearing tefillin (phylacteries), calling out to God from the depths (2:1–3). This embryo represents day and night two (II).

The dark blue star-studded background of the inner recesses of the fish

surrounding the embryonic sacs emulates the nighttime sky, giving the impression that the embryos are floating in space-time within the bosom of God.

Portrayed on the far right of the painting, above the second-trimester Jonah embryo, is the third-trimester fully matured adult Jonah. This embryo-adult represents day and night three (III). He is illustrated in the process of being birthed (vomited) out of the other end of the fish. His broken-off, bleeding placenta has separated and is simultaneously sinking downward, as he detaches and ascends. This parallels his rise in the text, as stated, "You brought my life up from the pit" (2:7). In the painting, Jonah's embryonic journeys follow the natural curvature of the fish, i.e., descent followed by elevation.

The deep sea underneath the fish is illustrated as turbulent crimson waters. Crimson symbolizes the blood of both birth and death. The fish is surrounded by two blue octopuses, one to the left, and one to the right, which occupy the ocean floor. Their exquisite beauty and strangeness represent Jonah's mysterious and mystical transformation within the fish. The Hebrew letters aleph samech, standing for *En Sof* – the Infinite – are written in yellow on the head of the octopus on the right.

Jonah emerges from the fish on the far right in this painting wrapped in his tallit (prayer shawl). Written in red letters on the bottom of his tallit underneath the fourth stripe from the top are some of the words Jonah spoke in the fish: "*Behitatef alai nafshi*" (2:8), which means "When my life fainted within me." *Hitatef* has a dual meaning. It also means "wrapped around" and refers to putting on a prayer shawl and wrapping it around one's body (*lehitatef batzitzit*).

Written to the left of Jonah's mouth in blue letters (emanating from it) are the words "Salvation is God's"; these are the words Jonah uttered just before he was spat out of the fish. Written underneath these words in red letters are the words his mother uttered to Elijah after Jonah was revived: "The words of God in your mouth are true" (I Kings 17:24).

On the far right of the painting, after he is expelled from the fish, Jonah is sitting on dry land underneath the gourd tree that God created to protect him from the terrible sun. Illustrated above Jonah to his left is an Assyrian sphinx representing the Assyrian nation. The sphinx is wrapped

in a black sackcloth, and is asking for forgiveness (3:7). He is standing on a red Nineveh land mass. The green land mass, to the far left, represents Tarshish, which is in the opposite direction to Nineveh.

Beneath Jonah in the far right of the painting, the roots of the gourd tree can be seen. The worm that God created, illustrated in black, is opening its toothy mouth to bite into the roots and destroy the tree as commanded by God, so as to teach Jonah a moral lesson.

Birds are illustrated flying out of the turbulent windy sky from the epicenter of the painting, heading left and right into the turbulent ocean. This represents an evolving unnatural meteorological phenomenon and a distortion of the ordinary course of events, which the sentient birds sense and respond to.

The painting is horizontally and chromatographically divided into three sections: the upper purple turbulent sky, the mid blue turbulent sea, and the lower deep crimson turbulent red sea. This three-part division symbolizes Jonah's three days in the fish, his three trimesters of rebirth, and his three lives. It also symbolizes the three times he prays for death, and the three times he ultimately dies (more details below). Turbulence permeates all three layers of this entire painting as it permeates all layers of Jonah's soul, and every aspect of his life.

If we read the story of Jonah literally, one gets the impression that not only is he a reluctant prophet, which hardly begins to describe the enormous extent of his resistance, but he is a mean-spirited prophet with no regard for the lives of others: not for the lives of the sailors, who will die unless he is tricked into helping them, and not for the lives of the people of Nineveh, who will all die – including all the innocent humans, children, and animals – unless he is divinely and unnaturally coerced to help them.

Furthermore, he is quite selfish. He only appreciates things that give him physical pleasure. He loves the gourd for the shade it provides him from the sun. He is also an ingrate who appears uncomprehendingly and unnecessarily depressed. He's saved from drowning, but nevertheless is always praying for death (when not praying for life) for no particularly good reason. In essence, he is an ungrateful, selfish, merciless, unhappy, suicidal sour pus. Only after being literally frightened to death by being

inside a big fish, and only after he is chased down and literally chewed up and spat out by God, will he do the right thing and help the poor innocent people of Nineveh avoid pain, sorrow, and suffering.

A superficial reading of the story would also lead one to conclude that Jonah's relationship to God with respect to Nineveh represents a completely opposite God-man relationship than existed between God and Abraham with respect to other sinning cities, Sodom and Gomorrah.

In the story of Sodom and Gomorrah, God is portrayed as the bad guy harboring absolutely no mercy for the horrible sinners and wanting to destroy them completely. Abraham, the first Hebrew prophet, is portrayed with amazing moral strength and compassion, pleading with God to have mercy, and entreating God to spare them if he can muster a quorum of good men, which he can't. Abraham in that story is the moral hero. God is the stern spoiler, the anti-hero.

In the story of Jonah, the God-man relationship appears completely reversed. Here God is pleading with Jonah to show some mercy. There are many innocents who will die in the absence of Jonah's intervention. Jonah has to be taught a moral lesson via a childish fable; if he feels sorry for a little tree that has been scarcely alive for barely twenty-four hours, can't his heart be moved a silly iota for an entire city of innocent people and animals? Where is his heart? Where is his compassion? Can't he be a fraction as merciful as the all-merciful God? Here God is the moral hero, and Jonah is the anti-hero, the stern spoiler.

What's up with Jonah, with this "Prophet of Mean"? And why is a person who is so thoroughly ethically flawed a prophet to begin with? Why bother resuscitating him twice, or even once for that matter? Aren't there better people to reawaken?

If this is how one reads this story, then Jonah is severely misunderstood. This impression exists only because we have lost the context of the story, which most people long ago probably would have recognized when the story was originally recorded.

The first question that must be asked is why was Jonah running away from God in the first place? Why did he not want to go to Nineveh to help the Assyrian people? As mentioned above, Jonah was a prophet in the Northern Kingdom of Israel. However, when he was asked by the sailors

who he was, he answers that he is simply a Hebrew – that he considers himself a member of the entire nation of both Israel and Judah (1:10).

Even if he weren't a prophet who can predict the future, he is still a human being who can read the writing on the wall. A very short time after this story is supposed to have taken place, the Assyrians, as symbolically represented by their capital Nineveh, drove Israel, the Northern Kingdom, into exile, and Israel ceased to be. Nineveh (the Assyrians) also threatened Judah, surrounded Jerusalem, and only by a miracle was Judah saved and not likewise taken into captivity by the Assyrians. The Assyrians deservedly rank high on the arch-enemy list of Israel because they are the nation who vanquished and exiled them, transforming them into the fabled ten lost tribes.

So who does God so desperately want Jonah to help save? The Assyrians! And what are God's true motivations for wanting to save the innocent Assyrians? So that within the next twenty-five years this saved innocent nation can be nurtured to grow stronger in order to be capable of destroying Israel. God wants to destroy Israel in the near future because they sinned, just like he now wants to destroy the Assyrians because they sinned – unless they repent, which God goes to extreme lengths to virtually guarantee. When their job will be satisfactorily completed in the future, only then will they get their just desserts. Thus this story is also very much about preparing the Assyrians, the sixth element in God's plans.

Jonah's purpose in life is to serve as the catalyst for the Assyrian's presumed free moral choice, which paradoxically leads to only one preordained path. God needs to save Assyria now, because shortly they will serve as His rod (Isaiah 10:5) that will successfully wipe Israel off the map. God knows the future He desires, and knows how to get it. God also knows that the prophet Jonah knows about this divinely ordained future, and that there's no way that Jonah can prevent it. Jonah will do everything in his measly power to actively prevent that future from occurring, or at the very least, not be an active or passive catalyst for its fruition.

It turns out, Jonah really is very much like Abraham, and God hasn't changed much since Abraham's time. The same God-man relationship exists. Jonah and Abraham are both moral heroes. In the case of Abraham it is obvious; in the case of Jonah it's not. The text superficially makes Jonah

look like the anti-hero, and hence he is both a heroic and a tragic figure.

Jonah is a deeply empathetic prophet who loves God, and also mightily loves his people. As Jonah stated, if God wants to help the Assyrians, He can do that on His own (4:2). He is fully capable. Jonah refuses to be used as an instrument for the destruction of his very own people. He runs away, he runs for the hills of Tarshish. He will under no circumstances betray his own people. He will not assist in sharpening the sword that the Assyrians will wield against Israel in the future. He will take no responsibility in their pushing Israel off the cliff into oblivion. No, not Jonah! Do it Yourself, God! Use another instrument of nature, use someone or something else, just please leave me alone!

He's got to run away. He boards the first ship he sees that is going in the opposite direction of Nineveh. God sees him. He creates a tempest and shakes the ship. What does Jonah do? He goes below deck and falls asleep. With any luck, by the time he wakes up it'll all be over. The ship will capsize, and he'll die and never wake up – a small price to pay for the preservation of the people of Israel. Even if all the sailors go down with him, at least Israel, his entire nation, will be spared. Without Jonah's help maybe Assyria won't repent; just maybe God will destroy them, and hence God won't have the tools and the means to destroy Israel. Assyria will go down in the future anyhow; hopefully they'll go down before destroying Israel. Jonah goes to sleep, but he is awakened by the sailors.

The sailors are scared for their lives. Jonah tells them how to save themselves. Throw him overboard. They will live, and he will die, and that's just fine, because death is what he craves, anything but being a sell-out to his people. Jonah indeed does die inside the fish. But God will have none of that. He's not letting Jonah off that easy. Jonah can't cowardly escape into death. He needs Jonah for his future ultimate plans.

God planned to use Jonah from the moment he was germinated in his mother's belly. When he died as a lad, he got Elijah to resuscitate him. Why? So he could use him to prepare Nineveh to be used as the rod against Israel. Now when Jonah is thrown into the sea, God gets a fish to swallow him whole and literally drag him back to his task. In the fish, after Jonah dies and is resuscitated, his human nature takes over. His fear of staying there forever overtakes him. He prays, he makes nice to God. God knows

what drives man: fear – fear of death, fear of darkness, of loneliness, of pain and suffering. Jonah thanks God, and prays long enough that God now knows Jonah is ready. His rebelliousness is thoroughly broken; he has kneeled before God, and he now knows the pecking order. It is now time to get thee to Nineveh.

Out of gratitude to God, Jonah is now compelled to go to Nineveh. He goes, and he perfunctorily performs his task. He speaks five Hebrew words: "Yet forty days and Nineveh shall be overthrown" (3:4).

Why would anyone suspect that with such a short discourse the Assyrians would take him to heart? But they do. And God knows they will. They repent and God forgives them. Everything is going according to God's plan, including the correct trajectory of Nineveh's freedom of moral choice.

Jonah camps outside of Nineveh watching, realizing, and mourning that God has forgiven them. He hoped it couldn't and wouldn't be. Say it ain't so. Too late, Jonah has now officially collaborated with God in sowing the seeds for his people's ultimate destruction.

Jonah now pleads for death. He cries out that death is far preferable to life (4:3). He is essentially the seal used to stamp Israel's death warrant. He is incapable of going on, he can't bear to live. He visualizes the deaths of millions before his eyes; he sees Samaria burn, he sees the near destruction of Jerusalem. With deep and prophetic empathy he feels the great inhumane suffering of his people. Woe unto him! Woe unto them!

What does God say to him? "Are you angry?" (4:4) (small understatement).

Exasperated, Jonah then sits under a sukkah to see what happens to Nineveh. God prepares a gourd tree to protect him. This momentarily comforts Jonah and delights him no end, allowing him some respite.

God then creates a worm to destroy the tree. Not only that, but he prepares an east wind so that the sun beats down on Jonah's head (4:8), physically disturbing him, salting Jonah's emotional wounds with even more physical pain.

Enough is enough! Jonah then asks God once again to finish him off once and for all: "It is far better to die than to live" (4:8). What really is left for Jonah to live for? He just helped God lay the groundwork for his

people's destruction, and God will physically torture him every day for the rest of his life.

What does God answer?

Are you expressing anger about the gourd (4:9) over Me destroying it (tiny understatement)? Yes, he answers. I am angry unto death (why don't you just finish me off already?). Then God says: You have pity on a gourd, so why can't you have pity on the town of innocent Assyrians?

The text does not record Jonah's answer to that query.

Jonah does not feel that he needs to be taught any moral lessons. Jonah believes it is God who needs to be taught a moral lesson (just like Abraham attempted to humanize God with respect to Sodom and Gomorrah). It is God who needed to be told: You don't need me to save the Assyrians, and You certainly don't need my help to destroy my own people. You're fully capable of that on Your own. You actually will destroy the Assyrians in the more distant future. You don't need to use me as a tool to deflect blame.

Jonah couldn't use Abraham's line – if you can find a quorum of innocent people amongst the Israelites, will You spare them? – because God would have used that line back to him about the Assyrians, and would have told him that there is a quorum of innocent Assyrians, and Jonah knew that.

Thus, in this story (although it is never mentioned), God intends to treat the Israelites no differently than He treated Sodom and Gomorra, as noted by multiple prophets throughout Tanach. God does not believe that Israel is worth saving, and He treats them contemptuously. In all fairness, multiple prophets unsuccessfully urged Israel to repent, but they didn't. So fair's fair. Jonah recognized this, but there was absolutely no reason to bring him into the fray.

Consequently Jonah truly lives up to his name. He is oppressed severely by God. Thrice he was given life only to be oppressed, in order to perform the will of God. In the end, although he may have been reluctant, he did as he was told, and as a result fell into a deep depression out of which he most likely never emerged, until God mercifully took his life for the third and last time (never recorded). In the text Jonah requests death three times, equaling the number of lives he lived (1:12, 4:3, and 4:8).

Some might say that although Jonah is labeled as a prophet, based on the text, he barely prophesied, and when he did, he prophesized not to his people but to another nation (in the Book of Jonah). In fact, Jonah prophesied the future, in his heart and in his mind's eye, about his people (although not to his people), and unfortunately there was nothing he could do about it other than to proffer his superhuman passive resistance. His hands were tied just like Isaac's while he awaited his own sacrifice.

Isaac never recuperated from his near sacrifice, and Jonah never recuperated from his prophetic journey whereby he facilitated his people's destruction. In this way Jonah was treated very similarly to Job. Job was morally perfect and never sinned, yet he was punished by God for sinning, even though God also knew Job never sinned. Only after Job confessed to sins that he never performed did God reward him. Jonah suffered more mightily then Job ever did. God merely took Job's wife, wealth, and children away from him. God took the entire nation of Israel away from Jonah and left him an orphan of history.

Jonah was no sour pus. He was a tragic national hero, a prophet of the utmost empathy, one whose suffering for others is unimaginable. Jonah ranks high amongst the great tragic figures of the Hebrew Bible.

The book of Jonah is read during Yom Kippur. The object lesson is that God answers man's prayers based on true repentance as demonstrated by Jonah's truly repenting prayers in the belly of the fish.

It is quite clear that the story of Jonah is a multilayered tapestry with many different interconnecting moral lessons, which can generate a multiplicity of interpretations. This painting attempts to simultaneously visually integrate these multiple interwoven conceptual strands.

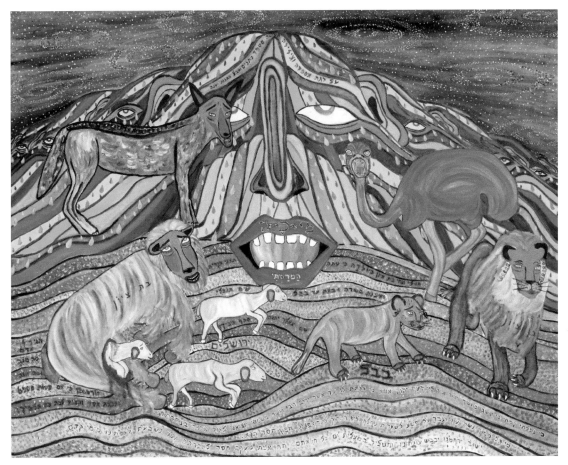

Micah: 2009/64X48 inches/oil on canvas

The Book of Micah: Exile and Metamorphosis

9

9

This painting visualizes the prophet Micah's metaphorical prophetic interpretation of the powerful transformative nature of Israel and Judah's impending exile. Whereas this exile is to be overtly cruel, bitter, and punitive, it is nevertheless an act of redemption and renaissance; it catalyzes the metamorphosis of a morally weakened people who act like submissive sheep into a nation of lions that possesses great physical strength, courage, and spiritual fortitude.

Micah prophesied from approximately 742 through 701 BCE during the reigns of Kings Ahaz, Hezekiah, and Jotham, and he is mentioned briefly in the book of Jeremiah. His name, which in Hebrew means "who is like You [God]?" is actually a contraction of the beginning of one of the last sentences of the book of Micah (7:18): "*Mi El Kamocha*," meaning "Who is a God like You?"

Micah is also referred to as "the Morashti," meaning coming from "Morash." Presumably this refers to the town of Morash-Gath that is mentioned in the book. However, "Morashti" most likely does not refer to this geographic locale. In Hebrew it means "my inheritance." Therefore, if we read Micah's entire name – "Micah Hamorashti" – it means, "Who is a God like You, who is my inheritance?" Thus Micah's entire name encapsulates the grandeur of God, and claims God as the inheritance of Judah and Israel despite their great moral failings.

Micah's prophecies, as opposed to some other later prophets, lump the sins and fates of both Judah and Israel together, treating them as one

unified nation. Many of the other later prophets address either Judah or Israel independently, and treat their distinct histories and misdemeanors quite separately.

The lumping together of Israel and Judah gives Micah a post-exilic feel (both Israel and Judah) as opposed to a pre-exilic sense of prophetic prognostication. This book also reads like a summarized compilation of the major prophetic moorings that have already been addressed separately both to Israel and Judah. The book of Micah includes an Amos-like warning to Israel of destruction due to their sins of social injustice, as well as an Isaiah-like negation of Judah's insincere sacrifices along with the concurrent promise of ultimate universal peace involving the transformation of swords into ploughshares, and spears into pruning hooks.

In fact, whole sentences in Micah are directly lifted from the book of Isaiah (4:1–7), almost word for word. Reading Isaiah's exact words in the book of Micah is a bit jarring, and at first glance raises the question of Micah's originality, if not authenticity. Thus, despite the historicity of the prophet Micah, it is quite conceivable that the book of Micah is a distillation of summarized prophecies by numerous seers who addressed pre-exilic Judah and Israel in real historical time. Despite this possibility, the book of Micah has its own, unified, overarching, distinct flavor and its own set of unique metaphors distinguishing it from the other prophetic books.

Micah, in the tradition of Moses and other prophetic intuits throughout Israel's history, imagines all of inanimate nature such as the earth and the mountains to be alive and sentient, capable of seeing, hearing, and silently watching the affairs of humans, and the actions and reactions of their Creator. Because of their immortality and timelessness they are frequently summoned respectfully by Micah and by other prophets to join with them in solemnly excoriating human immorality: "Listen attentively, earth, and all that it contains" (1:2).

"Hear now what God says: Rise, fight with the mountains, and let the high elevations hear your voice. Let the mountains and the enduring rocks, the foundations of the earth, hear God's battle, for God has a battle with His nation, and He will contend with Israel" (6:1–2).

These sentences were the inspiration for the huge mountain at the center of this painting with a human face. The central mountain is one of

a mountain range. All the mountains of the range have eyes and ears, and are Micah's and God's witnesses. The central mountain is fused with the prophet Micah himself, who together with the other mountains witnesses the misdeeds of Israel, and foresees the trajectory of history unfold across the undulating sand dunes beneath his face. Micah's name is written in Hebrew on the mountain's lips.

The mountains in this painting are crying, wailing, sweating, and melting, combining both Micah's mourning over Israel's fate and the mountains' melting according to Micah's theophany: "For this I will wail and howl! I will go stripped and naked. I will make a wailing like the jackals, and mourning like the ostriches, for her wound is incurable!"(1:8–9).

"Behold, God is coming out of His dwelling, and is descending and treading upon the high places of the land. And the mountains will melt beneath Him, and the valleys will be split, like wax before the fire, as water is poured down a steep place" (1:3–4).

In this painting, the wailing jackal on the left and the mourning ostrich on the right of Micah's mountainous face represent the combined forces of inanimate and animate non-human nature mourning the downfall of Israel and Judah. The words of 1:8–9 are written in Hebrew on Micah's forehead.

The concept of the metamorphosis of Israel from sheep into lions, which generated the essential anthropomorphic metaphorical concept of this painting, is inspired from passages dispersed throughout the book

Micah compares pre-exilic Israel and Judah to sheep directly or indirectly numerous times: "I will surely assemble all of you, Jacob, I will surely gather the remnant of Israel, and I will assemble them together like sheep in a fold, as a flock in the midst of their pasture, and they will make a great noise by reason of the multitude of men" (2:12).

"Shepherd your nation with your staff, the flock of sheep of your heritage that dwells alone as a forest in the midst of a fruitful field…" (7:14).

Micah then proceeds to discuss Israel's sins, and describes their illogical reasoning which almost sounds like the "bahing" of sheep: "You build Zion with blood and Jerusalem with iniquity.… Then they lean on God and say: Is not God in the midst of us? [Bah…bah…] Bah…bad things will not come upon us" (3:10–11).

"Therefore, because of you, Zion will be plowed like a field, and Jerusalem will become heaps, and the Temple Mount will turn into a forest on a high place" (3:12).

Illustrated at the bottom left of this painting is a sheep ("Bat-Tzion," meaning "daughter of Zion," i.e., Israel) crying out loud with labor pangs, giving birth to three little sheep. One sheep is illustrated coming out of her birth canal. The others have their heads bowed low, humbled and about to be exiled. This image is inspired by Micah's metaphors comparing Israel both to sheep (as mentioned above) and to a woman in labor (the daughter of Zion), as it is said: "Now why do you cry out so loud? Have you no king? Has your counselor been destroyed, that pangs have taken hold of you like a woman in labor? Daughter of Zion, be in pain and labor to bring forth, for now you will go forth out of the city, and you will dwell in a field, and you will come to Babylon, there you will be rescued. There God will redeem you from the hand of your enemies" (4:9–10). These words are written in this painting in Hebrew on either side of and underneath Micah's mouth.

The woman-in-labor metaphor is reiterated again: "Therefore, he will give them up, until the woman in labor gives birth, and the remainder of his brothers returns with the children of Israel" (5:2). In this painting the two metaphors for Israel – a sheep, and a gestating daughter of Zion – are fused into one image. The red Hebrew words "daughter of Zion" are written on the birthing sheep.

In Babylon, where Israel will be rescued, Micah compares Israel not to *sheep* but to a *lion*: "And the remnant of Jacob will be among the nations, in the midst of many peoples, as a lion among the beasts of the forest, as a lion cub among the flocks of sheep, who if they go through, treads and tears into pieces, and no one can be saved from them" (5:7).

Micah in his own words describes the physical metamorphosis of these sheep into a different species with a different physiognomy: "Arise and thresh, oh daughter of Zion, for I will make your horn iron, and I will make your hoofs brass, and you will crush many nations, and you will devote their gain unto God, and their substance to the Master of all the world" (4:13). The crushing hoofs of brass in this sentence are analogous to the treading and tearing characteristics attributed to the lions in the passage mentioned above.

In this painting, when focusing one's attention from left to right, we are viewing the process of a nation of sheep morphing into a nation of lions. Beginning on the left side of the painting the sheep is giving birth to three little meek sheep. In between the two sheep already out of the birth canal, "Jerusalem" is written in red letters, the locale where this birth is occurring. The little meek sheep trek along the desert from left to right, from Jerusalem to Babylon. As soon as they reach Babylon they are transformed into a young lion cub. The cub is standing on a hilltop, underneath which is written in Hebrew the word "Babylon." As the cub continues along his Babylonian journey he grows and matures into the strong confident lion that is illustrated on the far right of the painting.

Both the cub and the lion possess brass hoofs as prophesied by Micah. Written on the lion, in red letters, are the words "Ben-Tzion," meaning "son of Zion." The Judah-blue lion trots with his head held high, proud and confident. He is Israel reborn, cleansed of immorality, once again proud of his heritage and his magnificent inheritance, which, according to the title of this book, *Michah Hamorashti*, is none other than the incomprehensible, nevertheless incomparable God.

In the tradition of all other prophets Micah balances harsh words of rebuke (*tochachah*) with sweet words of comfort (*nechamah*). As part of the rebuke he enumerates the horrible sins of the people, and why their wretched fate is both justified and irreversible. This tactic he hopes will instill fear, which will lead to remorse and regret, and ultimately to true repentance. Once his captive audience has shifted into sincere repentant gear, Micah then bathes them with the sweet words of salvation and redemption (*nechamah*), providing them with further incentive to continue their journey along the path of righteousness.

As Micah says: "It has been told to you, mankind, what is good, and what God expects of you: Only to do justly and love mercy and to walk humbly with your God" (6:9). In this painting these words are written in Hebrew in the sand dunes to the left of the birthing sheep.

Micah provides insight on his take on personal salvation, which he hopes is internalized by everyone else: "Though I am fallen, I will rise; though I sit in darkness, God is my light. Because I have sinned against Him, until He plead my cause, and execute judgment for me; He will

take me out to the light, and I will behold His righteousness" (7:8–9). These words are written in Hebrew from right to left in the sand dunes immediately beneath the lion, cub, and sheep.

Micah's sweetest words of comfort are reserved for the culmination of the book, which provides succor and hope to the clueless, hopeless, and exiled: "Who is a God like You Who pardons sins, and passes over transgressions of the remnant of His inheritance, Who does not retain His anger forever, because You desire mercy? God will again have compassion upon us; He will subdue our iniquities, and He will cast out all our sins into the depths of the ocean. He will provide truth to Jacob, mercy to Abraham, as He swore to our forefathers from the days of old" (7:18–20).

These poignant words have echoed throughout time and space, uplifting the Jewish people from one humiliating exile to the next, until their deepest yearnings and hopes – against all human odds – ultimately transport them back to Zion, their birthplace and stomping ground.

These streaming soothing words are written on the lowest two sand dunes of the painting. The words "the remnant of His inheritance," in particular, emphasize an everlasting mutual reciprocity, an immutable unbreakable covenant between God and Israel. Just like God is called Israel's inheritance (*Morashti*), the remnant of Israel is called God's inheritance (*nachalato*).

Thus, with Micah's concluding thoughts, he seamlessly intertwines the debilitating exile that is about to unfold, with the glorious past that began with Abraham – together with the glorious more distant future to be, which shall be filled with truth, mercy, and national restoration.

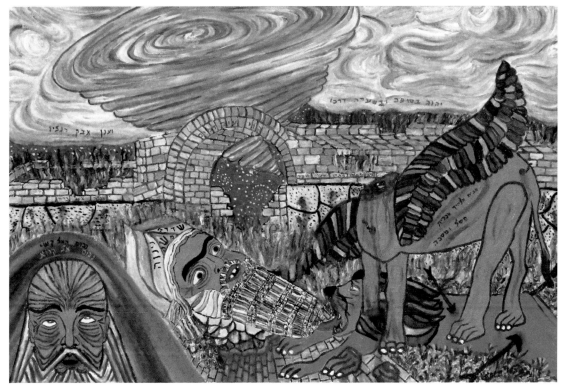

Nahum: 2007/36X24 inches/oil on canvas

Nahum: The Comfort of Vengeance

10

10

This painting visualizes Nahum the Elkoshite's prophecy of the destruction of Assyria, Israel and Judah's archenemy, and in particular, God's destruction of its powerful capital, Nineveh.

Portrayed in the bottom left of the painting is the prophet Nahum witnessing his vision unfold in the inner recesses of his mind. His forehead is sunny gold with emanating radial thought skin creases. Written above his forehead on the top line in purple letters is his name, "Nahum Ha'el Koshi." His last name, Ha'elkoshi – which refers to his geographic place of origin, Elkosh – is bisected in this painting into two separate words: *Ha'el*, "the God," and *koshi*, "Who is harsh" (root word *kasheh*, meaning "harsh"). In essence Nahum's full name means "source of comfort from the harsh God."

Nahum begins his vision by describing God as *El kano*, "a jealous God," and *nokem*, "an avenging God." On top of Nahum's forehead below his purple lettered name are the yellow Hebrew words *nakum El kano*, "avenging God of jealousy." It is of great interest to note that the book of Nahum philologically wishes to convey that the feelings of "comfort" (*nahum*) which arise from the satisfaction of "vengeance" (*nakum*) are two emotional sides of the same coin in general, and in particular with respect to the Assyrian destruction.

The second letter of the name or word "Nahum" in this painting is spelled with a kaf instead of a chet, *nakum* vs. *nachum*. The kaf without a central dot (*nekudah*) is homophonic with the letter chet, pronounced

"*cha*" (as in the word Chanukah). If we now take the letter kaf and put a dot inside it, the pronunciation changes from "*chu*" to "*ku*" which is homophonic with the sound of the letter kuf, also pronounced "*ku*." In this painting the Hebrew word for vengeance (*nakum*), which is placed underneath the Hebrew name for comfort (*nachum*) is spelled identically except that the second letter, kaf, is delineated with a central dot.

The point of the similarity in spelling and pronunciation of the words *nachum* (comfort) and *nakum* (vengeance) is that God's vengeance on Assyria is a welcome source of comfort for the Israelites. The yellow Hebrew bottom line on top of Nahum's forehead places the words *El kano* immediately beneath the similar upper words *El koshi*, because the spelling and pronunciation of the first portion of their names, "*el-k*," are identical. Furthermore the words *elkano* and *elkoshi* are also juxtaposed in this painting because they are entirely synonymous: *elkoshi* means "God of harshness" and *elkano* means "God of vengeance."

In the background of this painting is the royal palace of Nineveh, which once housed magnificent silver and gold relics looted from multiple civilizations. Built on the backs of slave labor from numerous nations, it is now aflame, and its architecture fractured as stated in Nahum's prophecy: "The gates of your land are set wide open to your enemies. The fires have devoured your bars" (3:13). These words are written in green letters on both sides of the bottom archway.

The major symbol of Assyria's destruction in this painting is the broken, teetering, anthropomorphized, winged guardian bull which once stood guarding the palace gates, and is now itself being guarded at the Louvre in Paris. Its bloodied decapitated head lays lifeless at the palatial entrance, its right wing partially aflame, and its right leg fractured into several pieces. This is consistent with Nahum's prophecy that states: "In the house of your gods, I will destroy idols and images" (1:14). This is written in blue letters on the torso of the winged bull. This also gives visualization to another portion of his prophecy: "And there is a multitude of slain, and a heap of carcasses, and there is no end of the corpses, and they stumble upon their corpses" (3:3; not written in the painting).

An enormous source of pride to the Assyrians was their identification with the powerful image of the lion. Artwork in their palace portrayed lion

hunts and their prideful confrontations and victories over their powerful lions. This symbol is deconstructed and smashed in Nahum's prophecy:

> Where is the den of lions, which was the feeding place of the young lions, where the lion and the lioness walked, and the lion's cub, and no one scared them? The lion tore in pieces enough for his cubs, and strangled for his lionesses, and filled his caves with prey, and his dens with torn limbs. I am against you, says God, and I will burn your chariots in the smoke, and your young lions will be eaten by the sword, and I will cut off your prey from the earth, and the voice of your messengers will no longer be heard. (Nahum 2:12–14)

Portrayed on the lower right of the painting is a lion, being killed by God's sword (arrows) as it lays injured and dying underneath the falling carcass of its master. Written on the head covering of the decapitated Assyrian human-bull head are the words in Hebrew "Nineveh is destroyed." In between these words is the word *massa* or "burden of Nineveh."

Written in green letters toward the top of the palace arch are the words "Alas, city of blood" which is what the Assyrians turned many cities into, and what its own city is now being turned into by God. Portrayed burrowing out of the falling Assyrian carcass are several cankerworms as stated in the prophecy, "I will devour you like the cankerworm" (3:15).

The powerful Assyrians and their mighty capital Nineveh in the time of Nahum were considered indestructible. As a people they were exceptionally and unnecessarily vicious and cruel. Who could offer protection from them? According to Nahum, only God could, who in his vision he describes as existing "in the whirlwind, and in the storm, which is His path, and the clouds are the dust beneath His feet" (1:3). Portrayed at the top of the painting is Nahum's vision of God as a swirling whirlwind and surrounding storm cloud, which wreak havoc, utterly destroying Assyria.

As a result of God's vengeance on the Assyrians, the entire civilized world breathed a great sigh of relief, as stated: "There is no assuaging of your hurt, your wound is grievous, all who hear your report clap their hands, for upon whom has your evil not passed eternally?" (3:19).

The book of Nahum is also comforting because for once a prophet is not rebuking Israel for its sins and imperfections, but rebuking its enemy,

Assyria, for its murderous cruelty. In this book good is rewarded and evil is punished. It is indeed comforting to know that there are concrete historical examples of divine justice.

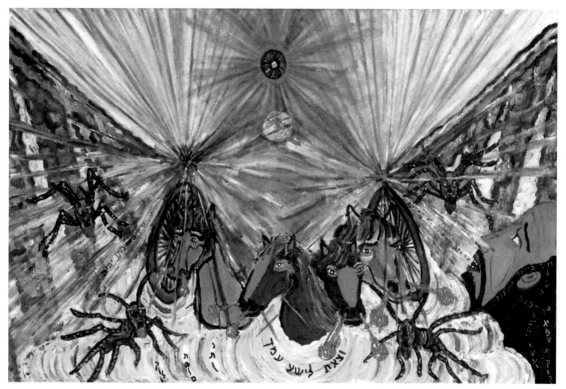

Habakkuk: 2007/36X24 inches/oil on canvas

Habakkuk Has a Look

11

This painting gives visual expression to the theophany experienced by the prophet Habakkuk, who most likely lived just prior to the Babylonian conquest and foresaw the impending exile of Judah by this fierce nation state. This is deduced by most commentators from the usage of the term "Chaldeans" in the text, which is interchangeable with "Babylonians."

Habakkuk cries out and appeals to God, trying to make sense not only of the existence of evil in this world, but of its apparent triumph over all that is good, and hence the upending or even abrogation of the essential moral essence of the Torah.

In this painting Habakkuk is seen to the far right, in awe of the vision of God which his mind has just conjured up. The surrounding imagery will be described below. Written in blue letters coming out of his mouth are the scolding words he directs at God: "Until when and how long shall I cry out to You, and You will not listen?" He continues (not in the painting), "I scream out to You about the violence, and You will not save me!" (1:2).

Unfortunately these words will always have contemporary relevance. Pesher (commentary) Habakkuk is a commentary scroll on the first two chapters of Habakkuk written by the Essenes roughly two millennia ago and is part of the Dead Sea Scrolls. The Essenes gleaned contemporary relevance from Habakkuk, equating their persecution by the Romans to their earlier persecution by the Chaldean conquerors who rode horses swifter than leopards, casting wide nets over people.

Incidentally, the Pesher scroll is written in modern Hebrew with the exception of the name of God, which is written in ancient Hebrew; the fact

that ancient Hebrew was reserved for God's name signifies the high regard ancient Hebrew was still held in two millennia ago.

How often have Habakkuk's questions been shouted out and echoed to the point of hoarseness by how many people throughout the course of history? Have they not been howled by those victims of the inquisition burned at the stake; by victims of crusades and pogroms; by those innocents about to be gassed, scorched, or shot; and by those who barely survived the flames of Auschwitz? Where, they all clamor, is God in the face of evil with a capital E?

It appears that the evil about which Habakkuk is complaining is the evil and corruption within his own people. God reassures him that this evil will not flourish and that it will be erased. How? God will raise a magnificent evil army of Chaldeans (Babylonians) who are fierce and fearless, and without a morsel of compassion. They, acting as agents of God, will root out this evil. Presumably they will succeed in exiling the Southern Kingdom and teach the evildoers a lesson. The end result of this devastation is that "the fig tree will not blossom, neither will the fruit be in vines…and the fields will yield no food" (3:17).

This presents an interesting solution to the theological conundrum of how a compassionate God can allow evil to flourish. Apparently the answer is that there exists a divinely ordained hierarchy wherein super evil must exist to stomp out ordinary evil.

After thinking about this, Habakkuk, stunned by this nonsensical interpretation, asks God how He can tolerate super evil people destroying people who are themselves far less evil than them. God answers, "Woe to him that builds a town with blood" (2:12). Essentially super evil will be avenged by none other than God himself, who is and must be even more fierce and scary than super evil to stomp them out. There is here no interpretive Kabbalistic *tzimtzum* (divine "contraction") to allow evil to emerge outside of God. Evil appears to be one of the necessary facets of God needed to achieve balance in the world. (This is pre-Lurianic Kabbalah, notably incorporating within the Godhead the *sefirah* of *Din*/Justice.)

Habakkuk is then overcome by a frightening vision of God, who is described with similar yet far greater ferocity then the Babylonians, and with significantly more luminescence and potency. This painting tries to

visually translate this awesome poetic vision. At the center of the painting God is portrayed standing with outstretched arms, with His hands spread out in priestly benediction. His body, arms and hands (a metaphor) are obscured by the rays of light that emanate from His head and left and right hands. This visage visually translates the words "His glory covers the heavens, and the earth is full of His praise. Brightness appears as the light, and He has rays of light emanating from His hands, and this is where His power resides" (3:3–4).

God's face is obscured and portrayed as an eye. This is based on the scriptural description "Your eyes are too pure to see evil" (1:13). This is somewhat paradoxical because it is God's beholding of evil which leads to divine retribution. On God's chest is the white moon, and below it a larger yellow sun, whose significant brightness is completely obscured by the indescribably bright light rays emanating from God. Illustrations of the sun and the moon give visual expression to the statement "The sun and moon stand still in their habitation" (3:11).

If you look at the central portion of the painting, you will note that the convergence of the rays between the upper eye, the left and right hands, and the blue horse forms a crystallized diamond of light in the shape of a pyramid. This four-faceted shining diamond represents the tetragrammaton of supreme light. The priestly benedicting hands of the *kohanim* likewise emit imaginary rays of light in an identical radial geometric diamond array. This patterned array is also the spiritual basis of the ancient Egyptian pyramid. (For Hebrew-Egyptian homologous religious symbolism, see *The Family Ankhyehova*, 2006; www.NahumHaLevi.com.)

To the mid and lower left and right of the painting are four pests (locusts or plagues) as described in the text: "Before Him goes the pestilence" (3:5). This symbolizes that God is an awesome force of destruction when He avenges His people.

This painting also portrays Habakkuk's vision of God riding a chariot with horses, shattering and splitting the trembling mountains above and within the foamy sea, as stated:

> And the eternal mountains are broken into pieces…. Are you angry at the rivers, or wrathful against the sea? Because you ride on your

horses and your chariot of salvation… You cleave the earth with rivers, the mountains have seen you and tremble, the tempests of water flow over, the deep utters its voice [written in Hebrew blue at the bottom left of painting], and lifts its hand on high…. You march through the land in indignation, and in anger you thresh nations…. You have trodden the sea with your horses, the foaming of great waters…. You have come for the delivery of your people [written in Hebrew blue at the mid-bottom of the painting]. (Habakkuk 3:6–15)

Habakkuk's vision of God is one that invokes awe and fear. It is an anthropomorphic view of what a person in his time period would imagine God to be like, if He were like a very powerful conquering and subduing King riding high in the heavens on His chariot, but infinitely and exponentially more powerful advancing with powerful horses, introduced by locusts, splitting mountains and oceans, and the world trembling before him.

Habakkuk's theophany is not very different from those of Ezekiel, Zechariah, King David, and other prophets. One can say that they are utilizing the imagery and metaphors of regal power visualized in their surrounding Near Eastern landscapes. The different holy animals in their visions that accompany God are usually similar to sculpted (idolatrous) deities strewn across the Near East and painted on palace walls (for example, Assyrian lions, Egyptian sculpted eagles and bulls). It would be difficult, as much as one wants to remain culturally separate, not to be influenced by these colossal images in describing one's own conception of the invisible, unimaginable God. The image of God riding a chariot (*merkavah*) has spawned a host of mystical and Kabbalistic speculations and theories known as *ma'aseh merkavah* (workings of the chariot).

In the end, Habakkuk is so overcome by the power of God in his imagination, that just like Job, it is no longer relevant that the penultimate fundamental question of why God tolerates evil in the world remains unanswered. God answers (but not really) this question by saying: "The righteous person will live by his faith" – that is, don't expect a better answer than this. Indeed this is the same answer given in the books of Job and Ecclesiastics.

Habakkuk picks up the beat just like Job will – and everyone else who has had the temerity and opportunity to directly ask God this question – and concludes with great satiety and relief after having been thoroughly exasperated, "I will rejoice in God [written in yellow letters on top of his ear], and I will exult in the God of my salvation [written in crossword style descending in yellow letters down Habakkuk's beard]" (3:18).

Habakkuk's name in this painting is part of a crossword written in orange horizontally underneath his ear. In another crossword, written downward from the first letter of his name in light purple is the Yiddish phrase "*Chapt a kook*," meaning "He steals a glance [at God]." This is a Yiddish pun on the name Habakkuk, and the basis for the title of the painting, which is an English translation of the rhyming Yiddish words "Habakkuk *chapt a kook*" – "Habakkuk takes a look." The root of his name is *chabak*, which means "cleave" (to God).

In this painting Habakkuk's emersion in the deep foaming waters also represents his "calling out from the depths [of his soul]" and his submersion in the glory of God.

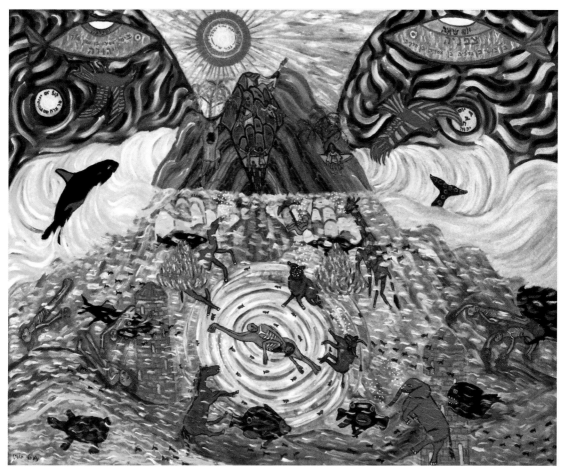
Zephaniah: 2009/64X48 inches/oil on canvas

Zephaniah: Zhacrifice, Shoah, and Zhalvation

12

This painting attempts to give concrete form to Zephaniah's 600 BCE prophetic visions of a looming cataclysmic *shoah*, or holocaust, about to mercilessly engulf Judah and the world, which will end all life on earth, as we know it. It also aims to crystallize Zephaniah's simultaneous, seemingly paradoxical, yet optimistic visions of the ultimate joyous return of Judah's post-holocaust survivors, the remnant of Israel, to Zion, and the reunification of all mankind through sharing a clear common language of righteousness.

Judah's punishment along with that of all human and animal kind occurs, according to Zephaniah, on the "Great Day of God" (1:14), also referred to as the Day of God's "Sacrifice" (or *zevach* in Hebrew, i.e., "slaughter" or "holocaust"; Greek for a sacrifice that is "wholly" consumed by "fire"; 1:8), also referred to as the day of "*shoah*" and "*meshoah*," which in Hebrew means "absolute devastation and desolation" (1:15). Because the Great Day of God will occur by fire (1:18; 3:8), it is clear that God's global human "sacrifice" (*zevach*) will be wholly consumed by this fire, and hence by definition it is a holocaust.

Thus, Shoah and Holocaust, the two twentieth-century alternative terms used to describe the greatest calamity ever to have befallen the Jewish people since their exile by the Romans, is derived from Zephaniah, as well as from other biblical sources. Zephaniah might be the only source where the two terms, *shoah* and holocaust (*zevach*), appear simultaneously in the same book. Other biblical references to *shoah* include the books of Job, Psalms, and Proverbs.

This painting fuses visual imagery of two other *shoah*s occurring before and after Zephaniah's *shoah*, thereby pictorially blending and melding a total of three distinct *shoah*s scattered throughout a smidgeon of the space-time continuum:

1) Shoah I: The Great Flood befalling all mankind, and land-based animal-kind, occurring during the age of Noah more than two thousand years prior to Zephaniah.

2) Shoah II: Zephaniah's Shoah engulfing all mankind along with all sea and land-based animal-kind.

3) Shoah III: The twentieth-century Holocaust occurring more than two thousand years after Zephaniah's Shoah, destroying one third of world Jewry along with other peoples.

Zephaniah, according to Tanach, prophesied during the time of Josiah, king of Judah (649–607 BCE). During this time Josiah was politically allied with the Babylonians against the Assyrians and Egyptians. Israel had already fallen to the Assyrians. Their exile and the destruction of Samaria were still fresh in Zephaniah's and Judah's minds. Assyria, unbeknownst to Josiah, was on the brink of destruction. Hence Zephaniah's prophecies must have occurred before the Babylonian captivity, when Judah was living in fear of following in Israel's exilic footsteps via the Assyrians. Therefore, Zephaniah's wrath is directed against the people of the North, that is, Assyria and its capital Nineveh (2:13). Babylon, or its equivalent biblical appellation, Chaldea, is not mentioned in this book. Thus, it is unlikely that Zephaniah's Shoah is referring to the Babylonian onslaught.

The first sentence of Zephaniah is unusually constructed with its exceptionally lengthy introduction of the prophet: "Zephaniah son of Kushi, son of Gedalyah, son of Amaryah, son of Hezekiah, in the days of Josiah, son of Ammon, king of Judah" (1:1). Whereas this lineage may be historically true, the length of this introduction exceeds that of any of the other prophets, and hence there must be a reason. The reason is that this entire single sentence serves as a mnemonic that summarizes the entire three chapters of the book. The mnemonic explanation of every name-word in this sentence and the particular aspect of the story that it condenses will

be outlined below. Thus this book must have had a long oral tradition, and this first sentence must have assisted the storyteller(s) in remembering its entire contents prior to the book being formally recorded.

The major theme in the book of Zephaniah and in this painting comes from the prophet's name. The root of his name is *tzafun*, which means "hidden" in Hebrew. "Hidden" is the underlying leitmotif of this captivating book. "Zephaniah" means "the hidden of God," or alternatively, "God is hidden."

The name Zephaniah itself is embedded with multiple hidden meanings. Zephaniah is spelled Tz-P-N-Y-H in Hebrew. The middle letters of his name, P-N-Y, spell out in Hebrew the word *PNaY*, or "the face of" … "God" or "Y-H" (the last two letters of the prophet's name), which throughout most of the book will remain hidden from Judah and the world.

A synonym for *tzafun* in Hebrew is the word *hester*. The Hebrew term *hester panim* (P-N-Y-M), means "the hiding of God's face," and is a biblical metaphor referring to occurrences of evil calamities when God turns or "hides" His face but for a microscopic "moment" (*rega* in Hebrew; Isaiah 54:7). Hence it would be said that any holocaust/*shoah* that befalls mankind can only occur during *hester panim*, or when God hides His face. This concept is the inspiration for incorporating/hiding Zephaniah's face in this painting. Look at the painting from a distance. Every feature of Zephaniah's face in this painting is embedded in the sky, and underneath the sea, and has a minimum of at least two visual interpretations (detailed below), and is thereby hidden.

The words *tzafun* – or *hester*, meaning " hidden" – which is encoded in Zephaniah's name also refers to the righteous people who Zephaniah implores to go into "hiding" to avert the holocaust: "Seek God, all you humble of the earth who executed His ordinance. Seek righteousness, seek humility; perhaps you will be hidden (*tisatru*) on the day of God's wrath" (2:3).

Furthermore, *tzafun*, if pronounced differently but using the same letters, can be pronounced *tzafon*, which means "north" in Hebrew. This is actually the hidden definition within "Zephaniah" that forms the first word of the mnemonic that refers to the people of the North, Assyria: "And He will stretch out his hand against the North (*Tzafon*), and destroy Assyria,

and make Nineveh a desolation" (2:13). The entire mnemonic sentence will be fully outlined below.

With respect to yet another hidden meaning of the word "Zephaniah," just to get a little eerily creepy, if we extract the letters Tz, N, and Y from Tz-P-N-Y-H and jumble them around, we get "N-Tz-Y," which spells Nazi, the twentieth-century Shoah III bad guys equivalent to the Assyrian bad guys of 600 BCE Shoah II.

At the beginning of the book God promises to destroy everything that exists on the face of the earth (1:2). He says that He will "destroy man and beast; the birds of the sky, and the fishes of the sea…and I will cut man off from the face of the earth" (1:3).

This wholesale destruction, this scorched earth policy, is quite analogous to the wholesale destruction of all of mankind and animal-kind during the time of Noah, except it is worse. During Noah's Great Flood, all the fish survived; they were not on God's hit list of species destined for destruction. Noah never took any fish pair into the ark. He didn't have to. Raising the sea level for forty days didn't kill any sea creatures. Now, even the fish must go. No living creature can be spared. The rainbow covenant symbolizing that there shall never be another wholesale grotesque destruction of human- and animal-kind seems to have been forgotten or ignored.

This painting layers imagery from Noah's Flood (Shoah I), grafting it on to Zephaniah's Shoah II. Illustrated in this painting is a great flood engulfing the city of Jerusalem along with its mountains and towers. The vast majority of this city of David, except for a single mountain top, the mountain of God, is submerged by the flood. All of animal-kind and mankind are actively drowning. Yellow-red birds, aglow from a fiery fire, are falling from the heavens into the cascading flooding waters. The dolphin on the left is jumping out of the waters in a feeble attempt to escape death. A representative menagerie of red glowing, burning animals is drowning, including an expelled human fetus with its attached umbilical cord and placenta, a camel, a giraffe, a cow, a bull, a horse, an elephant, and a turtle.

Another reason this flood imagery was chosen is because the multiple sea and fish references gives Zephaniah's Shoah II a watery Deluge–Shoah

I type of feel: "I will consume the fish of the sea" (1:3). "And on that day, says God, there will be the sounds of shrieking from the fish gates" (1:10). "Woe unto the inhabitants of the sea coast" (2:5). "And the sea coast shall be pastures, even meadows for shepherds and folds for flocks" (2:6).

At the center of the lower portion of the painting is a rotating angry vortex, the epicenter of a tsunami, which doubles as Zephaniah's mouth. It is acting as a sinkhole, an oceanic divine drain into which all mankind, fish, and animals are sucked into oblivion, cleansing the earth of sentient existence.

The survivors of Zephaniah's Shoah II will not be saved by floating on an ark as they were during Shoah I. In this painting they will be saved by physically and spiritually climbing out of the flooding waters (of iniquity) scaling high enough to reach God's mountain peak (a stationary ark; an oasis) which is saved from submersion:

> On that day you will not be ashamed for all your doings that you have transgressed against Me, because then I will take away from the midst of you, your proudly exulting ones, and you shall no longer be haughty on My holy mountain. And I will leave in the midst of you an afflicted and poor people, and they will take refuge in the name of God. The remnant of Israel will not do inequity, nor speak lies, neither will a deceitful tongue be found in their mouth for they will feed and lie down, and no one will scare them. (Zephaniah 3:11–13)

Illustrated in this painting is a man who has reached the very peak of the mountain and is lying down, as mentioned in the text above, bathed in God's light. Zephaniah's words, like those of other prophets, imply that poverty and humility represent idyllic human virtues. In this painting, the mountain peak, where the holocaust survivors congregate, together with the uppermost portion of the submerged middle mountain range, double as Zephaniah's nose.

What was the reason for such incomparable divine wrath during Zephaniah's time, which even exceeded God's antediluvian wrath? What inflamed God's sensibilities to such a degree that He felt it necessary to enact the great catastrophe of Shoah II?

The many sins of Judah, according to Zephaniah, include the idolatrous worship of Baal as well as the stars of heaven, and not seeking or inquiring of God (1:4–6). For "she did not listen to the voice, she did not listen to sermons (*mussar*), she did not trust God, and she did not draw near to God. Her princes in the midst of her are roaring lions. Her judges are wolves of the night. They leave no bone for the morning. Her prophets are wanton and treacherous people. Her priests profaned that which is holy; they have done violence to the Torah" (3:2–4).

God is the sorest at Judah. He is most disappointed with His chosen people to whom He has given the Torah, for He holds them to the highest ideals, from which they have so precipitously fallen. But all the other nations that afflict Judah and Israel are just as evil, if not more so. Some of the other peoples that God is wrought with include Assyria, Ethiopia, Moab, Ammon, and Philistine. For afflicting Judah, God will destroy them and leave no survivors.

This brings us back to the mnemonic encoded within the first sentence of Zephaniah, consisting of nine key words: 1) ZEPHANIAH son of 2) KUSHI son of 3) GEDALYAH son of 4) AMARYAH son of 5) HEZEKIAH in the days of 6) YOSHIYAHU (JOSIAH) son of 7) AMMON, 8) MELECH (KING) of 9) YEHUDAH (JUDAH).

Each of these capitalized names reference different parts of the narrative as outlined below. (Key words 1–5 are written in red letters in the burning sclera of Zephaniah's eye/fish on the upper right of the painting. Key words 6-9 are written in red letters in the left burning sclera of Zephaniah's eye/fish on the upper left of the painting.)

1) Zephaniah: As noted above, *tzafon*, the root word of Zephaniah, means "north" and refers to the Northern people – Assyria. As stated: "And He will stretch out his hand against the North, and destroy Assyria, and make Nineveh a desolation and a dry wilderness" (2:13).

2) Kushi: This refers to the Ethiopians (Kushim) whom God shall slay by the sword (2:12). Another reference to Kush includes: "From beyond the rivers of Ethiopia (Kush)…" (3:10).

3) Gedalyah:

 a) The first two letters of the name Gedalyah, G-D, when reversed spell D-G or *dag*, which in Hebrew means "fish." This refers to all the fish that will be destroyed. "I will gather…and destroy the fish (*DaGei*) of the seas…" (1:3). "And on that day, says God, a voice of screaming will come from the fish (*DaGim*) gates" (1:10).

 b) "In the same day I will punish all those who 'leap over' (*DoLeG*) the threshold – that fill their master's house with violence and deceit" (1:9). *Doleg* (D-L-G) contains three of five letters of Gedalyah's name (G-D-L-Y-H).

 c) The word Gedalyah means "great is God," which refers to the "great" (*GaDoL*) Day of God (1:14).

 d) Gedalyah also refers to the nation Moab: "They (Moab) grew/ multiplied (*vayagdilu*) on their borders" (2:8).

4) Amaryah: The root of this name is the Hebrew word *amar*, which means "says." Thus the name Amaryah refers to the references:

 a) "I will punish the men...that say (*AMRim*) in their hearts, God will not do good, neither will He do evil" (1:12).

 b) "This is the joyous city that dwelt without care, that said (*AMRah*) in her heart, 'I am and there is none else beside me'" (2:15).

5) Hezekiah: In Hebrew Hezekiah means "the strong of God" or "God is strong." The root of the word *chazak* means "strong." A Hebrew synonym for *chazak* is *gibor*, as in:

 a) "Wherein the mighty man (*gibor*) cries bitterly" (1:14), and

 b) "God, your Lord, is in the midst of you; He will save you with strength (*gibor*)" (3:17).

6) Yoshiyahu (Josiah): In Hebrew this means "God of salvation" or "God will save him." This name refers to several verses at the end of the book:

a) "God, your Lord, is in the midst of you; He will save (*yoshia*) you with strength" (3:17), and

b) "I will save (*v'hoshati*) the lame one" (3:19).

7) Ammon: When the name Ammon is spelled with the Hebrew letter ayin instead of the homophonic letter aleph, which is pronounced identically, Ammon refers to the nation Ammon (sons of Ammon) that will be destroyed (2:8).

8) Melech. The Hebrew homophonic word for M-L-CH (king) is a word that is spelled with the last letter chet instead of chaf – that is, M-L-CH, which means "salt." Salt references the sea (for example, *yam hamelach*, which means "sea of salt," meaning the Dead Sea), which references the Philistines, the sea costal-dwelling people. "Woe unto the inhabitants of the seacoast, the nation of cutting…. Canaan, the land of the Philistines, I will even destroy you, that there shall be no remaining inhabitants" (2:5).

9) Yehudah: Yehudah (Judah) is the nation to whom this book is addressed, and who will suffer both near-annihilation and salvation: "And I will stretch out My hand upon Judah" (1:4).

If one commits to memory the first sentence of this book – a very potent mnemonic – one will be able to recall the vast majority of the entire book's narrative.

What is the mechanism of destruction during Shoah II (Zephaniah)? The mechanism of destruction during Shoah I was water. During Shoah II (and III) it is fire: "Neither their silver nor their gold will be able to deliver them on the day of God's passing. But the whole earth shall be devoured by the fire of His wrath, for He will make an end, yea, a terrible end, of all the inhabitants of the earth" (1:18). "My determination is to gather the nations, and assemble the kingdoms to pour upon them My indignation, for the entire earth will be consumed by My fiery anger" (3:8).

Other references to destruction by fire metaphorically mention God's nose (*af*), which is synonymous with his fiery wrath, as in "The day of God's wrath (*af*)" (2:3). This metaphor is illustrated at the center of the

painting where two black fish are doubling as the left and right nostrils of Zephaniah's nose (which doubles as a mountain peak), which are each emitting the fiery wrath of God. The fire from these nostrils is heating up the sea to a slow boil. In this painting this is the mechanism wherein the fish in the water are destroyed. First they are boiled to death; then they will get sucked into oblivion down the central tsunami drain that is also doubling as Zephaniah's mouth, as mentioned above.

The fiery nostrils in this painting that illuminate the deep waters also are inspired by the passage: "And it will come to pass at that time that I will search Jerusalem with candles (*nerot*)" (1:12).

Submerged under the flooding waters are the towers and homes referred to in the text "Therefore their wealth shall become booty and their houses desolation. Yea, they shall build houses, but shall not inhabit them" (1:13). "A day of shofar and blasting against the fortified cities and against the high towers" (1:16).

In this painting the high towers are aglow with the fiery wrath of God. The red animals are aglow with the heat of boiling water.

Imagery of Shoah III, the twentieth-century Holocaust, is also grafted onto this painting with illustrations of naked, emaciated, bleeding corpses, dead from starvation, exhaustion, and torture, felled in killing fields, ghettoes, and concentration camps, and they have already sunken to the bottom of the mountains. Two corpses are at the epicenter of the tsunami, leading all the rest of the creatures being sucked into the mouth-drain of oblivion.

These images are also based on the text, "And their blood will be poured out as dust" (1:17). These words emphasize the sacrificial component of this Holocaust. While performing animal sacrifices, the Israelites are instructed in Deuteronomy that the blood of the animals should "be poured out like water" (Deut. 12:16), "for the blood is the life" (Deut. 12:23).

In Zephaniah, the blood of God's human sacrifices in Shoah II and, by extension, Shoah III shall be poured out like dust. Why like dust, and not like water? Because in Zephaniah, God is reversing the sequence of creation by going backwards; man was created by coalescing the dust from the four corners of the earth. To reverse the creative process, the aggregated

dust, which coalesces to form man, is now separated and segregated from man's earthly vessel and is poured out of it.

In this painting there are many large black and red sea creatures. They represent the other nations who consume the Judeans after being attracted to the smell of their blood in the water. These sea creatures are black and red, alluding to the color patterns of the Nazi insignia, thus representing the destroyers of the Jews during Shoah III, and by extension Shoah II, who will in turn be destroyed by the boiling water of God's wrath.

The sky above in this painting, to the left and right is dark and cloudy, as stated: "That day is a day of wrath, a day of trouble and distress, a day of *shoah* and *meshoah*, a day of darkness and gloominess, a day of clouds and thick darkness" (1:15). The dark clouds also constitute the smoldering, thick, black, smoked ashes of singed human flesh belched out of the Shoah III crematoria. The ashes, after rising upwards, are then dispersed by the wind into the four corners of the world from which they originated. The human remains are literally being poured out of the martyrs' bodies like dust, as stated in the text (1:17).

Illustrated in both left and right dark skies are Zephaniah's eyes, whose burning scleras ignite the fire of the Holocaust below. The burning scleras also symbolize the burning flames within the crematoria furnaces of Shoah III. Also each sky on the left and right of this painting has its own moon, which represents the nighttime sky. The moon on the right has the Hebrew words written on it: "A day of God's sacrifice (*zevach*, Holocaust)." The moon on the left has inscribed in Hebrew: "The voice of the Day of God wherein the mighty man cries bitterly" (too true).

Inscribed on the blue eye lens on the right is the Hebrew word *shoah*, and on the blue eye lens on the left is the Hebrew word *meshoah*. Each eye doubles as a burning, dead fish floating in the sky, outside its natural habitat, symbolizing the inversion of nature in the chaos of destruction.

Devastating imagery from Shoahs I, II, and III are fused in the left and right upper sides, and the lower portion of this painting. The middle upper portion of the painting illustrates the saved, non-submerged, mountain of God, an oasis for the post-Holocaust survivors of Shoahs II and III, and is the equivalent to Noah's ark of Shoah I. This dry fertile oasis with palm trees is a place of refuge for the survivors who have climbed, escaped, and

clawed their way up and out of the fire and water, and are thereby saved. They are "the remnant of Israel" (3:12). These Hebrew words are written high on the central mountain. This imagery fuses illustrations of post-deluge survivors (Shoah I), with that of survivors of Zephaniah's Holocaust (Shoah II), along with the concentration camp survivors of Shoah III.

Illustrated at the center of the non-submerged mountain peak is a surviving couple with their child, raising their arms in gratitude, singing joyously, as is written, "Sing, daughter of Zion" (3:14). These Hebrew words are inscribed on the mountain immediately above these individuals. The text further comforts Israel with the words "Shout Israel; be glad and rejoice with all your heart, oh daughter of Jerusalem. God has removed your punishments, He cast out your enemies; the king of Israel and God are in your midst, do not fear evil any longer. In that day it shall be said to Jerusalem: 'Don't fear; Zion, don't slacken your hands'" (3:14–16).

Illustrated on the left of the non-submerged mountain is a man climbing out of the water. The girl on the right is depicted resting comfortably, placidly dangling her feet. Two other men are illustrated scaling the mountain with the goal of reaching its peak. The man on top of the mountain is reclining peacefully, having already reached the peak of God's mountain. The radiant sun is shining brilliantly illuminating the post-Holocaust sky, and bathing the survivors of all Shoahs with a warm glow of goodness and hope. Written in orange letters in the center of the sun are the words "God is in the midst of you; He will save you with strength." Furthermore, "He will rejoice over you with joy, He will be silent in His love, He will rejoice over you with singing" (3:17).

Zephaniah also continues the prophetic tradition of appealing to people's fears and hopes by feeding them a great dollop of admonition (*tochachah*), followed by a smidgeon of comfort (*nechamah*). After going into a lengthy discourse about the sins of Judah – and the world – which led to exile and wholesale earthly destruction, Zephaniah smoothes it over with his concluding words of unmitigated salvation:

> I will gather them that are far from My holidays, who are of you that have borne the burden of reproach. At that time I will deal with all of them that afflict you; and I will save those who are lame, and gather

those who are driven away; and I will make them to be praise and a name, whose shame has been in all the earth. At that time will I bring you in, and at that time I will gather you up, for I will make you a name, and a praise among all the nations of the earth when I return your captives before your eyes, says God. (Zephaniah 3:18–20)

There is also an Isaiah-style universality incorporated in Zephaniah, as implied by the unification of mankind speaking the same language. Zephaniah repeatedly uses the literary technique of stepping backwards, or reversing history. Just like during the destruction, God reversed creation and destroyed everything that was created previously in history; just like He released the dust from man's body, which had been gathered from the four corners of the earth in order to create him – likewise with salvation He reversed the Babylonian curse of the tower of Babel, which divided mankind by imposing multiple languages. Now a unified language is to emerge, harkening back to an idyllic pre–tower of Babel righteous era: "For then I will return to the nations a clear language, that they all may call upon the name of God to serve him with unified consent" (3:9).

During Shoahs I and II God clearly outlined a cause-and-effect relationship between personal sin and suffering, and national immorality and global cataclysm. In both these Shoah narratives, it is made plain as day that good things happen only to good people and bad things happen only to bad people. If punishment and reward are to be meted out in the here and now, and there is no hereafter, the above rule must be applied in order to impose a moral and just society. It is clear in both these cases that the concept of a hereafter is not breached, and hence is nonexistent. All that exists after death is Sheol, an unpleasant abode for all, both good and evil. Thus reward and punishment can't wait for death.

The obvious uncomfortable paradox that bad things do indeed happen to good people, and good things do in fact happen to bad people has driven noble biblical personalities such as Ecclesiastics, Job, and Habakkuk (to name a few) into wild contorting moral conniptions, and have taken them on theological roller-coaster rides of logical and illogical loop-de-loops. After pure mental exhaustion from the inability to successfully address this question, they all settle into a sedate mental stupor maintaining that there

are no answers to this question, thus one shouldn't ask such a question; one must have faith in God, and it'll all be all right.

The book of Daniel, probably the last book of Tanach (refer to *The Book of Daniel: Back to the Future*, www.NahumHaLevi.com), breaks new theological ground by offering a long-sought-after explanation. It introduces the concept of a global resurrection and of an eternal afterlife where one's life is judged fairly and properly, and reward and punishment are posthumously meted out for all eternity. Judgment is simple, fair, and dualistic. Those individuals who are good, who have led a moral life, who are martyrs for God, are rewarded with resurrection, and a blissful eternal life. The opposite is true for those who commit evil. So why do bad things happen to good people? Don't be fooled; the scales of justice will be set right on the other side. The flesh is temporary; the afterlife is for all eternity. Why do evil people prosper? Have no fear, they'll get theirs when they cross over.

Some of those who survived the twentieth century Shoah (III), and/or those who became aware of its horrendous and despicable details, have been unable to come to theological grips with the magnitude of this catastrophe and the unimaginable destruction brought upon innocents. Some faithful lost their faith and concluded there cannot be a God in the face of such great injustice.

There are others who conclude – and take a page from the biblical narratives of Shoahs I and II – that if such suffering and cataclysm were wrought by God, then the victims could not be mere innocents. They must have done something wrong. Otherwise why and how could this have occurred? This is the same argument for the causality of human suffering that Job's comforters and God made, and the explanation that Job eventually (and of course paradoxically) embraces. So, sure the Nazis were evil, but they were mere instruments of God just like the Assyrians, or just like the Babylonians, and all the other evil empires throughout history.

Others conclude that the Holocaust is a non-issue with respect to theological belief. That is, God exists and is the inapprehensible essence of nature and of the universe, and is in no way personal in an anthropomorphic sense, and thus is independent of human-based morality. Hence, neither good nor bad fortune can be attributed to God, and the occurrence of

cataclysms does not disprove the existence of God; they are in fact part and parcel of the architectural fabric of that which is, as is everything else that we human beings arbitrarily and subjectively label good or evil.

The existence of terrible evil in the heart of man is an eternal human trait. It is unfortunately encoded in man's DNA, forged on the anvil of billions of years of environmental pressure, which since time immemorial has finely honed and perfected chillingly successful survival instincts. Thus, violence of evil man against innocent man (and other life forms in general) will always exist on small, large, and/or gargantuan scales.

Consequently, the shedding of innocent blood by brutal murderers does not implicate a lack of morality on the part of the innocent murdered victims, or on the part of God. It is not the victims who are abandoned by God; it is the murderers who have abandoned God, or who have not embraced any of the great moral teachings of the Torah and the Prophets. These teachings seek to soften and ethically transform people's naturally selfish and hardened human protoplasm into a selfless, altruistic form by bringing them to the realization that it is in every person's best selfish and unselfish interest to include and embrace all humanity as part of his family, in order to enhance his own personal survival and that of his own immediate family, clan, tribe, or nation. This cognitive capacity to apprehend and practice morality, which is the very elegant behavioral byproduct of the human brain that has been imprinted with the divine spark or the image of God, is fundamentally the only trait that separates man from beast. Without this characteristic, man is but a two-legged creature, or in other words, a brutal murderer.

Blaming innocent victims, predicated on pseudo-biblical analogies, by accusing them of not possibly being innocent – but somehow of being covertly evil or on the wrong side of the theological tracks – and thus deserving of the calamity that befell them during Shoah III, is theologically negated by occurring in the post–book of Daniel age. Infants who could not even speak or formulate thoughts, the elderly, the disabled, the saintly, the righteous, and the sinners were all swept up into the maelstrom of Nazi Europe. Thus, implying a cause-and-effect relationship between covert, blanket, national guilt and the horrible outcome in this case is both obscene and irrational. From a biblical, post-Daniel perspective, all the victims of

the Shoah (III) are considered "martyrs": *am kedoshei elyonim*, a "nation of elevated Holy Ones." Their suffering innocence will be rewarded in the hereafter. The evil perpetrators will be judged and dealt with on the other side.

Whether one is theologically or secularly inclined; whether one believes or doesn't believe in the direct causality between morality and post-mortem justice; whether one does or doesn't believe in an afterlife; whether one believes that there are or are not adequate answers to the complex issues of the suffering of innocents in the hands of capricious nature and/or selfish, violent man – the book of Zephaniah holds out fundamental truths that are self-evident, and if practiced by a greater proportion of humanity would greatly diminish suffering and enhance peace and well-being: that is, "Seek righteousness and humility" (2:3).

Perhaps this is the true, hidden, ageless message that the book of Zephaniah has bequeathed to mankind.

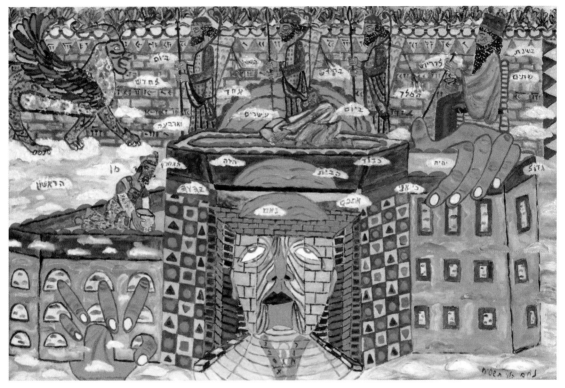

Haggai: 2007/36X24 inches/oil on canvas

Haggai's Home Improvement

13

13

This painting visualizes Haggai the Prophet's divine message enunciated in 521 BCE, several years after the Persian monarch Cyrus defeated the Babylonians and invited the Judeans back to Israel, granting them permission to rebuild the Temple. During this period Persia was under the rule of King Darius.

The Jewish exiles have returned home, and they hasten to rebuild their own dwellings but are in no particular rush to restore God's home, the Temple, which sits in shambles. Haggai admonishes both the civil leader Zerubbabel son of Shealtiel, the governor of Judah, and the high priest Joshua son of Jehozadak, for their egregious neglect and moral laziness in not hastening to restore God's house.

God speaks admonishingly through Haggai's voice: "Is it a time for you yourselves to dwell in your snug houses, and this house lays in ruins? You have sown much, and brought in little. You eat but are not satiated. You drink but your thirst isn't quenched. You are dressed, but not warm. He who earns wages does so for a bag riddled with holes" (1:4–6).

After Haggai continues his castigation, maintaining that there has been a drought and lack of material success because the Jews do not have their priorities in order, Zerubbabel and Joshua hearken to God's words and begin reconstructing the Temple.

At the center of this painting are Haggai's ethereal face and hands integrated into the Temple edifice, assisting in its reconstruction. On the left and center rooftops of the Temple, respectively, are Joshua the priest

and Zerubbabel the governor laying building stones. Haggai's prophetic forehead (mind) expands and rises upward, denoting his expansive, elevating prophecy. The words emanating from his mind are inscribed within the heavenly clouds floating above and around him. Dark blue Hebrew words in the uppermost clouds are read from right to left: "In the second year of Darius the King, in the sixth month, in the first day of the month [the date of the initial prophecy]…in the twenty-fourth day [the day the Temple reconstruction commences]" (1:1, 15).

Written in red letters in the middle-tier clouds are the words "Greater will be the glory of this last house compared to the first" (2:9).

Written in blue letters on the lowermost clouds are the words "Because I am with you, says God [the tetragrammaton is written in ancient Hebrew, as was the custom in 521 BCE]" (2:4).

Written on Haggai's neck on the bottom of the painting is a crossword: Etched vertically from right to left are the words, "Spirit of the Prophet." Written horizontally, connecting the two vertical columns, is the prophet's name, "Haggai."

At the right upper part of the painting is the image of Darius against the backdrop of his palace in Persepolis, accompanied on his left by three royal archer guards and a royal sphinx. This ancient Persian imagery places Haggai's prophecy in temporal-spatial historical context.

Graffiti written in ancient Persian (Aryan) on the palace wall, and read from left to right, starting from the upper yellow inverted triangles down to the bottom of the palace wall, are fragments of the words inscribed on the doorposts of the inner room of Darius's palace, "Darius, the great king, king of kings." (An identical Near Eastern appellation is used to describe God by the Judeans.)

The Hebrew names of each of the major characters in the book of Haggai, all of whom are represented in this painting, are laden with significance. The name Haggai in Hebrew means "My [God's] holiday." When the Temple is rebuilt, all the Jewish holidays – in particular, the three major pilgrimage festivals which are of central importance to the practice of Judaism – will once again be celebrated. It is no coincidence that the prophet, who agitated for the reconstruction of the Temple in order to celebrate these holidays, would be called "My holiday."

If we look at the name "Zerubbabel son of Shealtiel," governor of Judah, this too is pregnant with meaning. If we take his first name, and parse it into its two constituent Hebrew words, we get *Zar* (Z-R) *Babel* (B-B-L), "stranger [or exile] of Babylon," which is what he and his people were. He didn't belong in Babylon. He is now back in his natural home. His father's name is *Shealti El*, "I have asked God" – most likely asking to return from exile. Zerubbabel is known as governor, or in Hebrew *pecha*, which in the possessive form becomes *pachat*. In Hebrew these same letters create the word *pachot*, which means "less" – as in "less than sufficient" for not initially rebuilding the Temple when he had the civil authority to do so.

The high priest's name is "Joshua son of Jehozadak." By rebuilding the Temple, "Joshua" lives up to his name; he is being a "savior." He also lives up to his father's name, "God's justice."

"Darius" in Persian and Hebrew is pronounced and spelled "Daryavesh." If we break this word down into its two Hebrew constituent homophonic words, we get *Dar Yavesh* or "dry generation." In other words, life in Persia for the Judeans was a generation filled with dryness.

We know from the book of Ezra that the Temple's reconstruction finished roughly five years after Haggai began to prophesy, proof of one man's visionary power to change the course of history and the fortunes of mankind.

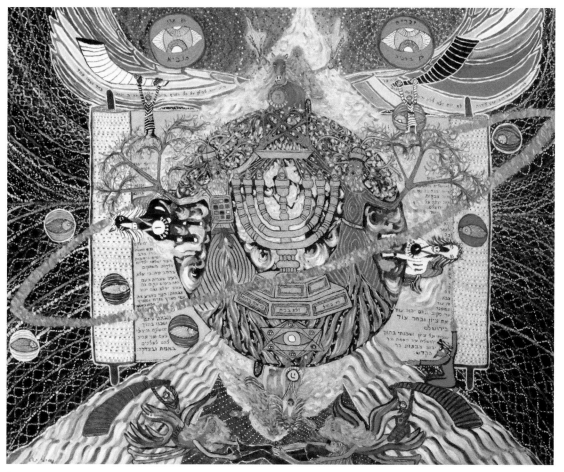

Zechariah: 2009/64X48 inches/oil on canvas

Zechariah: The Persistence and Reciprocity of Memory

14

14

This painting attempts to reconstruct and unify into one holistic visionary expanse, the many colorful, mind-explosive visions experienced through the eyes of the prophet Zechariah, son of Berechiah, son of Iddo. These visions, according to the text, take place between 520 and 518 BCE, between the second and fourth years of Darius's reign, during the seventieth year of Judah's exile. The only other Hebrew prophet that rivals Zechariah's wild and phantasmagoric imagery is Ezekiel.

In the book of Zechariah, just like in most of Tanach, there are no descriptions of the prophets' physical appearances. This is simply because their appearances are irrelevant. What is relevant is not how *they* appear, but what appears in their visions, which is described in glorious detail. For this reason, and to visually capture this sentiment on canvas, Zechariah here is not physically illustrated; his visions are (although a semblance of his face is embedded in the background).

The central theme at the crux of Zechariah is the mutual and reciprocal reawakening of the dormant, powerful, loving memory that God has for Israel (i.e., Judah and Israel), and that Israel has for God. This memory of what once was, is, will be, and that which can never be extinguished serves to propel mutual and reciprocal real-world actions and reactions. God is going to gather His people from their lands of exile and return them to Israel. The Temple will be reconstructed, restored, and protected in Jerusalem. In return, Israel will give up its immoral ways, and will rekindle and resume its ethical raison d'être and its devotion to God: "God said: Return to Me, and I will return to you" (1:3).

Zechariah's name itself reflects the reciprocity of memory between man and God. His name in Hebrew, when broken down into its constituent words, is *Zechar Yah*, which can be translated as "the memory or remembrances of God" (God remembers man), or alternatively, "remember God" (man remembers God). Zechariah is the son of Berechiah. Likewise, if this name is broken down into its Hebrew constituent words, it reads *Baruch Yah*, which can be translated as "the blessing of God" (God blesses man), or alternatively "bless God" (man blesses God). Berechiah is the son of Iddo. Likewise, when Iddo is broken down into its Hebrew constituent words *Ed oh*, it can be translated as "His [i.e., God's] witness" or alternatively as man "the witness of God."

Zechariah's name is probably loosely based on the only two references in the text using the root word *zechar,* "remember." One reference is used in the positive sense: "And I will sow them among the peoples, and they shall remember Me (*yizkeruni*) in distant lands" (10:9). The other reference is used in the negative sense: "And it shall come to pass on that day...that I will cut off the names of the idols out of the land, and they shall no longer be remembered (*yizachru*)" (13:2).

The sensory vehicle for memory in this book is visual, both for man and for God. Zechariah is repeatedly lifting up his eyes to apprehend his visions (2:1, 2:5, 5:1, etc.). God's seven eyes are traversing the earth (4:10). Israel is described as the apple of God's eyes (2:12). God is reciprocally described as the eye of man (9:1). The number of references in this book referring to either sight or eyes – that is, to the visual experience (both God's and Zechariah's) – tallies twenty-four, equal to the number of hours in a day (see notes at the end of this chapter, sec. A). These twenty-four references allude to the single twenty-four-hour day called the Day of God, wherein "there shall not be light, but heavy thick clouds, and there shall be one day, and it will be known to God not as day, and not as night, but it shall come to pass at the time of evening there will be light...and God will be King over the entire earth, on that day will God be one, and His name one" (14:6–9).

Perhaps the visual approach to memory is employed because the auditory approach of just hearing the words of God didn't work particularly well prior to the Babylonian exile: "Return from your evil ways and doings,

but they did not *hear* nor did they pay attention to me" (1:4). This is despite the fact that a well-developed sense of hearing is a crucial tenet in Judaism: "*Hear*, O Israel, God is our God, God is one" (recited while covering ones eyes, extinguishing vision, and meditating on the elusive sound of God). Perhaps, actually seeing these visions through the eyes of Zechariah, and imagining them with one's own eyes, will make a stronger impression on remembering the word and ethos of God according to Zechariah.

Additional recurrent, crucial thematic numbers in Zechariah include:

1) the number 4, which symbolizes the four letters of the tetragrammaton, Y-H-V-H. There are seven textual references to the number 4 (see notes, sec. B),

2) the number 7 which has four textual references (see notes, sec. C), and

3) the number 1, as in One God.

Seven symbolizes the creative essence of God as manifested by God's seven days of creation ex-nihilo of all inanimate and animate matter, and of space and time itself. This combination of seven-four-one is also reflected in the *lulav-etrog*, a major ritualistic feature of the Sukkot holiday, the set time when the apocalyptic Day of God occurs in Zechariah's final vision.

The *lulav-etrog* contains four species, yet has seven elements (one palm branch, three myrtle branches, two willow branches, and one citron), which are bound together and unified into one single construct. Seven plus four plus one of course adds up to twelve, which is the number of months constituting a single year. Hence Zechariah contains (direct and indirect) numerical references to incremental units of time: twenty-four hours, which constitute a single day; seven days, which constitute a single week; and twelve months, which constitute a single year. This all occurs within the recurrent background of the four letters of the tetragrammaton, which symbolizes the four corners of the earth, implying the never-ending (*En Sof*) expanse of the universe. Thus, in Zechariah, God's memory permeates the fabric of space and time; it is eternal and ubiquitous.

This painting also attempts to convey a synesthesis of sight and sound, alongside a synthesis of matter, energy space, time, and the building blocks

of life. This fusion of sensations, dimensions, and modalities is yet another reflection and expression of the multisensory, modal attributes of God reflected in Zechariah's visions. This will also be more fully elaborated upon below.

One of Zechariah's central thematic visions is of the Temple's seven-branched golden menorah, flanked by two olive trees, whose symbolism is illuminated by a heavenly avatar, an angel. This vision is illustrated at the center of this painting. It is based on the text: "And he [the angel] said: 'What do you [Zechariah] see?' And I [Zechariah] said, 'I have seen, and behold, here is the all-golden menorah, and a bowl is on top of her [the menorah], and it has seven lights; there are seven, and seven pipes to the lights that are above her [the menorah]. And there are two olive trees, one to the right of the bowl, and one on her left'" (4:2–3).

The golden menorah in this painting is centered in the middle of the world. The green African and European continents are behind it. The central branch of the menorah, the *shamash*, which is flanked by three branches on either side of it, is centered geographically on Jerusalem in Israel-Zion. The menorah illustrated here is patterned after the one etched on Titus's victory arch, and is therefore probably the most accurate rendition. The central stem of the menorah emanates from a stacked double hexagonal pedestal. There are other extant images of the menorah that illustrate a tripod pedestal. This is probably because a simply drawn tripod lends itself more to quick and reproducible engraving that nevertheless captures the general geometric shape of the menorah.

The central placement of the menorah in this painting represents the return of God to His Temple in Jerusalem, His earthly abode at the center of the world. An eye is illustrated in the center of each of the menorah's seven burning lights. These seven cumulative burning eyes represent the seven eyes of God in Zechariah's visions: "And they shall see the stone plummet in the hand of Zerubbabel; these seven are the eyes of God which traverse the whole earth" (4:10).

Thus the menorah with its seven branches of burning lights represents the eternally active, creative presence of God. The seven lights symbolize the seven days of creation wherein all matter, space, and time were created out of nothingness. The crown and capstone of creation, the seventh

day of Sabbath, which symbolizes the sanctification of time-creation, is represented by the central *shamash*. The burning lights of the menorah are the divine sparks, the emitted exothermic energy and brightness of God's creative process.

The eyes that stare out at you from the center of the menorah flames in this painting represent the reciprocal visual (memory) relationship between man and God. These are both the eyes of God that look out and see/observe/ protect Israel, as well as the eyes of Israel that receive and perceive God's illumination, and hence visualize His metaphysical presence. As stated in the text: "For God is the eyes of man" (9:1). Also, Israel is the apple of God's eye: "He that touches you touches the apple of His eye" (2:12).

Thus when Israel looks at the lit menorah, they see, experience, and re-experience (and remember) the eternal acts of the creation of heaven and earth, matter and time in the past, the present, and the future. By seeing the lights, they are synesthetically feeling the spirit of God. This is what the angel means when he explains the meaning of the menorah vision to Zechariah: "This is the word of God unto Zerubbabel, saying: Not by might, and not by strength, but by My spirit [My breath; My wind], says God" (4:6). In this painting these words are written in blue letters on the bottom hexagonal pedestal of the menorah.

"The spirit" stated by the angel is a direct reference to the creative narrative in the first sentences of the book of Genesis, which describes the inception of creation itself: "In the beginning, God created the heavens and the earth. Now the earth was unformed and void, and darkness was upon the face of the deep; and the spirit [breath] of God hovered [frolicked lovingly] over the face of the water" (Genesis 1:1–2).

In this painting, God's seven eyes look out at Israel from the burning menorah flames, while Israel's eyes simultaneously look toward God. The lines of vision that are directed between God and man interlock in mutual and reciprocal visualization, establishing a visual covenant. Thus the menorah lights flicker in one stationary dimension, yet her flaming eyes flutter to and fro in yet another dimension.

This now brings us to a discussion of the geometric significance of the menorah's hexagonal pedestal, and its relationship to the Star of David, the Magen David.

The text describes the Temple's foundation stone given to Joshua the high priest (*kohen gadol*), and later to Zerubbabel, as having seven eyes (faces): "For behold the stone that I have laid before Joshua, on one stone are seven eyes, behold I will engrave its carvings" (3:9). "And they will see the stone plummet in the hand of Zerubbabel; these seven are the eyes of God which traverse the entire earth" (4:10).

What is this foundation stone with seven eyes? We here hypothesize that it is the hexagonal pedestal of the menorah. The top surface of the pedestal's hexagon is one facet (eye) of the foundation stone. The six side-surfaces of the hexagonal pedestal are the other six facets (eyes). Six facets (eyes) plus one facet (eye) equals a seven-faceted (seven-eyed) foundation stone.

The pedestal's central hexagon is the radial equivalent of the menorah's linear central branch, the *shamash*. All the branches of the menorah branch out of the central stem, which emanates from the center of the pedestal's hexagonal upper surface. The *shamash* is at the center of these branches; it is perpendicular to the center of the hexagonal base, and is indeed an extension of it. Thus the seven-faceted (seven-eyed) stone, the foundation stone of the rebuilt Temple in Jerusalem, is in fact the foundation: the pedestal of the menorah.

For thousands of years the singular design motif that symbolized the Jewish people, and appeared on ossuaries and other Jewish objects, was a simple diagram of the Temple menorah. The Magen David (Star of David) is a relatively recent symbol of the Jewish people. For the same thousands of years, the Star of David had appeared as a nondescript decorative design in synagogues, churches, mosques, and other temples. It was only in the late 1500s in Prague that the Magen David was first introduced as a shorthand symbol representing the city's Jewish denizens. Eventually the Magen David was adopted by Jews in other regions of Europe and beyond. Today it is the universally recognized design motif of Jews the world over, and also adorns the Israeli flag. It has effectively usurped the menorah's position as the universal Jewish symbol. However, a Temple menorah (based on Titus's victory arch) flanked by two olive branches (referencing Zechariah) symbolizes the modern State of Israel.

If we analyze the geometry of the Magen David, we will find that it is

identical to the geometry of the hexagonal base of the Temple menorah, and hence is the deserving successor of Jewish-people symbolism. The near-universal subliminal realization of this geometric equivalence was probably why its use spread so rapidly and enthusiastically amongst the Jewish people.

In this painting, a three-dimensionalized Magen David appears underneath the menorah. The central portion of the Magen David is a hexagon just like the base of the menorah. If we extend a triangle from each of the hexagon's six surfaces, we get a Magen David. Geometrically that would be six small triangles, coming out of a single central hexagonal base. Six plus one is seven: it is the seven-sided stone that Zechariah refers to, the foundation stone of the Temple which is the pedestal of the menorah.

In this painting, the three-dimensionalized Magen David has an eye in each of its triangulated extensions. The largest eye (the *shamash* equivalent) is at the center of the Magen David's hexagon (equivalent to two triangles). Hence the Magen David's seven geometric constituents mirror the geometry of the menorah pedestal, which in radial form mirrors the menorah's seven linear branches. If we look at the menorah we notice that its horizontal branches and its vertical stem are arranged in linear x, y, and z coordinates. The hexagonal pedestal is arranged in infinite radial spatial coordinates. As mentioned above, the burning lights represent the dimension of time. Thus, in totality, the menorah captures linear and radial space-time, symbolizing the eternal presence of God. The Magen David geometrically reflects the same symbolism as the menorah (especially in 3-D), and hence is the menorah's proud, symbolic, deserving successor of Jewish peoplehood.

Let us now return to Zechariah's vision of the menorah, and focus on its two surrounding olive trees and their symbolism.

Zechariah is told by the angelic avatar that the two olive trees generically represent, respectively, the *kohen gadol* (the high priest), and the king of Judah, a descendant (*tzemach*, shoot) of David. Contemporarily (in Zechariah's time) they represent, respectively, Joshua the high priest, and Zerubbabel the governor of Babylonian/Persian Judah, the descendant of King David and a potential successor in line for the throne. Together they will lay the foundation stone of the Temple, and together they shall

successfully rebuild it. These two individuals are also assigned this task by Zechariah's contemporary, Haggai the Prophet.

> And I spoke with the angel saying: "What are these, my Lord?" Then the angel that spoke with me answered and said to me: "Don't you know what these are?" Then I said: "No, my Lord." Then he answered me and spoke, saying: "This is the word of the Lord unto Zerubbabel saying: Not by might, nor by strength, but by My spirit. Who are you Great Mountain, before Zerubbabel? You will become a plain and he will bring forth the top stone with shoutings of grace, grace unto her." (Zechariah 4:4–7)

> Moreover the word of God came unto me saying: "The hands of Zerubbabel have laid the foundation of this house…." And he showed me Joshua the high priest standing before the angel of God…. And the angel of God said: "If you will walk in My ways, and if you will keep My charge, and will also judge My house, and keep My courts, then I will give you free access among these that stand by…. For behold the stone that I have laid before Joshua, upon one of the stones are seven eyes…." (Zechariah 3:1–9)

Hence the seven-eyed stone, i.e., the pedestal of the menorah, i.e., the foundation stone of the Second Temple, i.e., the explicit task of rebuilding the Second Temple from the ground up is laid before both high priest and king.

This is further corroborated when Zechariah once again asks the angel: "'What are these two olive branches which are beside the two golden spouts that empty the golden oil out of themselves?'…'Don't you know what these are?' And I said: 'No my Lord.' Then he said: 'These are the two anointed ones that stand by the Lord of the whole earth'" (4:12–14).

Who are the two anointed ones? Aaron, the first high priest was the first priest (first person ever) to be anointed (*nimshach*) with oil, consecrating him for his services in the Tabernacle. Every subsequent high priest was probably similarly anointed. King Saul was the first king of Israel to be anointed with oil consecrating him for his services to God and Israel. Every subsequent king thereafter was similarly anointed with oil. Hence

the appellation *Mashiach* (Messiah) is typically used for the generational inherited position of king of Judah and Israel, which incidentally could just as easily apply to each generational inherited position of *kohen gadol*.

Thus what Zechariah visualizes occurring in Jerusalem while he is in exile in Persian Babylon is the soon-to-be reconstitution of the national State of Judah under the united theological leadership of the high priest and the civil leadership of the king. Both branches of leadership are vital to the national well-being of the State. Both stand on either side of God. In Zechariah's vision, there is complete unification – in contradistinction to separation – of Temple and State under the canopy of God.

In this painting, illustrated to the left and right of the menorah are two anthropomorphized olive trees. The olive tree on the left is the high priest, and the olive tree on the right is the king. The high priest is wearing his miter, which is inscribed in ancient Hebrew with the words "Holy to God." He is also wearing the breastplate with the twelve stones representing the twelve tribes (also representing the twelve months of the year, a discrete unit of time, numerically combining the seven-four-one theme of Zechariah's visions). The olive tree on the right of the menorah is the king. He is dressed in royal red, wearing his gold crown. His belt is inscribed in purple letters with the word "shoot," meaning he's a descendant of David. Ritual fringes (tzitzit) descend from his belt.

Both the high priest and king olive trees have their heads and arms extended in multiple olive-tree branches, from which emanate olive leaves and dangling olives. The fingers of their hands are separated in priestly blessing configuration. All four branched hands are individually and collectively blessing Israel. Centrally, the priest's hand to the left of the menorah, and the king's hand to the right of the menorah intertwine, symbolizing the union of priest and king, Temple and State.

Centrally, olives descending from the olive branches emanating from the priest's and kings' intermeshing hands drip out oil into the golden basin above the golden menorah. The oil then fills the basin running into its bottom fourteen pores, which are connected to fourteen conduit-pipes, which transport oil via gravity to the seven oil chambers atop the seven menorah branches. Two pipes apiece transport oil to each of the seven oil chamber cups, providing fuel for the continuous burning of the menorah

lights. As stated in the text, "seven pipes, seven pipes" (4:2) – that is, a total of fourteen conduits deliver oil into the menorah.

Seven conduits are provided by the priest, and the other seven conduits are provided by the king. Each light gets one pipe from the priest and one pipe from the king. This symbolizes that it is the unification of priest and king, of Temple and State, that anoints the menorah, and they jointly keep the lights of the menorah – the symbol of God – burning. The oil is generated from their own tree-body secretions, i.e., blood, sweat and tears (and oil). This further symbolizes Zechariah's conception of the mutual reciprocity between man and God. God anoints these two men, and these two men anoint God. Without God, the two men can't be anointed. Without the oil from these two men and their descendants, the menorah of the Temple, the symbol of God, won't illuminate the earth. Thus there is a mutual reciprocity with respect to vision, to memory, to need, thereby expressing a total man-God functional interdependence. This concept was later incorporated into Lurianic Kabbalistic thought.

In this painting, the olive-tree branches emanating from both the *kohen gadol* and the king merge, intertwine and coalesce to create a canopy covering the top of the world; they form the "roof" (in Hebrew, the *sechach*) of the sukkah of the world. This symbolizes that the world itself is one large, fragile sukkah, whose existence is dependent on God's compassion. This imagery is also integral to Zechariah's final apocalyptic Sukkot vision. According to Zechariah, the Great Day of God will occur during the seven-day holiday of Sukkot. Seven days of holiday symbolize once again the seven days of creation, which are reflected in the seven branches of the menorah, the seven eyes of God, and so forth.

In this painting the bodies of the high priest and king morph into tree trunks with tree rings. Their trunks are then subdivided into multiple roots that penetrate into the core of the earth and the depths of the oceans, from which they receive nourishment and thereby grow, reaching fantastic heights.

Zechariah, while experiencing his first-ever vision, is introduced to his heavenly avatar, an angel who explains to him the significance of his first and all subsequent other visions. During this first vision, which occurs at night, he sees this angel in the form of a man riding a red horse standing

between the myrtle trees. This angel may be the same angel mentioned in the subsequent book of Malachi (which in Hebrew means "My angel"); in the last sentences of Malachi he is identified as Elijah the Prophet (Malachi 3:23). Because Elijah departed earth in a whirlwind to heaven – in a fiery chariot transported by fiery horses (II Kings 2:11) – this angel who appears riding a chariot surrounded by horses is quite possibly the angel who appears in Malachi, that is, Elijah. (This will be discussed further in the Malachi painting to follow.) Therefore, in this painting the angel is illustrated with a fiery body.

Behind the angel are red, sorrel, and white horses. Thus there are four assemblies of horses/beings in this vision: 1) A man on a red horse, 2) other red horses, 3) sorrel horses, and 4) white horses. It is explained to Zechariah that these four sets of horses are wandering the earth, and can't help but notice that the world at large is quiet, at rest, if not asleep.

In other words, despite the fact that the kingdom of Judah has been defeated, the Temple is in shambles, and Israel is in exile, the entire world is alarmingly quiet. Where's the outcry? Where's the protestation? Can anyone hear any lamentation from any of the nations of the world? It is as though Judah never was, as though God is not, and no one really cares. The earth continues to lazily spin on its axis as though nothing is new under the sun: a central thematic concept in the book of Ecclesiastics (*Kohelet*), which is read on the holiday of Sukkot (as is the book of Zechariah).

The angel asks God: How, after Judah's seventy years of exile, can He too remain silent alongside the unfeeling sea of humanity? How can He not have any compassion on Jerusalem and the cities of Judah? Has it not been long enough? Has their seventy years of punishment and suffering not yet sufficed? Have they not endured enough pain? God concedes to the angel that the memory of Zion is indeed beginning to stir within Him. Yes, he is becoming upset, he is now jealous for Jerusalem and Zion. Just because he was ever so slightly displeased with Judah, all the nations helped commit a terrible evil against them. His memory, now stirred, begins to deepen and grow: "I will return to Jerusalem with compassion. I will rebuild My house, and a line shall be stretched forth over Jerusalem. Thus says God: My cities will again overflow with prosperity, and God will once again comfort Zion, and again choose Jerusalem" (1:13–17).

The four groups of horses described in this first vision are numerically analogous to the four horses described in a later prophecy of Zechariah's. In that prophecy he sees four chariots bursting forth from between two mountains of brass. The first chariot is pulled forth by red horses, the second chariot by black horses, the third chariot by white horses, and the fourth chariot by grizzled bay horses. It is explained to Zechariah that these chariots and horses are the four winds of heaven, which go out after consulting with the Lord of the earth. These appear to come from the same stable as the horses in Zechariah's first vision which went out and noticed the quietude of the world, and then reported back to God.

Thus, in this painting, Zechariah's two equine-centric visions are fused. Four horses are illustrated separately galloping forth in four directions to the four poles (corners) of the world: north, south, east, and west. They are all transporting chariots. Each of these four horses represents galloping agents, or avatars, of God. They are symbolically similar to the seven eyes of God traversing the earth, in that they embody the wandering, ubiquitous, all-seeing, powerful presence of God. God sees through the eyes of these horses while they travel throughout the globe inspecting the four corners of the world. The seven wandering eyes of God, and the four horses or winds of God, are yet another seven-four-one (twelve) association intimated in this book. There are incidentally eight references to horses in Zechariah (four horses, with two eyes per horse; see notes, sec. D). In this painting, each of the four horses is galloping to their respective poles, bursting forth from between the two mountains (wings) of brass (to be described below). They are propelled to the south, north, east, or west, by their respective streams of jettisoning directional winds, as noted in the text.

The four directional winds also reflect the dispersion of the Jews to these very same four corners of the earth where the horses and four winds are traveling. "For I have dispersed you like the four winds of the heavens. Zion, escape, you who dwells with the daughter of Babylon" (2:10–11). The four winds also visit the four corners of the earth from which God gathered dust to create man.

In this painting, one of each of four letters of the tetragrammaton (Y-H-V-H) is written on the chests of each of the four horses. The first letter, yod, is written on the white horse on the right (galloping on the eastern pole).

If one then proceeds to read the letters on the chests of the other horses, beginning with this Y (yod), in either clockwise or counterclockwise directions, God's name, Y-H-V-H is spelled out identically: Y-H-V-H vs. Y-H-V-H. This is in contradistinction to reading Y-H-V-H linearly backwards which spells H-V-H-Y vs. Y-H-V-H.

In Zechariah's apocalyptic vision, which deals with the Sukkot holiday (to be discussed below), horses on the Great Day of God will have bells upon them that are inscribed with the words "Holy to God." In this painting all the horses are wearing bells that are inscribed with these Hebrew words "Holy to God." The top red horse transporting the angel is illustrated galloping to the North Pole (the top of the world), and is given the honor of having two rows of bells. The text describes the angel riding upon a horse (implying a sitting position), yet he is also described as standing between the myrtle trees. To reconcile these positions, in this painting he is illustrated as standing on the base of the chariot and simultaneously riding the horse. To symbolize the angel's "standing between the myrtle trees" in this painting, he is illustrated as standing between the two *lulav-etrog*s that he is brandishing.

In this painting the *lulav*s are surrounded by light, and act as beacons lighting his path and heralding his arrival. The *lulav*s, along with myrtle branches (which come from myrtle trees) are brought to the Temple on the Sukkot holiday, during Zechariah's apocalyptic Great Day of God. During the Sukkot holiday, Jews gather and unite four species of vegetation: 1) three myrtle branches, 2) two willow branches, 3) one palm branch, and 4) one citron. Thus the total number of elements in the four species adds up to seven.

There are many different symbolic and midrashic explanations for the four species of the *lulav-etrog*. One explanation is that each species represents a different part of the human body. The *lulav* is shaped like and thus represents the spine, the backbone. The *etrog* (the citron) is shaped like and thus represents the heart. The willow leaves are shaped like and thus represent the lips. The myrtle leaves are shaped like and thus represent the eyes. The symbolism is that man's heart, spine, eyes, and mouth (lips) unify to pray to God.

The leaves of the myrtle branches, which are shaped like eyes, also

recapitulate Zechariah's central visual-eye-memory theme. In this painting, the myrtle branches of the *lulav*s are facing inward on the angel's right and left sides, such that the angel is literally emanating between the myrtle trees (branches). If we concentrate on only the myrtle branches (of the *lulav*s) of this painting on either side of the angel, it recapitulates the general structure of the menorah. The fiery angel represents the *shamash*, the major central light of the menorah. The three illuminated *lulav* myrtle branches on the left and right sides of the angel represent the three menorah branches on the left and right sides of the *shamash*. Their eye-shaped leaves mirror the flaming eyes of the menorah illustrated in this painting.

The four species of *lulav-etrog* as noted above contain a total of seven elements, which are combined to form one single construct. This seven-four-one numerical iteration is another recurring theme of Zechariah's visions. The four species represent the spatial totality of God's tetragrammaton, which encompasses and encircles the earth, just like the four winds or horses of God. The *lulav-etrog*'s seven elements are analogous to the seven eyes of God, the seven branches of the menorah, and the seven days of creation representing the creative-time totality of God. Thus the *lulav-etrog* is in essence a shorthand seven-four-one mathematical formula symbolizing not only God, but also man who is created in God's image (*tzelem Elokim*). The *lulav* and *etrog* coincidentally are also ancient Jewish symbols, alongside the menorah, inscribed on Jewish ossuaries, synagogues, coins, and ritual objects for thousands of years.

In one of Zechariah's later visions he sees Joshua the high priest standing before both the angel of God and Satan. The latter is standing to his right enticing him to err. In this painting, Satan is illustrated riding on the bottom, South Pole, galloping horse. He is the fiery mirror image of the North Pole angel. The only difference is that he is not carrying *lulav*s. His arms are outstretched, and his hands are empty. During this vision, the priest is wearing filthy garments, representing disuse during the period of exile. He is awarded with fresh robes and a miter symbolizing the restoration of his service to the newly, soon to be rebuilt Temple. Illustrated in this painting is Joshua, the high priest, wearing fresh clothing. He has chosen the correct path and walks in the way of God. The concept of the angel

and his antithesis, Satan, appear to be metaphorical representations of the freedom of will to choose good or evil, respectively.

In Zechariah's second vision, he lifts his eyes and sees four horns. The angel explains to him that "these are the horns that scattered Judah, Israel, and Jerusalem" (2:2). These four horns are illustrated in this painting; two horns are above the earth covering the northeast and northwest, and two horns are below the earth covering the southwest and southeast. Together they span the four corners of the world. These horns are the victory trumpets that were sounded by Israel's enemies announcing Israel's dispersion to the four corners of the globe.

Immediately after this vision, God shows Zechariah four craftsmen. It is explained to him that "the horns that scattered Judah, such that no man should lift his head [in assistance]; these [craftsmen] have come to frighten them to cast down the horns of the nations, which lifted up their horn against the land of Judah to scatter it" (2:4).

Illustrated in this painting are the four craftsmen bringing down each of the four horns. In keeping with the visual-eye theme of this prophecy, the craftsmen are portrayed with eye-faces. They are somewhat angelic. Starting with the upper-right craftsmen (northeast), one of each of the four letters of Y-H-V-H is written in Hebrew on the clothing of each of the four craftsmen, spelling out Y-H-V-H. Y-H-V-H is spelled out on these craftsmen when going either in clockwise or counterclockwise direction. The upper (northern) two craftsmen are aloft the olive-tree branches sprouting from the king and high priest. The lower (southern) craftsmen are hitching a ride on the women with the wings of storks that are flying the measure of evil off to Shinar (described below).

In Zechariah's next vision, he lifts his eyes and sees a man with a measuring line in his hand. He asks the man where he's going, and the man answers him: "To measure Jerusalem, to measure its width and length" (2:6). This man is illustrated in this painting in orange on the bottom right of the flying scroll. He is illustrated with two measuring sticks measuring the width and length of the world (for all intents and purposes Jerusalem).

Again in keeping with the theme of visual memory, this measuring man has a very large eye. Furthermore, he has a three-dimensionalized Star of David hat. This hat visually reemphasizes that the Star of

David consists of a central hexagon that mirrors the hexagonal base of the menorah adjacent to it. The hat has six triangles jutting out of it. This is equivalent to having six triangular candle lights jutting out of it radially. The central hexagon is twice the area of the small triangles, analogous to the middle *shamash* (twice the importance) of the menorah. This symbolizes that the menorah together with its horizontal seven branches and radial hexagonal extensions cover all spatial dimensions. These branches or lines can be extended ad infinitum, covering the entire expanse of space. The lights themselves illuminate and burn within the dimension of time in the past, present, and future. Hence the menorah, and its symbolic descendant, the Star of David, represent the enduring presence of God.

Suddenly, after the previous vision, yet another angel comes forth to talk to the angel who is talking to Zechariah. This angel tells the other angel: "Run, speak to this young man, and tell him: Jerusalem will be inhabited without walls, with many people and animals within it. And I will be for her, God says, a wall of surrounding fire, and I will be the glory at the center of it" (2:8–9).

Illustrated in this painting is a fiery Saturn-type ring surrounding the world – that is, Jerusalem. This symbolizes the protective "wall of surrounding fire" as mentioned in the text above. Seven roving satellite planetoid eyes (of God) are rotating and revolving around the earth in the same gravitational sphere as the ring of fire. God's seven planetary eyes join together with his protective encircling ring of fire, watching and protecting Jerusalem and the world. God's "glory" is represented by his menorah at "the center" of this fiery ring (2:9). God's burning creative eyes stare out from the menorah lights, constantly creating time and space, endlessly (*En Sof*) repeating the process of genesis. Thus, God's fire burns within (menorah) and around (ring of fire) the world.

The other angel that is referred to is illustrated in this painting as the angel (Satan) on the South Pole horse. The assumption is that this angel and the Satan previously referred to are one and the same. This is because initially only two angels are mentioned, and later in Zechariah's next vision Satan and the angel are mentioned. Satan is another type of angel. The function of this second angel is to relay messages, and also serves as a

contrast to the other angel. This interpretation is in line with the Kabbalistic concept that both good and evil are necessary parts of the Godhead.

In a later vision Zechariah lifts up his eyes and sees a flying scroll. It is explained to him that "this is the curse that goes forth over the face of the whole land; for everyone that swears will be swept away on the other side of it" (5:3). Illustrated in this painting is a very large flying Torah-like scroll in the background of the world. Emanating from the top of the scroll are two wings, which are propelling the scroll into flight. The inner feathers of these wings are lined with bronze. Hence these wings are fused with and represent the two bronze mountains between and from which the angel emanates in Zechariah's earlier vision.

Written in Hebrew on the scroll are quotations describing God's return to Zion and Jerusalem, which is the essence of this book:

> Therefore, thus says God: I return to Jerusalem with mercy; My house will be built within her, says God, and a line shall be stretched forth over Jerusalem. Again proclaim, saying: Thus says God of hosts: My cities will again overflow with goodness, and God will once again comfort Zion, and will once again choose Jerusalem. (Zechariah 1:16–17)

> I return to Zion and I dwell in the center of Jerusalem, and Jerusalem will be called city of the truth, and the mountain of the God of hosts, the mountain that is holy. Thus says the God of Hosts: Once again elderly men and women will sit in the streets of Jerusalem, every man with his staff in his hand for every age. And the city streets will be filled with boys and girls playing in her streets. Thus says the God of hosts: If it is wonderful in the eyes of the remnant of this nation in those days, it will also be marvelous in My eyes, says the God of hosts. Behold I am saving My people from the country in the east, and from the country in the west. And I will bring them, and they will dwell in the midst of Jerusalem, and they will be for Me a nation [people], and I will be for them their God in truth and righteousness. (Zechariah 8:3–9)

These quotations written on the painting's scroll are blessings. Despite the fact that it is explained that the scroll is a curse delivered to the house

of unrepentant thieves, if the thieves read this scroll, they realize it is a blessing that does not apply to them, and hence it is a curse for them.

After the flying-scroll vision, the angel instructs Zechariah to lift up his eyes, and to see what goes forth. Zechariah can't quite make out what he sees. It is explained to him that what is going forth "is the measure which goes forth."

> This is their eye [evil] of all the land; and behold there was lifted up a round piece of lead, and this is a woman sitting in the midst of the measure. And he said this is wickedness. And he cast her down in the midst of the measure, and he cast the weight of lead upon her mouth. Then I lifted my eyes and saw there came forth two women, and the wind was in their wings; for they had wings like the wings of a stork, and they lifted up the measure between the earth and the heavens, then I said to the angel: where are they taking this measure? And he said to me: to build her a house in the land of Shinar; and when it is prepared she shall be set there in her own place (Zechariah 5:5–11)

Illustrated at the bottom of this painting is a purple "wicked" woman with a lead weight stopper in her mouth, essentially shutting her up, preventing her from speaking evil. She is being carried off by two feminine anthropomorphized storks. Coincidentally they are traveling in Satan's dimension, beneath him. His outstretched arms are directing them to "Shinar," which is written in Hebrew beneath Satan's head.

Shinar is the appellation for Babylonia, and is first mentioned in Genesis (11:2). There are multiple condensed messages in this vision. Babylon (Shinar), where the Jews in Zechariah's time are residing, is considered evil, and hence the Jews should leave evil Shinar and return to good Jerusalem. Similarly Joshua was told not to follow his evil inclination, Satan, but to choose good.

Shinar is also the Babylonian city where the tower of Babel was built, and received its name when God "babbled" the tongues of those who were building the tower. Hence the tower of Babel in Shinar represents the height of hubris – that is, the antithesis of humility and righteousness. Indeed the house that is being built for the evil woman in Shinar is the tower of Babel. But since that house will never be completed, she will be

hovering forever in the netherworld above Shinar, awaiting the completion of her home which will never come to be. Hence, in this painting, she is eternally banished from the world, suspended in nether-space, hovering beneath the protective arms of Satan (metaphorically).

The last three chapters of Zechariah culminate with an apocalyptic vision of the Great Day of God. In summary, Jerusalem will suffer greatly before it is saved. All the nations of the earth will be gathered against it (12:3), but God will come to the rescue and will seek to destroy the nations that come against Jerusalem (12:9).

> On that day will be a great morning. On that day there will be a fountain opened for the house of David and the citizens of Jerusalem for repentance and sprinkling. All the idols and unclean spirits and prophets will be destroyed from the land.... And it will be that two parts will be cut off and die and a third will be left. And I will bring a third part through the fire and will refine them as silver is refined, and will try them as gold is tried. They shall call on My name and I will answer them. I will say: It is My nation, and they will say God is my God. (Zechariah 13:1–2, 8–9)

All the nations will be gathered in battle against Jerusalem. The city will be taken, the women ravished, half the city will go out in captivity. God will go forth that day and fight against the nations. His feet will stand upon the Mount of Olives. Half the mountain will move to the north, and half of it to the south. And the people will flee to the valley of the mountains. In this painting, the angel of God is standing atop the mountain of olives (Mount of Olives), which is formed by the convergent olive branches emanating from the priest and king of Israel. Thus God's agent, Zechariah's angel, is hovering above the sukkah roof (*sechach*) and bearing *lulav-etrog*s, as the roof of the earth/Jerusalem provides Judah protection. As mentioned before, the one *lulav-etrog* construct, with its four (tetragrammaton) species and seven elements (seven days of creation), symbolizes the creative saving grace of God hovering above the sukkah of the world.

"And it will come to pass in that day that there will not be light, but heavy clouds and thick. And there will be one day that shall be known to

God, not day and not night, but it will come to pass that at the evening time there will be light" (14:6–7). This latter sentence in this painting is written on the lower right-hand wing of the flying scroll.

In order to convey the sensation of this Great Day which is not day or night but something altogether mysterious and unknown, illustrated in the left and right black background sky are God's emanating sinusoidal waves radiating and traveling throughout the expanse of the universe. These sinusoidal waves are composed of the seven alternating wavelengths of the light spectrum: violet, indigo, blue, green yellow, orange, and red. Like the seven branches of the menorah, this symbolizes the seven days of creation and the colorful extension of God's light.

The multiple colors of these waves constitute the modality of light. Light is perceived by the human retina, and thus these colorful sinusoidal waves represent the sensory modality of vision. If you look closely, the waves are composed of multiple small particles. Thus these waves represent both mass (particles) and energy (light). Each sinusoidal wave is constantly transforming from mass to energy and from energy to mass. Thus these light waves represent God's everlasting energy (of creativity) and the inter-convertibility of mass and energy.

These waves also represent sound waves, which are sinusoidal. They therefore symbolize not only the sensory modality of vision (light) but also the sensory modality of audition (sound waves). Furthermore, sinusoidal waves are also employed in the statistical Fourier analysis of time series such as signal processing. Hence these sinusoidal waves also represent the dimension of time.

In addition, the crisscrossing of the sinusoidal waves illustrated in this painting represents the crisscrossing strands of DNA, the building blocks of all life including human beings. This is yet another creative manifestation of God.

Thus, this painting illustrates that on Zechariah's Great Day of God when there is no light or darkness, the universe is being showered with sinusoidal waves packed with quanta of light, sound, energy, time, and the creation of all matter and life. In essence on this day, ordinary space-time reality is suspended, and is replaced by a different multimodal existence which is perceived by Zechariah's keen prophetic senses.

In this painting, the blue sky above the flying-scroll wings represents the eerie night sky during which Zechariah is having his visions ("I saw in the night"; 1:8).

"And on that day living waters will go out from Jerusalem; half of them toward the eastern sea, and half toward the western sea" (14:8). Illustrated at the bottom of this painting, emanating from the southern oceans of the earth/Jerusalem, is half the water of the earth/Jerusalem flowing to the east, spilling out into the cosmos, and the other half flowing to the west.

In this painting written on the left lower wing of the flying scroll are the words: "And God will be King over all of the earth, in that day God will be one and His name will be one" (14:9). The text continues: "And then there will be no extermination, and Jerusalem will dwell safely" (14:11). The nations that fought against Jerusalem will be punished terribly. "And it will be that everyone that is left of all the nations that came against Jerusalem will go up from year to year to bow down to the King God of hosts and to celebrate Sukkot" (14:16).

Thus Zechariah concludes his visions by reassuring Israel that Babylon is no place for them. Not only will they return to Israel under the providence of God, God will return to them and pay them back with munificence. The Temple shall be rebuilt. God will battle for them, and eventually in the end, their enemies who have destroyed their Temple and continually seek to destroy Jerusalem – and by extension extinguish the flame of Judaism – will themselves be celebrating Sukkot, worshiping and recognizing the God of Israel, and God will indeed be King over all peoples, and His name will be one.

Since only those of Judaic faith celebrate Sukkot, the implication is that all the nations will join the Jewish people in practicing Judaism (celebrating Sukkot is not a Noahide law). Thus, according to Zechariah's prophecies, not only will Israel be taken out of exile and be returned to Jerusalem, the concept of exile itself will be extinguished, and shipped to the nether land of Shinar. If the entire world practices Judaism, there is no place in the world where Judaism can be in exile.

The four wandering horses in Zechariah's earlier visions, which were wandering around the four corners of the earth like the scattered wandering Jews – are now, in his last vision, adorned with bells inscribed with the

words "Holy to God." This spells the end of universal exile (*galut*) wherein the expanse of the earth where the horses have roamed will become "Holy to God," where all people live in one big shaky sukkah, on one fragile planet, on one microscopic dot in the vast cosmos, rotating in the ether of space and time.

Zechariah's two large eyes are illustrated at the top of this painting. Written in Hebrew on his right eye are the words "Zechariah son of Berechia." Written in Hebrew on his left eye are the words "son of Iddo the Prophet." His eyes are simultaneously looking up and down. This is inspired by the text, which repeatedly describes the action of his eyes, "And I lifted my eyes" – he brought them from a lowered to an elevated position as illustrated here. The central menorah doubles as Zechariah's nose, and the three-dimensionalized Star of David with the pink central eye doubles as his mouth and also symbolizes a synesthesis of his mystical vision and prophetic speech.

Some of Zechariah's visions are also incorporated in the painting *Sukkoth* (2004; www.NahumHaLevi.com).

Notes

A) Twenty-four references for eyes and sight:

1) I saw during the night... (1:8)

2) And the angel told me I will show you (*areka,* visualize to you; 1:9)

3) And I lifted my eyes and I saw (2:1).

4) And God showed me (*vayareni,* visualized to me; 2:3)

5) And I lifted my eyes and I saw (2:5).

6) Surely he who touches you, touches the apple of his eye (2:12).

7) And he showed me Joshua (3:1).

8) Here is the stone I laid before Joshua; upon one stone are seven eyes (3:9).

9) And he said to me what do you see? And I said I see; behold a golden menorah (4:2).

10) And they shall see the stone plummet in Zerubbabel's hand; these seven are the eyes of God surveying the entire land (4:10).

11) Then again I lifted my eyes and I saw a flying scroll (5:1).

12) And he said what do you see? And I said I see a flying scroll (5:2).

13) Lift your eyes and see what it is that goes forth. (5:5).

14) And I said what is it? And he said this is the measure that goes forth. This is their eyes for the whole land (5:6).

15) And I lifted my eyes and I saw (5:9).

16) And I lifted my eyes and I saw (6:1).

17) For God is the eye of man (9:1).

18) For now I have seen with my eyes (9:8).

19) And God will be seen over them (9:14).

20) And their children will see it and rejoice (10:7).

21) If it is good in your eyes (11:12).

22) And upon his right eye (11:17).

23) And his right eye will be utterly darkened (11:17).

24) And on the house of Judah I will open My eye (12:4).

B) Seven references for the number 4:

1) I saw in the night, and behold a man riding upon a red horse (1), and he stood among the myrtle trees that were in the bottom; and behind him there were horses that were red (2), sorrel (3) and white (4); (1:8).

2) And I lifted my eyes, and saw, and behold four horns (2:1).

3) And God showed me four craftsmen (2:3).

4) The four winds of heaven (2:10).

5) And again I lifted my eyes, and saw, behold there came four chariots out from between the mountains (6:1).

6) These chariots go forth to the four winds of heaven (6:5).

7) And it was in the fourth year of King Darius that the word of the Lord came unto Zechariah in the fourth day (7:1).

C) Four references for the number 7:

1) For behold the stone that I have laid before Joshua, upon one stone are seven eyes (3:9).

2) I have seen and behold a menorah all of gold, with a bowl on top of it, and its seven lights on top of it, there are seven and seven pipes to the lights that are above it (4:2).

3) Even they will see with joy the plummet stone in the hand of Zerubbabel even these seven which are the eyes of God that run to and fro through the whole earth (4:10).

4) When you fasted and mourned in the fifth and in the *seventh* month, even these *seventy* years (7:5) that you have had indignation these *seventy* years (1:13).

D) Eight references for horses:

1) I saw in the night, and behold a man riding upon a red horse…and behind him there were horses, red, sorrel, and white (1:8).

2) In the first chariot there were red horses, and in the second chariot black horses, and in the third chariot white horses, and in the fourth chariot grizzled bay horses (6:2–3).

3) And I will cut off the chariot from Ephraim and the horse from Jerusalem (9:10).

4) And make him as his majestic horse in the battle (10:3).

5) And the riders on horses will be confounded (10:5).

6) I will smite every horse with bewilderment (12:4).

7) And so will be the plague of the horse (14:15).

8) In that day will there be on the bells of the horses (14:20).

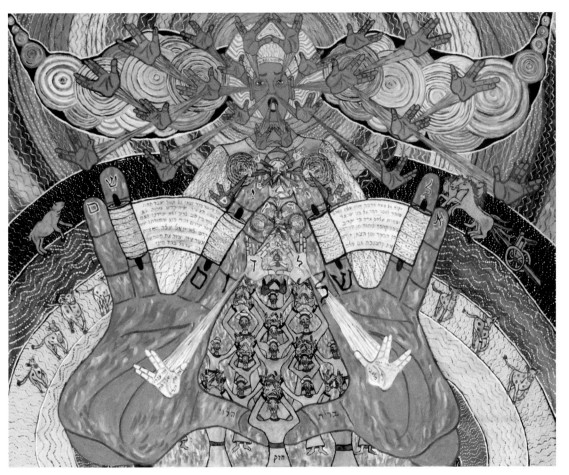

Malachi: 2009/60X48 inches/oil on canvas

Malachi: Hands across Time

15

This painting attempts to illuminate the book of Malachi's esoteric core by giving concrete form to God's mystical and transcendent messages (blessings), which are transmitted "through" and betwixt the priestly blessing "hands" (in Hebrew, *beyad*; 1:1) of Malachi, his messenger.

The book of Malachi is fundamentally about the virtues and vices of the *kohanim* (priests). The virtues belong to the exemplary ancient sons of Levi. The vices belong to this book's contemporary failing and flailing nascent Second Temple Priesthood (*Kahunah*), which have just recently returned to Israel from Babylonian captivity. Malachi delivers a stinging rebuke to their immorality circa 515–445 BCE, and envisions their future divine rehabilitation and recuperation on the Great Day of God.

The *kohanim*'s (priests') faults lay more in their sublime indifference to man and God, than in their frank corruption, although according to Malachi, this doesn't really constitute even a subtle distinction. This book could be construed as a supplementary manual to the book of Leviticus outlining the spirit of the "Priestly Law" (*Torat Kohanim*), which needs to accompany the letter of that law that is described in great detail throughout Leviticus, the third book of the Torah.

Surprisingly, Malachi is not read as a Haftarah portion coupled with any of the Torah weekly readings (*parashot*) of Leviticus. Although it is read as the Haftarah portion coupled with the Torah weekly reading of Genesis (*Toldot*), and is also read on Shabbat HaGadol (the Great Sabbath) preceding the Passover holiday.

203

This book is also in a certain respect a sad epilogue to the book of Zechariah. Zechariah's visions provided the major prophetic thrust for the post-exilic reconstruction of the Temple, and the purification of the *kohanim*. The priests upon their return from exile not only didn't live up to their potential, they actually denigrated their position and, worse yet, deeply insulted God. For reasons discussed below, this book may very well have been written by Zechariah, or by an author writing in the style of Zechariah.

Both the identity of the prophet Malachi and the authorship of this book remain controversial.

Who in fact is Malachi? There are multiple possibilities but only one makes sense, which will be explained below.

The name Malachi itself has multiple meanings. The word *malach* may mean "angel" or "messenger," or both. The word "Malachi" means "my angel," or "my messenger," or both. Alternatively, the name Malachi pronounced "Malachay" instead of "Malachi," but retaining the same Hebrew spelling, can also be used in Hebrew to denote the plural possessive form – "my angels," or "my messengers," or both. The possessive "my" in all cases is of course referring to God's possession. Whoever Malachi is, this name specifically refers to a *kohen* (a priest) or *kohanim* (priests). We know this because this definition is clearly spelled out in the text:

> You should know that I have sent you this commandment, that "My covenant" (*briti*) will be with Levi, said God. My covenant was with him, of the life and of the peace; and I gave them fear, and they feared Me, and in the presence of My name they were afraid. The Torah of truth was in his mouth, and unrighteousness was not found on his lips; with peace and uprightness he walked with Me, and he prevented a multitude from sinning; for the lips of the *kohen* guarded the knowledge, and Torah was requested from his lips; for he is a *malach* (a messenger, an angel) of the Lord of Hosts. (Malachi 2:4–7)

Hence every *kohen*, every descendant of Levi, is a representative (a messenger) of God on earth. This is a serious responsibility and a heavy mantle to bear. Accordingly, every *kohen* has a covenant with God (a Levitical Covenant; *Brit Levi*), an agreement that as a messenger he is to

be upright, his lips are to speak Torah and truth. He prevents, and does not provoke, sin. Herein lies the problem. The *kohanim* during the time of Malachi's composition fall very short on these requirements. Thus the book of Malachi is essentially a stinging rebuke to the priests of that time, and calls for them to return to their original calling: to be true messengers of God.

Thus we know, at the very least, that whoever Malachi is, or whoever he represents, he is either an individual priest or the entire priestly order (from Levi down to his descendants to this very day). Additional textual references, however, further hone in on Malachi's specific identity: "Behold, I send My messenger (*Hineni shole'ach Malachi*) and he will clear the way for Me... and the Messenger of the Covenant (*Malach Habrit* – the covenant being specifically the Covenant of Levi) that you want, he comes, says God, the Lord of Hosts" (3:1).

The Hebrew phrase "*Hineni shole'ach Malachi*" is reiterated later in the text with identical language, but then definitively identifies the messenger, substituting the generic priestly name of Malachi for his specific name: "Behold, I send to you (*Hinei Anochi shole'ach lachem*) the prophet Elijah before the arrival of the Great Day of God" (3:23).

Hence Malachi is not only generically a priest; he is specifically Elijah the Prophet. Thus Malachi, because he is Elijah the Prophet, is included in the section of Prophets in Tanach.

We also know from the very first verse of this book that Malachi must be a priest: "The burden of the word of God to Israel is in the hand (*beyad*) of Malachi" (1:1). "The hand" or generally speaking "the hands" refers to the outstretched priestly hands through which and betwixt God's blessings to Israel are physically and metaphysically transmitted. The word "hand" (*yad*) is the primary inspiration, and the essence of, this painting, and will be described in detail below.

The first words of the first verse of this book, "The burden of the word of God," are mentioned frequently with respect to many prophets, introducing their prophetic visions that are about to unfold. However, the use of the subsequent terminology "in the hands" is unique to the book of Malachi, and it specifically refers to the calling of the prophet-priest. This terminology is not used in any of the other twelve lesser or other prophets

throughout Tanach. Incidentally, the image of converging blessing hands has remained a symbol of *kohanim* for millennia, and has been and is frequently engraved on their tombstones throughout the generations.

If Malachi is indeed Elijah, and Malachi is a priest, is Elijah a priest (*kohen*)?

Elijah is never specifically identified as a priest in Tanach, but it is highly likely that he is. The Midrash compares him to Phinehas the *kohen* (the son of Eliezer, and grandson of Aaron) in his anti-idolatrous zeal. Also, in the biblical episode where Elijah challenges the prophets of Baal to a sacrificial divine-acceptance competition, and wins, he demonstrates a deep understanding of the details of animal sacrifice preparation and execution that only a priest would possess:

> Then said Elijah unto the people: "I, even I, only am left a prophet of God. But Baal's prophets are four hundred fifty men. Let them therefore give us two bullocks and let them choose one bullock for themselves, and cut it in pieces, and lay it on the wood, and put no fire under, and I will dress the other bullock, and lay it on the wood, and put no fire under. And you call on the name of your god and I will call on the name of the Lord, and the God that answers by fire, let him be God." And the people answered and said: "It is well spoken." (I Kings 18:22–24)

Elijah proceeds to gather twelve stones representing the twelve tribes of Israel. Moreover these twelve stones represent a makeshift *kohen hagadol* (high priest) breastplate, which has twelve precious stones embedded within it, representing the twelve tribes. Thus, Elijah is providing all the necessary sacrificial prerequisites, re-creating a poor man's *ephod*-breastplate (which he lacked under the persecutory circumstances under Ahab and Jezebel), which is vital to the success of sacrifices in general, and this most important sacrifice, in particular:

> And Elijah said to the entire nation: "Approach me"; and the entire nation approached him. And he repaired the altar of God that was thrown down. And Elijah took twelve stones, just like the number of tribes of the sons of Jacob, unto whom the word of God came,

saying: Israel will be your name. And with the stones he built an altar in the name of God; and he made a trench around the altar such that it would contain two measures of seed. And he aligned the wood, and cut the bullock in pieces, and placed it on the wood. And he said: "Fill four jars with water, and pour it on as the burnt offering and wood…" and the water ran around the altar, and the trench also was filled with water. (I Kings 18:30–36)

In the preceding book of Zechariah, a *malach*, a guiding "angel," also figures very prominently. Zechariah's angel appears suddenly, from out of nowhere, at night on a chariot and horses. Likewise, when Elijah suddenly departed from earth, ascending to the heavens in a whirlwind, he was accompanied by a fiery chariot and horses. According to Kabbalistic midrash he was transformed into the angel Sandalfon. It is therefore possible that the angel (*malach*) in Zechariah, like the angel (*malach*) in Malachi, is indeed Elijah.

The similarities between the books of Zechariah and Malachi, however, do not end there. Just like in the book of Zechariah, in the book of Malachi there are two textual references to the concept of memory (*zikaron*), the root word of Zechariah's name:

1) "And a book of remembrance (*zikaron*) was written before him" (Malachi 3:15), and

2) "Remember (*zichru*) My servant Moses's Torah" (Malachi 3:22).

Furthermore, the use of language for the purification of Israel in Zechariah and for the purification of the *kohanim* in Malachi is virtually identical:

Malachi (3:3): "And he [Malachi] will sit as a refiner and purifier of silver (*metzaref umetaher kesef*), and he will purify the sons of Levi and purge them as gold (*kazahav*) and silver (*vechakasef*), and they will approach God with sacrifices in justice."

Zechariah (13:9): "And I will bring the third part through the fire, and refine them (*utzeraftim*) as silver (*kesef*) is refined, and try them as gold (*zahav*) is tried, they will call on My name, and I will answer them. I will say it is My people, and they will say the Lord is my God."

Yet furthermore:

> Malachi (3:7): "Return unto Me, and I will return unto you, says the Lord of Hosts."

> Zechariah (1:3): "Thus said the Lord of Hosts: return unto Me, says the Lord of Hosts, and I will return unto you."

Zechariah pleads with Israel to return and rebuild the Temple. In one of his visions the *kohen gadol* (high priest) is given fresh clothing, replacing his sullied impure clothing, and chooses good over evil. He, along with the king of Israel, are the olive trees providing oil and illumination to the Temple menorah (see preceding chapter, "Zechariah").

Oh, what high hopes! What optimism! But alas the *kohanim* did not live up to Zechariah's high expectations upon their return to the reconstructed Second Temple:

> Unto you, O priests, who despise My name. And you say how have we disparaged Your name? You approach My altar with polluted bread and you say, how have we polluted You? In that you say this table of God is contemptible. And when you offer the blind for a sacrifice, this isn't evil? If you were to offer this to your governor (*pechatecha*: Persian terminology) would he desire it? says God. [*Hayisa panecha*? –"Would He elevate His face to yours?" This is a homologous analogy to the second verse of the priestly blessing; see below]... Is there anyone amongst you that would shut the doors, that you would not light My altar in vain? I have no use for you, said God, and I do not desire sacrifices from your hands. For My name is great amongst the nations, says God. But you profane it in that you say the table of the Lord is polluted, and the fruit and the food are contemptible. And you say: Behold what a weariness it is. And you snuffed at it, says God. And you have brought that which was taken in violence, and the lame and the sick. Should I accept this from your hands?" (Malachi 1:6–13)

> And I will curse your blessings [ouch], yes curse them, because you do not lay it to heart [there is no feeling]. Behold I will rebuke the seed for your hurt, and I will spread dung upon your faces, even the

dung of your sacrifices [double ouch]…. You have turned from the correct path, you caused many to stumble in the Torah, and you have corrupted the covenant of Levi. (Malachi 2:2–3, 8)

Your words have been all too strong against Me, says God, and you say: What have we spoken against you? You said it is vain to serve God, and what profit is it that we kept his charge, and that we walked mournfully because of the Lord of Hosts? And now we call the proud happy; they that perform evil are built up. (Malachi 3:13–15)

Compounding their sins, when Israel and the priests were brought back from exile, they divorced the wife (God) of their youth and replaced her with new wives – Baal and Ashera – retrogressing and backsliding as usual (2:12–16). Because Malachi tells Israel to return to their original wives, some scholars believe that this identifies Ezra the Scribe as the author of Malachi. Ezra encouraged Israel to leave their non-practicing Jewish wives to purge any relic of paganism from Judaism. It is contextually clear in Malachi that the first and second wives referred to are God and strange Gods, respectively, not literal wives. As mentioned above, Zechariah, or a Zechariah disciple, is a much likelier candidate than Ezra to be the composer of Malachi.

So how does God deal with these wayward priests? The priests are the leaders. If they can't lead the way, if they are detached and indifferent, if they disregard the widow, the orphan, and the poor, then what can be expected from the ordinary folk?

What to do?

The big guns have to be brought out. The Big Kehunah must be summoned: the Uber-priest, the Priest of priests, the High Priest of all high priests…Elijah the Prophet.

Approximately 400 years earlier, in 900 BCE, Elijah dealt with a far gloomier situation under the evil reign of Ahab and Jezebel, when they had most of the Hebrew prophets executed. Elijah risked his life when he challenged the prophets of Baal to a divine sacrifice acceptance face-off. He won the competition when his sacrifice and not that of the priests of Baal was accepted by God, and thereby won the hearts and minds of the people, and as a result the people of Israel returned to God:

And it was at the time of the evening offering, that Elijah the Prophet approached, and said: "God, the God of Abraham, of Isaac, and of Israel, today let it be known that You are God in Israel, and that I am Your servant, and that it is by Your words that I have done all these things. Answer me God, answer me, and this nation will know that You Lord, are God, and that You turned their heart backward" [just like the Priests in Malachi who "did not lay it to heart"; Malachi 2:1]. Then the fire of God fell, and consumed the burnt offering, and the wood and the stones, and the dust, and licked up the water that was in the trench. And the entire nation saw and fell on their faces and they said, "The Lord He is God, the Lord He is God." [These words have been incorporated into the Yom Kippur liturgy.] (I Kings 18:36–39)

Elijah is now sorely needed to work his magic again, and once again confront the specter of Baal (the new wife). Elijah, who had ascended in a whirlwind, accompanied by a fiery chariot and horses (II Kings 2:11) never to be seen again in the flesh, is now summoned back to purify the *kohanim*, and once again extricate them and Israel from the jaws of Baal and return them into the bosom of God, their first wife.

Elijah successfully restored faith in Ahab's time, and rehabilitated the people of Israel who broke their covenant (*brit*): "And he [Elijah] said, I have been very jealous for the Lord, the God of hosts, for the children of Israel have abandoned Your covenant, thrown down Your altars, and murdered your prophets with the sword, and I alone am left, and they want to take my life away" (I Kings 19:10).

Likewise, Elijah is now summoned back to rehabilitate the priests who broke their covenant (the Covenant of Levi) with God. Malachi/Elijah is charged with enabling the Torah and truth to once again germinate and sprout from the priests' lips, and fill their hearts with true feeling and intent (*kavanah*).

Just like in Zechariah's prophecy, this will all occur on the great and terrible Day of God.

Multiple legends and midrashim abound concerning Elijah. In Kabbalistic literature Elijah is indeed a *malach*, an angel. He is identified

as the angel Sandalfon whose twin titan brother is Metatron. Metatron is the angelic transformed Enoch, who like Elijah was also whisked away heavenward (Genesis 5:24). It is posited that both Enoch and Elijah were transformed into twin archangels as a reward for their exemplary behavior on earth.

On Passover there is a chalice filled to the brim with wine prepared for Elijah on every Seder table for him to partake in when (not if) he visits. There is a chair set up for him at every circumcision ceremony (*brit*) to prove to him how wrong he was in thinking that Israel broke their covenant (*brit*) with God. In the Talmud, the answers to the most perplexing unanswerable halachic conundrums will be solved upon Elijah's arrival.

Let us now focus on the painting.

At the relative center of this painting is Malachi and/or Elijah with large, projected, fiery, extended hands simultaneously blessing all of Israel – and refining and purifying the Temple priests within a self-contained furnace of fire, a condensed echo chamber containing the fiery voice of God, created by the juxtaposition of Malachi's burning blessing hands. He is like a smith, purifying and remolding the Temple priests, who are casted in gold or silver. As it is stated: "For he is like a refiner's fire…. And he will sit as a refiner and purifier of silver, and he will purify the sons of Levi, and purge them as gold and silver…then will the offering of Judah and Jerusalem be pleasant to God as in the days of old, as in ancient years" (3:2–4).

The priests, who are being purified in this painting between Malachi's frontally projected huge hands, are also raising their hands in priestly benediction, blessing Israel. Their erring hearts have been successfully mended, purified, and transformed by Malachi. Once again they are true messengers of God.

In this painting, blessing light-ray hands are emanating from Malachi's eyes, two sets of ears, nostrils, and mouth. The light rays are inspired by the second verse of the priestly benediction: "God shine His face upon you" (see below).

These hands in turn are emanating and reflecting additional light-ray hands, which in turn are emanating and reflecting additional light-ray hands. Furthermore, Malachi himself is seen serially contracting downwards into

smaller and smaller reflective mirror visages of himself, continuing to shrink down and downward, until his fourth serially contracted reflected image appears between his own large hands in the midst of the other *kohanim*. In his final compacted form his head is a fiery ball of light, his hands are glowing red, and his mantle is sun-yellow. Each subsequent contracting reflected mirror image of Malachi (going from the top of the painting toward the bottom) releases his own series of light-ray hands.

The multiplicity of blessing hands reflect one off the other, in multiple dimensions, yet all emanate from the same central source, like concentric ripples in a pond emanating from a single thrown pebble. They are extended throughout this entire painting, simulating the blessing's traversing path through space and time. All the combined multidimensional hands are functionally unified in dispensing God's unified and unifying penetrating benediction.

What is this benediction?

It is the blessing that God instructed Moses to transmit to the sons of Aaron to convey to Israel. In this painting, it is written in Hebrew on the multiple fingers of the multiple hands, and is composed of the following three sequential verses:

> God bless you and keep you (*Yevarechecha Hashem v'yishmerecha*);
>
> God shine His face upon you and provide you grace (*Ya'er Hashem panav elecha vichuneka*);
>
> God lift up His face towards you and grant you peace (*Yisa Hashem panav elecha, v'yasem lecha shalom*). (Numbers 6:24–26)

This ancient blessing is a masterwork of poetic, mathematical, transcendent ascension. In Hebrew:

> The first verse is composed of 3 words,
>
> The second verse is composed of 5 words,
>
> And the third verse is composed of 7 words.

These are ascending prime (indivisible) numbers.

Likewise the number of letters in each verse also mathematically ascends:

The first verse has 15 (3 x 5) letters,

The second verse has 20 (4 x 5) letters,

And the third verse has 25 (5 x 5) letters.

These are all ascending multiples of the primary number 5.

The total number of words in these 3 verses adds up to 15.

The total number of letters in the 3 verses adds up to 60.

These numbers are also multiples of the prime number 5.

The combined word-letter priestly benediction stepwise ascent is:

3–15,

5–20, and

7–25.

If we plot this out, each of these numbers could represent a series of points, or particles, on a sinusoidal wave (see below).

This benediction written in ancient Hebrew is found on an ancient engraved silver amulet, the oldest archeological document ever excavated that is written in ancient Hebrew, and dates back to the seventh century BCE. It is on display at the Israel Museum in Jerusalem.

The book of Malachi in its architectural composition mirrors the basic structure of the priestly benediction. Like the benediction, the book of Malachi is composed of three chapters, rather than three verses. Like the three priestly verses, each of the three Malachi chapters has an ascending stepwise number of verses:

The first chapter has 14 verses,

the second chapter has 17 (prime number) verses,

and the third chapter has 24 verses.

The second chapter has 3 more verses than the first.

The third chapter has 7 more verses than the second.

These differences are both prime numbers. The total number of verses in Malachi is 65. This number is also a multiple of the prime number 5.

If we look at the number of words in Malachi: The first chapter has 239 words, the second chapter has 269 words, and the third chapter has 368 words. The second chapter has 30 more words than the firstand the third chapter has 99 more words than the second.

These numbers are multiples of the prime number 3, thematically mirroring the 3 verses of the priestly benediction. Incidentally prior to chanting the *Shemoneh Esrei*, the "eighteen-benediction prayer" which is said three times a day, three steps are taken forward, and upon its conclusion, three steps are taken backward. This is a reciprocal stepwise approach toward God simulating God's three stepwise benedicting approaches toward man.

The combined chapter verses-words, stepwise ascent in the book of Malachi is:

14–239,

17–269, and

24–368.

If we also plot out each of these numbers, they too could represent a series of points, or particles, on a sinusoidal wave. This reflected sinusoidal wave only differs from the priestly benediction sinusoidal wave in frequency and amplitude.

Thus the priestly benediction and its mirrored reflection, the book of Malachi, irrespective of the meaning of the blessing's words, has an underlying divine mathematical message of ascending, infinitely expanding, indivisible grandeur. As the light rays of blessing emanate and traverse the infinity of space and time, they ascend higher and higher, and remain ultimately indivisible. The mathematical message is that the essential characteristic of the infinite God, who is without beginning and without end, the All, the *En Sof* (no end), represents the ultimate eternal and ubiquitous prime number and mover that is indivisible, abstract, unknowable, and uncontainable.

This painting also attempts to capture the poetics of ascension and

expansion by the multiplicity of concentric emanations scattered throughout the painting. The contraction of Malachi – and obviously the converse, his re-expansion – is a Kabbalistic reference to the concept of *tzimtzum*: a contraction of the universe at its inception, with the concentration of light in one area leading to a corresponding absence of light, or darkness, in another area. This is represented in this painting by the blackened concentric waves on either side of Malachi's shoulders, surrounding his hands, and the shadow of darkness on the wings to the left and right of Malachi's head.

While chanting the priestly blessing, the *kohanim* bring their left and right hands together. Specifically they place their hands side by side, then angle their fingers in such a way that their opposing thumbs touch each other at their apical tips, and their index fingers touch each other at their medial tips, thereby creating a triangular space between their hands. In addition, they separate their third and fourth fingers in both hands as widely as possible. Most people will recognize this as Spock's "be well and prosper" greeting from *Star Trek*, which Leonard Nimoy appropriated and popularized from the priestly benedictions he received from the *kohanim* of his local synagogue. This can be best appreciated by the illustrated huge blessing hands in this painting.

What is the significance of this hand-finger positioning? We hypothesize that the *kohanim* are figuratively reproducing with their hands and fingers the images of the cherubim in the Holy of Holies. The thumbs represent the heads of the cherubim heads, which are facing each other while simultaneously looking downward on the Ark of the Covenant. The opposed second and third fingers and the opposed third and fourth fingers represent the diverging, separated two wings above each cherub. The triangular space formed between the opposing hands represents the space between the cherubim through which God spoke to Moses and Aaron.

Thus when the *kohanim* go out and bless Israel they are essentially holding up their hands, mirroring the cherubim, and taking this mirror image out of the Holy of Holies. They are directing the voice of God that speaks from betwixt the cherubim, and are now rechanneling God's voice through and betwixt their own hands upon the heads of Israel. The left and right hands are mirror images of each other (levo/dextro) just like the

cherubim are mirror images of each other, just like the hands are mirror images of the cherubim.

When the *kohanim* bless Israel (down to this very day) it is prohibited to look at them in the process of this blessing. One must look downward, or cover ones eyes with a prayer shawl (tallit). Why? Because it is prohibited to look at God's face, and "whosoever looks at God's face shall surely die" (Exodus 33:20), as instructed to Moses when he asked God to show him His countenance (*hareni kevodecha*; Exodus 33:18).

If indeed the blessing messages of the voice of God are transmitted via the *kohanim*'s chanting voices and channeled through their hands, then the voice of God emanating betwixt the *kohanim*'s hands is considered a synesthetic visual reflection of God's image, and hence one should never look directly at the hands of the *kohanim* when they are performing the blessing, lest one glimpse God, and suffer blindness or death. (Other theories on the origin of this symbolism are outlined in the discussion of the painting *The Family Ankhyehova: Cross-Cultural Blessings and Mixed Messages*, 2006; www.NahumHaLevi.com.)

In this painting, each of Malachi's large blessing hands has a Torah scroll attached to its third and fourth fingers. The spreading of his third from his fourth fingers enables the opening of the scrolls. The Torah scroll on the right is opened up to the first paragraph in the book of Leviticus. Written in blue letters are the words: "And he called to Moses, and God spoke to him saying: Speak unto the children of Israel and say unto them, when any one of you brings an offering unto God, you shall bring your offering of the cattle, even of the herd of the flock. If his offering..." (Leviticus 1:1–3).

The Torah scroll on the left is opened up to the last chapter in the book of Leviticus. Written in Hebrew are the words: "And all the tithe of the herd of the flock, whatsoever passes under the rod, the tenth shall be holy unto God. He will not enquire whether it be good or bad, neither will he change it. And if he change it at all, then both it and that for which it is changed will be holy; it will not be redeemed. These are the commandments that God commanded Moses for the children of Israel at Mount Sinai" (Leviticus 27:32–34).

These Torah scrolls symbolize Malachi's teaching the priests the

entire set of Levitical laws as outlined in the entire third book of the Torah, which is named after its first word, "*Vayikra.*" In the Septuagint this book is referred to as the "Book of Leviticus," which is the book containing the laws of Levi, the priestly class. Its older Hebrew title is "*Torat Kohanim,*" the teachings or laws of the priests.

In this painting, while Malachi is blessing the Temple priests and Israel, he is simultaneously educating them by reintroducing them to the letter and spirit of Leviticus, the *Torat Kohanim*, so that they execute their duties with righteousness according to the laws of Moses.

Surrounding Malachi's large blessing hands in this painting are concentric emanating waves of different colors. In each surrounding concentric wave there are alternating vertical or horizontal sinusoidal waves of scattered particles representing the interconvertability of mass and energy. These sinusoidal waves, like those in the Zechariah painting, represent a synesthesis of vision, audition, space, and time (see preceding chapter, *"Zechariah"*).

In this painting, written in white letters on the palms of the small pink hands immediately above the left and right Torah scrolls, are the letters aleph and samech, which is the acronym for *En Sof*, meaning God, "the Infinite One."

Written on the right blue extended hand on the bottom of this painting are the blue Hebrew words: "The word of God in the hand of Malachi." Written in blue letters on the palm of the extended left blue hand are the words: "Behold I am sending you Elijah the Prophet." Thus these two hands express the dual mirror-image identities, left and right of Elijah/ Malachi.

In this painting, behind Malachi's face is the burning sun out of which emanate wings from the left and right sides of the sun. This is inspired by the text: "And the sun of righteousness with healing on its wings will shine upon those that fear My name , and you will go forth and gambol as calves in the stall" (3:20).

The multiple concentric emanating waves within the wings illustrated in this painting symbolize God's blessing healing powers. On the left- and right-hand sides of Malachi's large blessing hands are gamboling calves symbolizing the restored righteous people of Israel. Seven of them are

gamboling in the left and right background of a green pasture–concentric blessing wave. One of them on the left is gamboling in the black concentric blessing wave.

The sun behind Malachi's head is fused with the epicenter of the whirlwind into which Elijah ascended. The multiple concentric expanding waves surrounding this epicenter, each with their own sinusoidal inner waves, represent this mystical whirlwind of God. It is into this epicenter that Elijah enters, and it is through this very same epicenter that Elijah exits. It is the portal used for both his entrance into and exit out of the world of human perception and sensation. His faithful four fiery horses and chariot, his means of transportation, are illustrated patiently waiting for their master to the right of his large hands in the black background. They too enter and exit the same portal heralding Malachi's/Elijah's arrival or departure. The four horses represent the four letters of the tetragrammaton (Y-H-V-H).

In this painting, Malachi's miter is inscribed with the ancient Hebrew words "Holy to God." In his first contracted smaller mirror image beneath his large head, the same words are spelled out in modern Hebrew. Written on Malachi's large left and right thumbs are the blue Hebrew words "covenant of Levi."

Toward the end of the book of Malachi, immediately preceding the revelation of the coming of Elijah and the unveiling of Malachi's identity, the text states: "Remember the Torah of Moses, My servant, which I instructed him at Horev for all Israel, its laws and judgments" (Malachi 3:22).

The word Horev also directly associates Malachi with Elijah: "And he [Elijah] arose and did eat and drink, and went in the strength of that meal forty days and forty nights unto Horev, the Mount of God (I Kings 19:8).

In turn, Horev in this sentence connects Elijah to Moses at Horev (Exodus 3:1), who is Malachi's-Elijah's Levite ancestor, who in turn is the grandson of Levi.

Malachi is the last of the twelve Lesser Prophets, and the last prophet in the entire book of Prophets. The book of Malachi is a fitting end to the book of Prophets in that it seamlessly weaves into one unified tapestry Levi from the book of Genesis, Moses from the book of Exodus, Numbers,

and Deuteronomy, the *Torat Kohanim* from the book of Leviticus, Elijah the Prophet from the book of Kings I and II, and Zechariah from post-exilic times.

It is customary to end an entire collection of sacred works with the Hebrew word *Chazak*: "Be strong and be fortified." This is written in Hebrew Bibles at the completion of Malachi, and written on the golden priest's tunic at the center-bottom of this painting.